PUSH
COMES
TO
SHOVE

The MIT Press Cambridge, Massachusetts London, England

PUSH
COMES
TO
SHOVE

NEW IMAGES
OF AGGRESSIVE
WOMEN

MAUD LAVIN

MIT Press books may be purchased at special quantity discounts for business or sales promotional use. For information, please email special _sales@mitpress.mit.edu or write to Special Sales Department, The MIT Press, 55 Hayward Street, Cambridge, MA 02142.

This book was set in ITC Stone Serif and ITC Stone Sans by Graphic Composition, Inc., Bogart, Georgia. Printed and bound in the United States of America.

Library of Congress Cataloging-in-Publication Data

Lavin, Maud.
 Push comes to shove : new images of aggressive women / Maud Lavin.
 p. cm.
 Includes bibliographical references and index
 ISBN 978-0-262-12309-9 (hardcover : alk. paper) 1. Women in art. 2. Women in popular culture—United States—History—20th century. 3. Women in popular culture—United States—History—21st century. 4. Aggressiveness in art. 5. Aggressiveness in popular culture—United States—History—20th century. 6. Aggressiveness in popular culture—United States—History—21st century. 7. Arts, American—20th century. 8. Arts, American—21st century. 9. Popular culture—United States—History—20th century. 10. Popular culture—United States—History—21st century. I. Title. II. Title: New images of aggressive women.
 NX652.W6L38 2010
 704.9'4240973—dc22

 2009046986

10 9 8 7 6 5 4 3 2 1

TO MY BROTHERS Douglas, Franklin, and Carl Lavin, with love

Contents

Acknowledgments

While writing this book, I told a friend that working on this project made me feel alternately fearful and excited, and my friend replied, "Sure, because that's the way you feel about aggression." So, true! I couldn't have rappelled deeply into this exploration without my friends and colleagues and the emotions and ideas they so generously shared. It is a great pleasure to thank them: Sarah Alford, Alyson Beaton, Maureen Burns, Mark Cannon, Peter Chametzky, Romi Crawford, James Elkins, Sue Felleman, Catherine Grant, Vanalyne Green, Joseph Grigely, Anne Higonnet, Szu-Han Ho, David Joselit, Jamie Keesling, Anne Kreamer, Kathy Livingston, Kai Mah, Katie McCarty, Karen Morris, Mignon Nixon, Linda Nochlin, Peg Olin, Chris Pinney, Patrick Rivers, Shawn Michelle Smith, and Lori Waxman. The people I interviewed for the book also stirred my heart and mind; for that and so much else, I thank them—Jessica Bendinger, Lynda La Plante, Lisa Lee, Marlene McCarty, Susan Orlean, Laurie Palmer, John Ploof, Julia Steinmetz, and Amanda Riecke.

The research for this book was supported by a John Simon Guggenheim Memorial Fellowship, and I'm grateful for it. The School of the Art Institute of Chicago, where I'm a professor,

provided funds for the final formatting and image collecting for the book through a Faculty Enrichment Grant, and I thank the School as well.

I also appreciate the discussions I've been fortunate to have with graduate students at the School of the Art Institute in my ongoing Lust and Aggression seminar and with my wonderful colleagues and students in the department of Visual and Critical Studies there.

Roger Conover, the book's editor at the MIT Press, has deepened the pleasure and the challenge of creating this book in ways that have made the book better and sharper. In addition, without him, I'd never have looked hard at boxing, which was an eye-opener. Thank you, Roger. My thanks also to designer Erin Hasley and manuscript editor Kathleen Caruso at the MIT Press.

My gratitude goes to my adult stepchildren, David Bowman, Kris Bowman, and Amanda Steen Bowman, with my love.

And, finally, this book is dedicated with love to my brothers, Douglas, Franklin, and Carl Lavin, and with heartfelt thanks to them for being my friends as well as my siblings.

PUSH
COMES
TO
SHOVE

INTRODUCTION

Aggression rolls through our bodies and our psyches. We can express it as a key ingredient of anger, of determination, of movement forward, of space clearing, of lust, of harm, of survival, of creation. We can enjoy it. Or we can be afraid not only of aggression expressed toward us, but also of our own aggression. It can also stir hope, defensiveness, offensiveness, confusion, and motivation. Aggression is necessary, large, messy, psychological, and physical.

Historically, in U.S. culture, women's aggression has been repressed, frowned upon as inappropriate behavior, or branded as low class. In the mass media, women's exercise of aggression has at times been represented as a punishable offense. In contemporary U.S. culture, though, a large shift visible in the representation of women's aggression appears. There's been a cultural turn since the 1990s: feminine aggression is now often celebrated. In cultural manifestations ranging from indie grrl rock to consumerist Spice Girl girl culture, from video-game action heroines to mainstream sports movies, from street activism to national political figures, there exists for the first time in the nation's history, albeit unevenly, a growing, heavily viewed array of positive representations of aggressive women. So, now the questions are: How are these images evolving? How can we add to and form them? And how does and could this cultural turn impact women's lives?

Traditionally, definitions of aggression have been restricted to meaning harm to another. My rethinking, part of a contemporary discourse on the subject, explodes and expands the definition of aggression—as a drive, expressed emotionally, and/or as a key element of action.[1] I define aggression as *the use of force to create change*—fruitful, destructive, or a mix of the two. It exists internally within an individual, in the interactions between

individuals, and in the dynamics of a group and its relationships to other groups. Aggression is also necessary for radical democracy and the exercise of dissent.

With this broad definition in mind, what then could be the complex impact of these new images of aggression? Culture functions as both the enforcer of accepted norms *and* the hopeful arena of change, and U.S. culture is a composite of many different subcultures. Just as we can see that the disallowing of women's aggression could be dangerously disempowering, we can also be wary of the repression of aggression in any societal subgroup. The "pushy Jew," "the angry, black man": these stereotypes have been loaded over time with negative connotations and today are still used against people trying to express themselves with necessary aggression. Feminine aggression is only one of a series of controversial positions: it is the one under discussion in this book because its historical repression now appears to be changing. The new feminine aggression, too, becomes a useful model for considering other evolving identifications and the intersections between them. Culture is the set of a society's articulations and representations. In U.S. culture, for a variety of women, we've seen and heard the repressive commands and results again and again. Eat your words, keep a lid on it, turn the other cheek, lower your voice, demur. Or, with that repression and the resulting interiorized aggression, we've experienced the nauseating drip, drip, drip of passive-aggressive behavior: malign, disapprove, withhold, dampen, poison. Alternatively, cultural representations of feminine aggression can be complex and messy signs of hope, and can contribute to friction so key to collective and individual action.

One way to think about this question of possible cultural impact on societal habits is to ask what happens to members of

a group—say, all women in the United States, or a more selective one, for example, African American professional women—when aggressive behavior on their part is not allowed. By "not allowed" I mean considered illegitimate in socioeconomic contexts in which the individuals perform for survival—a workplace, a marriage, and so forth. If the women in question were to act aggressively, for instance, in order to win a conflict, to demand fairness, to argue forcibly for a raise or needed change in an institution's structure, would it—to put it crudely—cost them? Would their access to power and material goods subsequently be diminished? This question, although complex, is all too easy to answer on one level because until recently in many institutional contexts in the United States, the performance of feminine aggression was in fact likely to lead to a loss of power or even ostracism, as in being fired and/or labeled crazy, for instance. Are things changing now in women's experience as well as in the general culture?

If so, if there's a widening of the range of women's ability to express, articulate, and represent their own aggression, this would mean an expansion in the identity "woman." And yet, that is not the main dream of this book, nor is it to have women act more like men, themselves burdened with too narrow a societal and cultural expectation of how to articulate their aggression. This study aims instead to consider "woman" as an already huge, encompassing umbrella term for a great variety of intersectional identities, ones marked by race, class, gender, ethnicity, employment, sexual orientations, familial relations, and so on, in which a range of behaviors and self-representations already exist and are performed. It's not a blanket redefinition or a letting go of all gender definitions that is sought here, but instead the luxury of using that vast term "woman" in connection

with the many who define themselves as women and to explore a cross-section of their deep relationships between culture and experience as concerns their aggression. With this book, I articulate a great hope for a stronger incorporation of aggression and power within this large matrix. Chapters of this book proceed from looking at the new images of women and sports to exploring those of a subset of women over fifty to examining the representation of violent women to considering recent representations of certain subsets of African American women to taking a closeup look at art, activist, and workplace groups and their inner-group aggression. None of these identities under the term "woman" is separable really from any of the others. Instead the different foci, bringing out different issues in examining different cultural examples, are like changing the twist on a kaleidoscope. With each twist the large set of pieces is viewed in a different pattern. And each view delights in its complexity.

Chapter 1 considers the contemporary wave of women and sports movies in the context of the implementation of Title IX, the federal law mandating equal educational spending for males and females, which has brought a generation of high school and college women into team sports. In looking at celebratory women and sports movies, this chapter also incorporates psychoanalytic theory—particularly Juliet Mitchell's writings on sibling dynamics. The three examples of Hollywood sports movies examined in depth are the surfer girl drama *Blue Crush*, the cheerleader comedy *Bring It On*, and the gymnast movie *Stick It*.

Chapter 2 moves into culture related to a specific subset of women, women fifty and over, and considers Helen Mirren's globally distributed performance in the TV series *Prime Suspect* with its overflowing aggression in light of issues of ageism. In doing this, it also raises the complex question of refracting

issues of feminine aggression through a consideration of different subsets and intersecting identities.

These first two chapters stress the creative, libidinal, interpersonal, and survival functions of aggression and its articulation. The center of the book, chapter three, takes on the dark side of aggression: violence. The cultural examples here are the *Kill Bill* movies and artist Marlene McCarty's mural-size drawing series, *Murder Girls*. Reception issues related to images of women's violence are raised. Even here, there's something of a positive angle, an analysis relying on, among other theories, those of psychoanalyst Melanie Klein; the chapter considers as useful psychic functions concerned with acceptance—to a degree and as part of a process—of violence.

Chapter 4 returns the reader to a subset exploration and (mercifully) to issues of fusing aggression with libido. This chapter looks at the range of cultural production from the 1990s to the present of African American women artists, writers, and others reshaping representations of African American feminine sexualities. Quite diverse producers and audiences are involved. Accordingly, the examples here are the mainstream erotica writings of Zane and the art of Kara Walker.

Finally, chapter 5 adds another twist. While the book focuses mainly on images, this chapter also explores women's aggression in group dynamics of cultural production. This chapter takes as case studies two artists groups, Toxic Titties and Haha, and one nonprofit workplace, Hull House. Specific interviews with producers (as elsewhere in the book) are incorporated with theoretically based cultural questions.

The book concludes with some images of women's boxing, pulling together the issues *Push Comes to Shove* started with—embodiment, representation, celebration—with complexities

gathered along the way, such as embracing the uncontainability and full range of aggression in order, paradoxical as it may seem, to manage it. It also notes the continuation of a counterdiscourse repressive to women's aggression, at least in its representation. The primary example is a series of Amanda Riecke's YouTube videos of her training, sparring, and amateur matches and Flickr-posted photographs of her Golden Gloves match. Riecke's self-aware entry into physical aggression closely relates to her use of public social media, and this relationship raises hard, hopeful questions concerning future discursive possibilities for feminine aggression.

Here I want to be clear about the great expanse of the red carpet I'm laying down for aggression. I argue that aggression while at times manifesting as hate or a desire for destructiveness is not limited to those emotions; it also works with a widely operative libidinal thrust to fuel lust—of all kinds. Kicking goals, grabbing the brass ring, taking a bite out of an apple, shooting hoops, coming. And it works interpersonally to define boundaries, which in turn are indispensable for coexistence, debate, coworking, love, friendship, and so forth. Like bumper cars crashing—or gentler forms of friction—interpersonal aggression, (ideally) short of harm and violence, keeps spatial boundaries and social flow alive. The airing of disagreements can also help democratic actions, which work for a more equitable division of goods and services.

Aggression is powerful and once unleashed, hard to control. So, how do we culturally communicate our aggression; how do we articulate our force; how do we use these articulations to create change; how are subjective and individual and, of course, different desires for change meshed in group culture and action? The intricacies and layers of aggressive images, desires,

and actions, individual and group, are explored in this book through critical interactions with specific cultural examples—the creations of Jessica Bendinger, Helen Mirren, Kara Walker, Zane, Marlene McCarty, Haha, Hull House, and others—and with appreciation for the large inquiries these stir.

Women need aggression and need to use it consciously—but how to manifest it, how to represent it, how to keep opening a cultural space for its breadth—these are the delicious, fascinating, crucial, powerful, lustful questions ahead. Ones to reach, grasp, push, knead, fuck, explore, explode.

1

SIBLING PLAY: WOMEN, SPORTS, AND MOVIES

Why Does *Bring It On* Matter?

Since the 1990s Hollywood has produced a wave of cheery, inspiring, and entertaining girls' and women's sports movies. Like the fictional cheerleaders, surfers, basketball stars, and gymnasts they celebrate, their light weight belies their strength. Culturally, they mark a watershed in how women and sports are represented and identified within the United States—and, by extension and translation, women in everyday, forceful motion as well. They spin corporeal fantasies with the potential to help viewers imagine and visualize their own fantasies around powerful female bodies.

For me, as a cultural critic, the women in sports movies raise some large questions. I am focusing in this chapter on the wave of films created from the 1990s to the present, made for mass commercial viewing and starring a female protagonist. How do these female athletic fantasy films contribute to the ways a range of women viewers could picture our own, as Freud would put it, "bodily egos," roughly defined as a conflation of our sense of selves and images of our bodies?[1] And how, if at all, could these visual imaginings contribute to women moving and acting more fully, more aggressively, and more powerfully at will in our daily lives?

The recent sports movies also raise questions about current trends in representing femininity since the protagonists tend to be complex montages of traditionally masculine signs like muscles and overt, athletic competitiveness and traditionally femme ones like ponytails and female bonding. When I began the research for this book, I was most drawn to the "pretty girl" athlete movies about noncontact sports, which comprise the majority of today's mainstream women and sports movies—the

ones where public performances of feminine athleticism like cheerleading and gymnastics partially mask prowess and competency with smiles and rigid adherence to longstanding social mores. These seemed to me representative of where we as a mass culture are in terms of accepting and literally buying (in the form of movie tickets) athletic women. And some years into working on the book, I still feel that, my thesis backed by readings on and observations about the sports world itself, such as the marketing of the Women's National Basketball Association (WNBA). But now, too, I see a stretching of the new stereotypes celebrated in the pretty girl sports movies through their exploration of the rough play of sibling-like relationships, and that, then, is the primary focus of this chapter. (The "unpretty" sport of women's boxing and its uneasy reception in mass media is highlighted in the book's conclusion.)

Mass-culture entertainment impacts different individuals and different subgroups differently, so although asking these questions ambitiously across a large U.S. population, I'm not searching for universal answers, but instead using these general, gendered questions to explore a range of reception issues. That said, though, in focusing on the United States, it's possible to look at some broad acculturation patterns for women and girls in athletic competence and experience and some broadly shared stereotypes in representation as well as subgroup variations. (Other chapters of the book focus on subgroup reception issues.) There has been a dramatic sea change in athletics for women and girls since the late 1970s.

With the signing into law in 1972 of Title IX, which "mandated equivalent programs for males and females in schools receiving federal funds"[2] and its gradual, uneven implementation since then, the percentage of high school girls participating in

sports grew dramatically, for instance, from one in twenty-seven in 1971 to one in three in 1994.[3] As contested as the implementation has been, it still has caused an enormous shift in education; in feminine relationships to the body, corporeal strength, and team sports; and in core experiences of acculturation in adolescence and young adulthood for those one in three and others connected to them.

A pertinent point here is that key Title IX "babies" like Hollywood screenwriter and director Jessica Bendinger, who lettered in three sports in high school, have gone on in adulthood to be among those creating images of athletic women in the media. In Bendinger's case, she's written the cheerleading cult film *Bring It On*, released in 2000, and written and directed the gymnast movie *Stick It*, released in 2006. Title IX is not the only factor influencing the production of sports movies starring girls and women. This surge also coincided with Girl Power's spread from riot grrl rock to mass media and commodity culture in the 1990s, as the female echo boomers—that is, the girl children of baby-boomer parents—became little consumers. The consumer-culture version of Girl Power, initially a marrying of a cute aesthetic with empowerment messages, has evolved to include more mass-culture images of muscled women and girls as well. The women and sports movies that feature pretty girl sports—gymnastic, cheerleading, ice skating (as opposed to, say, wrestling and boxing) are part of Girl Power, literally showing ultrafeminine girls with muscular power. Within this group, basketball and soccer "girls" provide an interesting twist with their connotations of both traditionally attractive femininity (lean and toned female bodies) and traditionally masculine behavior (fierce blocking, pushing, and thrusting). Basketball and soccer movies occupy an interesting middle ground, although one of

course "prettied up" in mainstream movies, yet still in ways that allow for some valuable explorations of ambiguity. Hence in the British movie *Bend It Like Beckham*, 2002, there is a subplot about whether or not its main character Jess (Parminder Nagra) is perceived as a lesbian. Part of the pretty girl sports movie formula usually is to provide a heterosexual love interest for the protagonist as a subplot to counter this orientation-bending reading. *Stick It* is an important exception among the mainstream movies.

To underline how new the mass participation and mass culture are around women and sports, consider sports-clothes industries. Since the 1970s, there has been growing corporate investment in manufacturing clothes and equipment for women. Astonishingly, the jog bra was invented as late as 1977, and it wasn't until the late 1980s that athletic shoes for women were mass-produced. "And, in 1986, for the first time, women bought more athletic shoes than men did—148.5 vs. 116.7 million pairs."[4] Advertising promoting athletic women has grown hand in hand. Ads, of course, provide visuals, which filter into films, and vice versa; the asetheticization of the female athlete's body has become something that recent audiences expect to see.

No matter how glorified the athletic female body has been in advertisements and other forms of culture since the 1990s, though, the exercise of aggression in daily life, including the physical joys and power of using one's own body aggressively, is still partially closed to women acting within mainstream U.S. cultural norms. And, as Dana Crowley Jack and other psychologists have reported, women's aggression still tends to be aimed primarily inward, making women prone to depression and eating disorders.[5] The feminist implications about redirecting fantasies and actions concerned with the implementation

of feminine aggression away from self-hurting and toward a complex of outside foci are strong. By "feminist" I mean a combination of concerns from the second wave, specifically the emphasis on activism and righting of power relationships and access to material goods and services, and those from the third wave, particularly the focus on race and differentiation, a broad array of cultural choices including but not at all limited to a participation in female athleticism.[6] This is a combination that resonates in terms of political power and change, cultural pleasure and meaning, and lived experience (as opposed to tidy categorizations). The girls' and women's sports movies, made in Hollywood and elsewhere, can be seen as providing welcome if quite complicated fantasies that seem to open doors to counter the long tradition of inward-facing aggression. Specifically, the movies' evocation of sibling aggression is one area where a socially condoned, outward-thrusting kind of aggression from childhood can be renewed and/or built on for teenage girls and adult women.

An internalization of new attitudes toward aggression could influence even how girls and women move in everyday walking and gesturing. It's possible to speculate, as philosopher Iris Marion Young has, that culture influences how individuals depict their bodies to themselves and that these images are key to how we each implement and style our movements. The experience of using the body to exert power, in this light, is at the core of being able to imagine and implement other kinds of power as well, because body and psyche, outer and inner, are not divisible. And conversely, I'd argue that without such movement or the fantasy of it there could be a hampering or repressing of strength on many levels. In her seminal essay, "Throwing Like a Girl," Young goes into depth illustrating how traditional

feminine movement patterns, such as the lack of lateral movement and fully three-dimensional use of the spatial volume surrounding the body, can limit a girl's feeling of strength and in general her concept of the effectiveness of her body as it moves in the world.[7] The changing of these movement traditions is not straightforward and as the contours of movement and gender are altered, issues of sexual orientation and what it means to be a woman are brought into play.[8] Various kinds of retaliation for women acting aggressively are still daily and commonplace. Strength can come at a price then, and with unexpected rewards as well. For women, the positive results of experiencing strengths in the body as these competencies ripple through everyday life are underexplored. It's these everyday results and the fantasies that accompany them in our culture (here in movies) that interest me greatly. These tie into large issues of what lust, greed, peer relations, and goal orientation have to do with aggression, and these explorations link also to controversies in psychoanalytic theory and among psychologists about whether or not aggression always has to involve harm to another.[9] Viewing aggression, as D. W. Winnicott does, as embedded in all motility, the connections between a comfort with one's own aggression and a confidence in one's own physical competence are suggestive. The relationship between the self and identifications with characters on the movie screen raise another layer of issues, ones often discussed but inflected in a particular way here by the moment of cultural history we are inhabiting and its experiences of women and athleticism.

I see fantasies about and the experience of strength and physical competencies as intertwined with a new, more conscious acceptance of feminine aggression, and that acceptance in turn as key to individual survival and collective change. Since

social space, which is to say shared space, is often marked with contestation (for resources including space itself), admitting to aggressive emotions, which as psychoanalyst Melanie Klein would argue and I would agree, we all always have, and implementing them through bodily movement and self-concept can be regarded as necessities.[10] I also see verbal aggression as related to physical potential for aggression at least in the operations of the ego and the ways in which we conceive of ourselves and enable ourselves to act. Sports arenas and the unabashedly aggressive behavior (not solely aggressive of course, but aggression felt and experienced effectively in concert with other emotions) allowed, even encouraged, and necessitated within these spaces provide a beautiful metaphor for complex, mainly constructive uses of aggression in daily life.

Further, in U.S. culture sports (female and male) competition is a packed, multiuse metaphor; it's often used to describe marketplace competition within capitalism and to verbally heighten team spirit within business—for example, "let's run with it." More broadly, sports metaphors are commonly used to express striving of all sorts. The sheer physical relief of exerting aggression outward instead of inward engages me—the joy and relief of doing it and of watching others do it—and what that might mean for women especially.

At this point in U.S. history, many adult women are consciously exploring how to employ their aggression in public arenas. It's in this context of the public exercise of aggression, and in imagining how it might be done and might be received, that sports and sports movies have impact. In sports movies, it's possible to see individual aggression meshing with others' efforts to strive and obtain. I'd assert that in the sports movies it's the relationships between athletes that allow for complex

emotions about aggression, feminine athleticism, and viewing ego ideals to be aired.

For many of us this teamwork mix of fondness and aggression, of group effort and individual ambition, of inner-group conflict and combined goals is a familiar one and harkens back to the puppyish rough-and-tumble of siblings growing up together. A sibling metaphor for sports aggression is powerful on a number of levels: camaraderie on a sports team is so like the fun part of sibling play; physical jostling without (usually) actual injury is so like sibling roughhousing; striving together to win a game is so like siblings banding together while growing up; rage that gets mixed in with sports competition is so like the rage at the heart of sibling rivalry. More than any of these, though, the sibling model is fruitful for learning about and remembering how to regulate the messy kaleidoscope of emotions that aggression can connect to and unleash in an individual negotiating among a group, as in sports. To be a sibling, like being a member of a sports team, is to learn that an angry competitiveness can be experienced side by side with a fondness for a teammate; to learn to be aggressive within the rules; to sublimate a mix of emotions, including aggression, in order to work with others.

Sports, however, have a different relationship to time than sibling jostling. In sports, wins and losses fall safely into timed segments like quarters, halves, and games. In an orderly if intensely followed fashion, these wins and losses are tallied over seasons. This calming effect of careful measuring becomes part of the lesson of winning or losing. In contrast, actual sibling relationships imprinted at an early age are fraught deeply with love and hate. Thus negotiations among actual siblings are likely more meaningful than among most teammates (and definitely more meaningful than stories of fictional teammates), but

also messier and more dangerous. Sports narratives then appeal in this light all the more strongly as parables that—in fantasy—can safely contain the passions of siblinghood. Add to this the neat time frame of commercial feature-length movies and the pretty girl sports movie formula, which requires a happy ending, and time factors even more in achieving a comforting resolution.

Cinematic time and sports time have the potential in these viewing situations to open the psyche to a range of fantasies concerning aggression. For so many girls and women, still socialized to swallow and fear the internal aggression that is necessary for jostling with teammates (and workmates and friends and generally others in a group), the team sports model—and cultural representations like sports movies of its relationships, and fantasy relationships—can serve to revivify sibling feelings of aggressiveness, and this is extremely useful for women in terms of experiencing, exploring, and implementing feminine aggression in adulthood. In turn, I'd argue that while feminine aggression is not the same as feminist aggression used for the self, within groups, and for activism, it is an indispensable contributing factor to feminist aggression.

For this chapter, I watched a whole raft of mainstream, U.S.-made women and sports movies—the major examples from the surge of these created in Hollywood since the late 1990s and some precedents.[11] These included *Stick It*, 2006; *She's the Man*, 2006; *The Cutting Edge: Going for the Gold*, 2006; *Herbie: Fully Loaded*, 2005; *Ice Princess*, 2005; *Million Dollar Baby*, 2004; *Edge of America*, 2003; *Blue Crush*, 2002; *Bring It On*, 2000; *Love and Basketball*, 2000; *Girlfight*, 2000; *The Cutting Edge*, 1992; *A League of Their Own*, 1992: *Personal Best*, 1982, and *Ice Castles*, 1979. (*Bend It Like Beckham*, 2002, as we've seen, is helpful to this discussion,

but it was made in Great Britain, and for this chapter Hollywood's pretty girl movies, selected from the preceding list, are the focus.)

There are differences, of course, between watching sports movies and playing sports and watching live sports on TV. The movies, when they come out in increasing numbers in a genre, provide as cumulative representations a whole level of inviting "mythification," a set of representations about girls, women, and aggressive movement. In particular, in this chapter, I focus on three of the recent movies that portray in a variety of ways women's aggressive movement within a shared space and aggression mixed in among the joys and fears, love and hate, of sibling relationships.

I use three movies to explore key points concerning the viewing of representations, which stir the emotions of sibling love and aggression. In John Stockwell's *Blue Crush*, 2002 (script by Lizzy Weiss and John Stockwell), I consider an idealized notion of sisterhood as exploded and reconstructed to include aggression both internally within the group dynamics and externally vis-à-vis nature and mortality. In discussing Jessica Bendinger's *Stick It*, 2006, I go deeper into the representation of group dynamics with an emphasis on shifting and multiple points of identification. In examining Peyton Reed's *Bring It On*, 2000, I analyze the play of race in the aggressive sibling dynamic where the self is kin to but differentiated from the other and where the relationship between self and other is marked by appropriation, closeness, distance, and competition.

In each of the three movies, within its own sibling-like sports context, the girl and women protagonists fight and train to use their bodies with power and aggression, and the corresponding ego development is explicit. The characters oppose or intricately mix their bodily and bodily-ego desires articulated through

athletics with other identification factors—ethnicity, femininity, class, tradition, friendship, and/or romance. As in male sports movies like *Jerry Maguire* (Cuba Gooding Jr., Tom Cruise, 1996) with its famous "Show me the money!" yelling match, their sports arenas are also shown as places to make money and win valuable endorsements or scholarships. But while the ability under capitalism to make a living by using one's talents can be a useful fantasy, particularly for women, a historically underpaid segment of the work force, one of the cultural advantages of women's sports movies in the 1990s and 2000s is that this goal doesn't dominate or upstage other body-ego issues. The relative newness of so many women succeeding at public sports (e.g., the WNBA was founded in 1996), tends female sports movies more toward broader character development; the plots focus on the attainment of aggressive power against societal and interpersonal odds.

These three movies are exuberantly full of sibling-like aggression, and while seemingly light, for me they stirred deeply involving pleasures and anxieties. I'd initially felt a satisfaction from watching the characters in the movies literally protect their space and their metaphoric weight: a self-protection that women need and haven't always been socially and culturally allowed. But of course there's so much more than protection involved in the actual playing of sports and its movie representations: these athletes and actresses are shown fully inhabiting their own space and aggressively moving through a shared and contested space with strong will and corporeal power. At the same time, they need to exercise a complicated mix of team support and competition with the other team. Even more complex an addition to the sugar-and-spice mix, there is the competitiveness among teammates and a shared bond between competitors, brought about by the sport (or in surfing and other activities by

a bond both with the sport and against nature and mortality and danger). Movies open up a wide space in fantasy for visualizing play, play with these experiences and concepts, play that connects deeply to feelings about and desire for sibling interactions. Most women in sports movies star teens and twentysomethings mainly for box office reasons—that is, to attract young heterosexual male viewers looking for toned young female bodies in revealing athletic clothes and to attract young female viewers; both the men and the women are pre-family-building and have, the market assumption is, expendable incomes for entertainment. But this youth casting, in addition to attracting young audiences, fits nicely into an association for viewers of all ages of the characters with play. Play is not restricted to children and young adults, and, for an adult viewer who chooses to engage, the connection can be felt between play and childhood (or young adult) experiences and the present-day body of any age. For me, images of siblings and movies about sibling-like interactions starring female protagonists, of whatever age, resonate with where I stand and move vis-à-vis my actual siblings, other lateral relationships like those with coworkers and friends, siblings in fantasy and play, and the sibling-like relationships concerning my own bodily ego and will and space.

Aggressive play is so often sibling play. Psychoanalyst Juliet Mitchell in her book *Siblings: Sex and Violence* reminds us how very important this play is in learning how to relate to oneself and others and to navigate the intense, attendant emotions. As she summarizes that early childhood process of recognition:

I love myself, I will love my sibling as myself, my sibling is not myself, I must love my sibling as another who is like me. I thus put at risk my unique, grandiose self: with luck I can see myself seen by my sibling. Rage and terror mark the overcoming of the trauma that necessitates

the transition and transformation from narcissism to object-love, from self-importance to self-esteem, from the choice between murder versus being annihilated on the one hand, and, on the other hand, tolerance of self and other, self-esteem and respect for the other.[12]

Descriptively, these interactions can't be simply reduced to sibling rivalry, or rather they can be but then can't be dismissed as just that. Instead a larger grasp is necessary: these dynamics and our positioning of ourselves vis-à-vis our siblings (and others in similarly lateral relationships—friends, peers, colleagues) has much to do with our deep understanding of how self and others relate and, accordingly, our social behavior as adults as well as in childhood. From an early age we need to be able to protect our space and ourselves from siblings but also to share that space; and to understand that the person whom we want to hit over the head (or may've in fact pushed through a plate glass window or . . .) also will want at times to do the same to us; that the person we'll need to defend desperately against may also need to do the same with regard to us; that the person most like ourselves is yet different; that this same person we fight with is one we treasure and love; that a sharing of resources with this person is not necessarily desired but is necessary (for mutual survival) to effect. This is a tall order to process and achieve. Play helps try on and mix these roles of love and aggression. It is in fact essential.

Viewing women and sports movies can stir sensitivity to and nostalgia for expending aggression within a sibling space and for some, then, corresponding memories of bodily strength exercised through roughhousing and sibling play. Perhaps they can inspire a desire to reapply and revise such play and aggression to gendered adult experience. Moving within a group and/or competitive sports arena, the female protagonists exhibit

and convey a passion of movement and positive body ego along with uncensored use of aggression that together are also channeled toward a positive and socially condoned goal. These images and related fantasies can be powerful, especially for women for whom some of these have been historically denied and repressed at least in adulthood. Their accompanying passion is a sibling passion: the yearning for aggressive play, the joy of seeing a space for the self and the full-out physicality of the body in action—all this made space for in the middle of aggressive play *with* others and corporeal memories of this play in childhood. In the movies, the protagonists usually, but not always, win competitions within the shared space. But more to the point, they always win their space, the full expression of their bodies and strength according to their will while playing with others.

You could say these movies are an homage to interdependence with full strength expressed by the female protagonist. That's a large ambition and deeply satisfying to watch and to fantasize about and to relate to one's own life. These representations in the pretty girl sports movies are displays and realizations of aggressive movement that don't usually hurt others (because they are not about contact sports); on the contrary, they involve playing well, playing with very mixed emotions—light and dark, and playing with others.

These movies provide a model for thinking about what other forms and fantasies of aggression might look like. This is a key issue, and a complex one. Internal fantasies, or in Freud's term "daydreams," are not manufacturable, but they can share and adapt a common vocabulary. Like positive visualization exercises used by men and women in sports competitions and even in just working out, these visual vocabularies can be employed

and internalized in relation to one's own body in motion. Whether it's ripping waves in a two-women heat at a surfing competition in *Blue Crush*, performing alongside, against, and with various other gymnasts in *Stick It*, or sharing and competing within and outside a cheer squad in *Bring It On*, these film fantasies and their associated visual vocabularies matter. They have particular resonance now when, for the first time in U.S. history, the majority of a generation of women has grown up playing sports. They matter to those women (who with younger cohorts now in high school and in their early twenties are their target demographic), and they matter also to those of us in the baby boom and older who came of age before Title IX and have found or are finding other ways on our own to enhance our bodily egos and our muscles and our fantasies of strength.

The huge increase in sports participation for high school and college women is a behavioral transformation on a mass societal level in the United States, and correspondingly—though creatively and not purely reflectively, and also within the requirements of mass distribution—fantasies and images of athletic girls and women in mass culture are changing. Using representation, this is a positive time to question and explore these inventive if also mythologized first steps and to fantasize about next ones.

Blue Crush: Growing Stronger with and Despite Sisters

Surfer girl movie *Blue Crush*, 2002, is full of sibling aggression and is worth considering for the ways these issues intersect with those of sex, love, death—and the representation of a bodily ego as it grows stronger.[13] It opens with flashbacks of the main protagonist Anne Marie Chadwick's childhood surfing, a joyous wunderkind

performance, interspersed with images of her more recent near-drowning experience when she hit her head on a rock deep underwater after wiping out while surfing. Together they represent a desire to reclaim yet another aspect of childhood aggression exercised freely in sibling play; this desire has to do with a liberating aggression expressed in fighting off fear and felt strongly when experiencing one's own talent and exuberance in athleticism as a child (and for some who grew up in or near the country or a city park, playing on one's own in nature). In *Blue Crush*, aggression in surfing trumps fears of nature and of mortality.

Viewers then see Anne Marie (Kate Bosworth) in the present (she seems to be in her early twenties) working out on the beach, and we understand, in the tradition of guy sports movies, that she's striving for some sort of physical and mental comeback. We're quickly informed that it's only seven days before the all-important and dangerous Pipeline competition. We next see Anne Marie perform the role of older sister as she wakes her friends Eden (Michelle Rodriguez) and Lena (Sanoe Lake) and her younger sister Penny (Mika Boorem), who all live together, without parents, in a romanticized Hawaiian rambling shack of a house on the beach. The emphasis in *Blue Crush* is on sister-to-sister relationships even more than other kinds of sibling connections, although those are present, too. With the same-gender focus, homoeroticism is spotlit, and the closeness of self to other is intensified. In *Blue Crush*, too, Anne Marie's role as older sister pops her in and out of a maternal function: she thrives, though, when not taking care of others and instead staying as sister, not as mother. As sister, she participates in the group camaraderie and has space too—or takes it—to embrace her own fears and triumph individually.

After dropping Penny off at high school, the three friends head for the beach where they run into a group of Hawaiian

boys who are also going surfing, one of whom, Drew, is a former boyfriend of Anne Marie's. Tension develops between the joys of surfing and friendship, on the one hand, and a sibling-like egging on to more dangerous waves and the possible glory of success at Pipeline, on the other. The boys pressure Anne Marie to pit herself against killer waves. Is their encouraging Anne Marie to try waves that could actually kill her aggression or love or both?

Also early on in the movie we're introduced to surfer-phenom Keala Kennelly: the three friends see her filling her car at a gas station, and they gossip about her legendary surf stardom and her financial backing by her sponsor Billabong. There are several points of affinity in this scene for viewers—Kennelly herself, the young girls who come up to Kennelly for her autograph, and then the three friends. We watch Kennelly spotting the three and describing them as local surfer girls to her Billabong sponsor who's riding with her—it's the local quality, the friends having fun on the highways, worrying about money together, and the fact we see Anne Marie working out that allow us to feel a kinship with her and her pals (even those of us who've never surfed).

Quickly one of the two main plots (the Pipeline surfing competition being one, romance the other) is introduced: there are NFL football players (another sibling group) staying at the resort where Anne Marie and her friends work day jobs, and Anne Marie's love interest is a sensitive guy/quarterback Matt (Matthew Davis). Dropped in these developing, parallel plots is a key scene that again brings up the underside of the sibling relationships— their tie to dangerous aggression. While Anne Marie is at the beach surfing, boys who'd been partying with Penny the night before and had witnessed Anne Marie yelling at her little sister confront her in the water; one drops down on her (meaning

literally falling on her—on purpose) while she's surfing a wave, causing her to wipe out and break her board. The local boys are like the girls' brothers in the movie. Siblings are your friends *and* your enemies; the emotional message is that they can turn on you. As any viewers in the surfing culture know and as the rest of us get an inkling of from this scene, the male surfer practice of dropping down on each other and especially on "interloper" women in the big surf—harmful aggression of space and body— is all too common.[14] In the movie, Anne Marie gets angry in response: her sibling aggression, this time against a "brother," is not repressed.

This key scene also introduces viewers to some amazing surfing footage that appears in this movie. Kate Bosworth learned to surf for the film (we see her at least getting up on boards), and Sanoe Lake is an experienced surfer. There are also documentary montages of Hawaiians of all ages surfing—with children, with dogs, in couples—and stunning scenes of name athletes and doubles ripping large, dangerous waves.

The most intense relationship in *Blue Crush* is not the rather predictable romantic one between Anne Marie and Matt but instead the sister-like one between Anne Marie and Eden. She is both Anne Marie's friend—she coaches her and is her roommate and Anne Marie explains later, like Penny and Lena, her family—and her enemy. Eden is the most overtly competitive with, envious of, and angry at Anne Marie. At one point in her running lecture to Anne Marie to ignore the boy (Matt) and get back to her training, Eden says, "I would *kill* to be in your shoes." Soon after there's a dramatic scene of Eden on a jet ski pulling Anne Marie on a surfboard through heavy waves. Anne Marie wipes out, Eden looks for her and rescues her on the jet ski, then both are caught in a wave and go under. Once

righted, they start yelling at each other: "Where were you?" "I almost freaking died out there." "Stop being such a freaking Barbie." Anne Marie announces she's quitting and starts swimming for the shore, while Eden follows in the jet ski, taunting her, both hating and "helping" her. Eden tells Anne Marie it all sounds too familiar, quitting as Anne Marie's mother did, which of course inflames their argument. Anne Marie is not literally Eden's older sister but often functions as one in their home. Here she rages at Eden with a classic and deeply felt older sister line: "You know what I want from you is to get your own life and stop living through me." Some time later at their home, the fraught dialog continues in a more retrospective tone while Eden is watching an amateur (home) video of Anne Marie surfing as a child: "The first time you beat me . . . I was so pissed." This is actually a moment sweet in its openness and its owning of complex emotions including aggression; when Eden is admitting to her sibling rivalry, the viewer understands it is also a cornerstone ingredient in their adult friendship ("You were such a cocky little shit"). There's also eroticism here as Eden's sexuality is undefined in the movie. Eden exchanges punches with boys instead of femme-flirting with them; there's an intimation that she's homoerotically attached to Anne Marie and that that's part of her objection to Matt; what Eden and Anne Marie's friendship reads most like is a kind of sibling homosocial bond. There's an unstated racial tension, too. Anne Marie does look like a Barbie with her blonde hair and doll-like Anglo features, while Eden with her dark, wavy hair and dark skin is implicitly presented as native Hawaiian (actually Michelle Rodriguez is Latina): with this differentiation, the fact that white Anne Marie is the main protagonist and person-of-color Eden her supporting friend is a tired racial cliché.

There are various ups-and-downs in the Matt/Anne Marie romance. The viewer understands that Matt will be leaving Hawaii, so that although the bond between them is taken seriously it's clearly going to be a lower priority in the long run than what happens at Pipeline and between Anne Marie and her "family." She, of course, needs to discover this, though, and that her athletic success is also somehow bound up with her sibling relationships.

Blue Crush peaks and also ends at the Pipeline competition, and while this plot development is predictable the camera work is not. It's spectacular—cameras were taken right into the waves, at the actual North Shore beach of Oahu in Hawaii where Pipeline, a famously brutal competition, takes place. The rules of the two-women heats are detailed by the voice-over announcer. As a constant throughout these prolonged scenes, the drama shifts back and forth from interpersonal competition to a sense of shared pitting and striving and accomplishment of the body against the ocean and very much against mortality (we are reminded again and again that this is a location where surfers have died, pounded on the reef). The direction and script tell the Pipeline story in a way that highlights the tensions between fear and exhilaration, between frozen stillness and skilled power, between death and life—set against the beautiful, crashing seascape. It also includes a sensual and erotic set of relationships pictured between individual surfers and the waves; contrasting with the truly frightening wipeouts are the successful rides in which the surfers stroke the inside of the curl for prolonged and highly erotic contact with that which can excite them, propel them, balance them, and/or kill them. In the movie's version of the Pipeline world, the sibling figures unite against the challenge of the waves even while competing. Most notably Anne

Marie scores high enough in her first heat to face Keala Kennelly in a second, and the two establish some (unlikely in real life) collaboration.

In the heat with Kennelly, Anne Marie out on the ocean with her board keeps freezing with fear and letting waves go by while Kennelly successfully rides first one and then paddles out to catch another unimaginably huge wave in. Kennelly's ahead in the heat and Anne Marie is nowhere, so Kennelly helps her out. Not only is Kennelly portrayed, and as the viewer knows in fact is, the far more experienced surfer, she looks older and more sun-weathered than Anne Marie. Kennelly is now the older sister as she asks Anne Marie, "Whaddya doin?" And Kennelly then advises her, "OK, I'm going to tell you which wave to take and then you're going to paddle hard, paddle, paddle, no fear" . . . and Anne Marie does (figure 1.1). Anne Marie goes but wipes out. Again, this is a very mixed kind of sibling love. Is Kennelly sending Anne Marie into danger or success? Is she her enemy or her friend? But Anne Marie comes back, Kennelly coaches her again, and this time Anne Marie rides to the glory of a perfect judge's ten, taking a killer wave beautifully, and again erotically. Raising her arm in an air punch at the end, she surfs her board toward the beach and celebrates her hard-earned strength (for the surf crowd in the movie and we movie viewers). There's the personal triumph—conquering fear, performing full-out strength and skill, strengthening the bodily ego. There's the invitation from Billabong for sponsorship. And there are the all-important hugs and reconciliations and shared joy with her sibling/friends Eden, Lena, and Penny. Matt's there, too, but with a kiss that seems merely a film-narrative obligation. The first people to greet Anne Marie and share her victory are her close sibling/friends (figure 1.2). And Kennelly is there

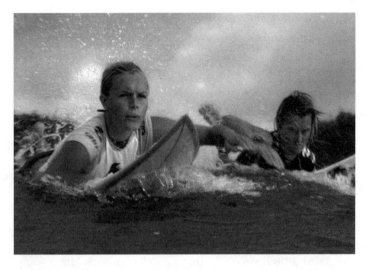

Figure 1.1
Paddling out at Pipeline, Kate Bosworth as Anne Marie and Keala Kennelly as herself, *Blue Crush*, 2002

too, having ridden in on a third wave, giving her a high five. It's exhilarating to watch.

In general, the viewer of a sports movie is sensitive to perceptions of camaraderie and/or competitiveness among the characters that may or may not derive from the script or the directing. The viewer has a feeling or a fantasy about the relationships. No matter who the protagonists are or what their star power might be, these sports movies are ensemble pieces—ensemble pieces *about* teamwork or group competitions, and the viewer watches for the unscripted ensemble dynamics. (Surfing of course isn't a team sport, but Anne Marie's training for the big competition is seen throughout *Blue Crush* as a team effort including Eden and Lena.) Different female viewers will bring different contexts

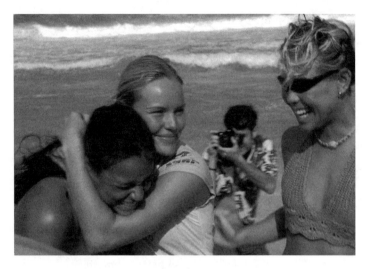

Figure 1.2
Celebrating at Pipeline, Michelle Rodriguez as Eden, Kate Bosworth as Anne Marie, and Sanoe Lake as Lena, *Blue Crush*, 2002

into their movie-watching: experiences with sports teams (this in turn often hinging on whether a viewer attended high school before or after the passage of Title IX), with friendship groups, and/or with siblings. Accordingly, a range of reactions may come from viewing the movie athletes practice cooperation mixed with aggression among the "teams." This mix can elicit a continuum of emotion from a perceived cultural permissiveness as regards aggression to a reminder of its necessary inclusion in deep relationships, particularly friendships, with others.

In *Blue Crush*, aggressive force and athleticism are shown as having impact internally too: to battle one's fear of death. From its inception *Blue Crush* was a story that dealt with comfort and/or fear in a potentially fatal and always beautiful ocean. *Blue*

Crush was inspired by a 1998 article, "Life's Swell" by Susan Orlean for *Women's Outside*. The story focuses on the girls' fearlessness and comfort in the waves; Orlean draws the reader into the utopian lifestyle of the girls hanging out almost nonstop on the beach and in the water. Ironically, the issue of fear is represented in Orlean's story only in its absence. For Orlean herself (a baby boomer born in 1955), watching the girls surf when she was reporting the story made her feel as though she "couldn't picture being that brave." Despite the girls' urging her to try surfing, and despite Orlean's own marathon-running history and lifelong self-propelled athleticism, what seeing the surfing girls feel "so comfortable in their own skins," made Orlean recall was as follows: "It drew me back to being the same age as they were and being one of the girls who wanted to stay on the beach. It made me feel my limitations. Awed, envious."[15]

The movie's screenplay, written by Lizzy Weiss and John Stockwell, borrows from Orlean's watery, sunny, endless-summer scenes, but builds plot tension between fear and fearlessness, near-death experiences and get-ahead sports competitions, romance and training, class divisions on land and classlessness in the water. The girls are made older—early twenties—than the prepubescent girls splashing in a utopian latency in Orleans's story, and as adults they have to deal directly with sex, romance, money, and death.

What's most extraordinary about *Blue Crush* is its surfing scenes, and in them both the erotic joy of physical power and the vulnerability of facing death is represented over and over. And Pipeline is, in reality, a potentially deadly location for surfers. The movie's culmination with the women's surfing competition at Pipeline on the North Shore of Oahu includes actual in-the-wave shots of dangerous drops, rides, and wipeouts. The

fact that Keala Kennelly appears as herself competing with but also encouraging Bosworth's character and Kate Skarratt also appears as herself and wipes out at Pipeline reminds the viewer that elements of what she's watching are real. The threat of death is real as are the overwhelming waves and the regularity of people pitting themselves against them. And the threat of death also derives from the practice of surfers dropping down on each other. This practice, as surfer and writer Bruce Jenkins reports, was one of the factors that in years before the movie kept the traditionally smaller bodied and less violent female surfers excluded from surfing at Pipeline—not only in competitions (there was no women's Pipeline championship at the time the movie was filmed) but always on regular days.

It's worth quoting writer and surfer Bruce Jenkins at length as he reports on the relationship between the movie and the surfing reality it's kin to:

The dilemma for Bosworth's character is the massive leap from accomplished Hawaiian surfer—shredding places like Makaha, Sunset, the Ehukai Sandbar and Rocky Point—to Pipeline surfer. That is a remarkably accurate barometer of the real world, for as we speak [2002], no woman has made that transition. Not that [Rochelle] Ballard, [Keala] Kennelly, [Kate] Skarratt, and a few others couldn't handle it; there are simply too many angry, violent and insanely talented male surfers prowling the lineup to allow for experimentation of any kind.

... For most women, [Layne] Beachley said recently, "a place like Pipeline is the ultimate challenge. ... While I don't mind admitting that I'm terrified of big Pipeline, I think a few of us have got it into our heads that we can pull it off out there—but who's willing to take on that crowd? You can do everything right in a situation like that, but if one guy drops in on you, it can turn into your worst nightmare."

Over the last three years, women's tube riding has taken quantum leaps through contests at Teahupo, the feared Tahitian left believed to be even heavier than Pipeline. A few select performances there left the

distinct impression that women deserve a contest at Pipeline. . . . And that's the fascinating part about 'Blue Crush'—there *is* a women's contest at Pipeline [in it], you're looking at people like Beachley and Ballard on the beach, and Bosworth's character is heading out for a woman-on-woman heat with Kennelly. Fantasy is on the very edge of reality.[16]

Not until 2005, three years after the release of *Blue Crush* (and it seems the movie helped the lobbying effort) was there a women's Pipeline Championship in actuality. Ninety-six women from nine countries competed. This extreme competition evolved—quite literally—from women's aggressive fight for space, and Pipeline continues, for men and women, to involve a negotiation of fear of death and aggressive joy, since surfing there means facing a very real threat of drowning or being pounded on the reef. As one of the 2006 shortboard competitors Melanie Bartels, of Waianae, described it, "'I hardly ever even get to surf out here, because it's always so crowded,' [referring to] the heavily male-dominated lineup that usually fills Pipeline to the brim on any day worth surfing. 'So to be out here alone with just five other women in the water is unbelievable. It's so cool. There definitely needed to be a competition for girls out here.'"[17] In the movie, Bosworth's character Anne Marie represents for the viewer the comeback character—the person who survived a near-drowning experience and her resulting enflamed fear of death; we see her negotiating within a series of different sibling groups to reassert herself aggressively against human and ocean potential violence to face her fear of death and triumph. To those in the know about the growth of women's surfing, the resonance between Anne Marie's fictional experience and those of the actual competing athletes in ongoing surfing competitions is strong. Even for those not informed about surfing, the verisimilitude heightened by the camera work in real

waves, along with the sibling emotions represented in such a thoroughgoing way throughout the movie, keeps *Blue Crush* from being consumed as merely a candy-coated summer movie: and means that it can resonate with intensity for the general female viewer around issues of athleticism, fear, accomplishment, friends/siblings, and a triumph of feminine aggression.

Stick It: Siblings as Multiple Points of Identification

Juliet Mitchell, again, writes eloquently of those early childhood moments where play blends real and imagined relationships with siblings and with oneself:

It simply feels better to play and to dream. But what is of relevance here is that dreams and play have in common personification of aspects of the self: one plays and dreams others as the self and the self as others; in both cases the personification is both other and self—a doll is one's baby or one's little brother or school mate, all of whom will be both who one perceives these real and imagined people to be and the aspects of oneself one has used to understand them, one's identification with them.[18]

A sibling—particularly for women, a sister, biological or otherwise—can personify both the self and an other. The "sisters" in women in sports movies exemplify a towel-snapping love complete with both friendship and competitiveness. Although still utopian, this kind of "sisterhood" is already a healthy step away from a flatly idealized one of universal sameness, which crept into some aspects of 1960s, second-wave feminist claims to sisterhood. Perhaps these were historically and briefly necessary at the time, but they have since been rejected as too often celebrating a sameness that obstructed the recognition of important differences among women in terms of race,

class, and sexual orientation. In the sports movies, even though sugarcoated in parts, physical and psychic aggression in relation to the material world and among the "sisters" is central to the stories. For the viewer, seeing the physical challenge and even danger in sports can echo psychically the potential sibling violence inherent in defining oneself with, against, and as part of others. To watch a protagonist develop her bodily ego as she also negotiates relationships with teammates strongly parallels the experiences of growing up with siblings. Female teammates, like actual sisters, in their same-sex, close physical resemblance intensify the relationships between self and other and the always-existing potential of experiencing the self as the other, the other as the self. The sisters in their matrix of relationships also offer multiple and mobile points of identification or affinity for the female viewer.

In the sports movies, a particularly interesting and loaded case of the complexities of multiple and shifting identifications is when the ensemble includes recognizable, "name" or famous athletes. In the 2006 gymnast movie *Stick It*, the name athletes serve in the movies sometimes as doubles, sometimes as personifications of themselves, sometimes as characters—often, a mix of these.[19] Like surfer Keala Kennelly in *Blue Crush*, Olympic gymnast Nastia Liukin in *Stick It* appears as herself. In such cases, by a strange turn of events, the (comparatively) ordinary—at least in athletic terms—actors like Kate Bosworth in *Blue Crush* and Missy Peregrym in *Stick It* serve as non-idealized stand-ins and points of identification for the viewer. In other words it's the actors like Kate and Missy who, we media-savvy viewers understand, had to train for months just to do the *beginnings* of the athletic feats (before the doubles take over and rip the wave or somersault the vault). It's the actors who, oddly

enough, look to us like the girl-next-treadmill-over-at-the gym, compared to the Olympians and elites.

Stick It is an appealing but unlikely story about a rebellious gymnast, Haley Graham, who inspires her fellow nationally ranked gymnasts to buck the judging system and take over control at a national meet. In addition to Missy Peregrym (Haley), her comic nemesis Vanessa Lengies as Joanne, Jeff Bridges as Hayley's coach Burt Vickerman, and other actors, elite gymnasts such as Carly Patterson, Mohini Bhardwaj, and Tania Gener, and others appear throughout the movie.

When the actors playing athletes appear in scenes with the actual elite athletes, the actors can appear to viewers sympathetically as amateurs in gymnastics, much like the majority of viewers. The ranked gymnasts perform with stunning athleticism. The actors can't compare, but viewers can still admire the results of their training and hard work, and identify with these effortful traits as well. When viewers see the muscular cuts of the actors' bodies and their well-executed even if neophyte performances running to and leaping on the vault, doing floor exercises like handstands, and starting routines on the balance beams and parallel bars, we easily recognize that even these "minor" moves require great efforts in skill-building and fitness. Any viewer who has had high school gym classes in her past, not to mention wide experience viewing mass media, with its ranging depictions of "realities," understands rigorous (but somehow reachable and imaginable) practice was involved. Simply put, it's hard for an amateur to jump on a balance beam looking as if she has the prowess of an elite athlete; and when we in the audience see an actress in a movie doing that, we know that not only acting but much physical training is required. Depending on how much fan literature viewers read and hear, we're also

likely to know the norm for these movies is that actors attend a sports boot camp of, say, four months, to train before filming starts. Still the viewer sees the enormous contrast between the actors' athletic performances and those amazing and spectacular ones of the professional or nationally ranked athletes in the movies. And the comparison between the actors' and the athletes' performances encourages viewer empathy.

There is a kind of observer logic that says, well, if even these actors who are in incredible shape and trained to do the simpler stunts in the movie couldn't possibly do the professionally done pyrotechnical athletic feats, imagine what kind of strength and talent and arduous work it takes to accomplish them. Seeing those elite athlete gymnast performances in *Stick It* is like watching the Olympics—but with better music, camera work, and editing. Limitation as well as inspiration can be felt. In this situation, the actors serve as markers, albeit highly polished ones, of where "mere" hard work can get you, while the athletes serve as the ideal. Then the subtext of (depicted) camaraderie between the actors and the athletes also puts the two types of performers in a situation of mutual affection and fandom. The viewer imagines, and is encouraged to do so by scenes in the movies, the athletes as impressed with the Hollywood lives of the actors as the actors are with the physical prowess of the athletes. If the actors are amateur athletes, it's also true that the athletes are amateur actors. So, in this light, both categories of performers in this mutual-fandom way become stand-ins/points of identification for the viewer—and also can connote (shifting) relationships between older and younger siblings. We can identify with groups as well as individuals, and our identifications can also be mobile across a screen, connecting us in different ways to one character and another. While this experience is in

some ways unique to film viewing, in other ways it echoes well the complexities of mobile and adaptive subjectivity within a sibling group. In gymnastics where the athletes are more accomplished and the actors, or so we imagine, are the fans, the athletes would represent the older siblings, the actors the younger ones; in acting the actors function as the older, more experienced siblings, the athletes as the younger ones.

Psychoanalyst Melanie Klein talks about the delicate balance in projection between good-object relations and idealization, which gives us a more nuanced way to regard mass-culture film fandom than the two grim options film theorist Mary Ann Doane offered in her early work.[20] Doane argued that faced with a movie star's image, female viewers had the choice between a masochistic self-comparison and a narcissistic identification with the ideal. Klein, not speaking of movies, but rather, as usual, her model of infancy, relates: "The projection of good feelings and good parts of the self into the mother is essential for the infant's ability to develop good object relations and to integrate his ego. However, if this projection process is carried out excessively, good parts of the personality are felt to be lost, and in this way the mother becomes the ego-ideal; this process too results in weakening and impoverishing the ego. Very soon such processes extend to other people, and the result may be an over-strong dependence on these external representatives of one's own good parts."[21] While a too literal application of Klein's theories to women's sport film fandom is not helpful, they provide yet a useful metaphor of how an integrated ego can benefit from some positive projection. In the case of the sports films, I think it would also make a difference if the female fan were accepting of and participating in her own physical aggression—thus encouraging resonance between the self and the

athleticism of the movie characters. Perhaps for some female viewers, identification with an actor along the lines of athleticism and training can encourage this kind of acceptance. The actors, as extreme physical specimens as they might be in a Hollywood context, are closer to the viewer—working hard at working out, themselves watching the elites with admiration—than the name athletes, and I'd argue they can function as good objects, which can partially block some of the masochistic pull of idealization and vivify positive projection.

The potentials for identification, however, stretch well beyond athleticism to, again, the social relations. It's helpful to consider the elasticity of identification—the potential to connect primarily to one character, to more than one character, to a team, across a scene, and/or to the dynamics among characters. Or the viewer can shift between different identificatory states over time while watching a movie. There can be a fluidity to viewer identification, and I believe viewing sports movies where team or group dynamics is emphasized encourages this movement.

If the draw of these female sports movies is primarily one of the appeal of aggressive sibling play in addition to identifying with the building and joy of strength in the female body, these fascinations, together with the fluidity of identification, also give us a platform to explore further how aggression and its representations can function for women. Here again Juliet Mitchell's discussion of the psychoanalytic relationships between siblings is helpful. Mitchell writes of the potential, once and while the trauma of a new sibling's arrival is negotiated, of the loss of a grandiose self and the growth of a sense of sameness and differentiation of the self within a social space. But because the potential displacement by a new baby (or an already-existing older

sibling) is felt as an actual and painful trauma, traces of the murderousness and violence also persist and these need acknowledgment, boundaries, and sublimation. Aggressive play among siblings (or their peer-group substitutes) is a crucial way the violence of the trauma gets negotiated and sublimated. The most basic sibling taboo is not to kill or be killed.[22] When this rule is not only obeyed but deeply felt, a continuum is established in which not murdering/being murdered stretches to some kind of a realization that one's own survival is linked emotionally and conceptually to the survival of the sibling/peer/friend/teammate. This dawning is involved with seeing and experiencing the other and also gaining some knowledge of how the other might experience the self, and it can grow into deep increases in both respect for the other and self-esteem. Along this continuum, sibling play can achieve for its participants a deep sense of justice.

Stick It, in particular, can be read as a fable of justice among siblings and the exercise of aggressive physical power in the interest of fairness. Its main theme is gymnasts banding together in rebellion against judgmental authority figures and in unity to honor individual and group drive, athletic talent, and aggression. In this gymnastic tour de force, both the fantasy and the emotional involvement intensify at the end when the four elite-gymnast main characters/sibling-substitutes—renegade Haley, winsome Wei Wei, gentle Mina, and comic bitch Joanne—compete at the National Gymnastic Championships (National). These four train together at the Vickerman Academy. The plot tells that the six top-ranking gymnasts from National are slated to go to the Gymnastics World Championship (World). (Haley, we already know, bailed at the last World for personal reasons involving an evil coach and her untrustworthy mother; now

she's trying again—there is almost always a comeback in sports movies.) Bendinger's script and directing have skillfully layered messages about the hard work, extreme talent, and incredible perseverance needed for the sport, on the one hand, and the ridiculous pettiness of the judging and the parental ruling of the girls-in-training's schedules, on the other. Offsetting this is the teens' joy in their own accomplishments and performances as well as their contested friendships and/or heated competitiveness with each other. (Haley also has platonic guy friends in the movie, guys who are very funny and refer to each other as "hetero life partners"; she is at different times one of the boys and one of the girls—in a characterization very unusual in female sports movies, her gender is flexible and not tied to romance.) At the National, in this movie version, it's all girls. This movie was in fact aimed at girls, and when I saw it at its opening in Chicago, I got to watch it with many groups of young girl gymnasts who had been comped tickets by the public relations firm promoting *Stick It*. Girls dominated the movie's in-theater audience, at least according to opening weekend statistics, and, I would bet, throughout its run. It should be noted, though, that in general opening weekend audiences for movies tend to attract a younger crowd than the movie's overall run. For *Stick It*, the exit polls taken its first weekend indicate that 73 percent of its total initial audience was female and two-thirds of the nonfamily audience was under twenty-one.[23]

As the plot tells it, Mina performs an amazing vault, three somersaults off the vault into a dismount, with a start value of 10 (the highest); the voice-over on-air announcer leaves no doubt about the difficulty of the feat she's pulled off. And Bendinger shows us the vault three times (the vault was actually performed in parts by Maddy Curley, the actress and former NCAA

gymnast who plays Mina, and her double, the powerful Kate Stopper). Even though perfection is impossible, this vault is near perfect. Suspense. Then the score. Not a 10 as expected, which would've guaranteed Mina a spot at the World, but instead a 9.5. Vickerman, their coach, pries out of the judges the reason for the deduction: Mina's bra strap was showing. He yells it to the stands, and the audience groans in frustration at the unfair implementation of this outmoded, trivial rule (and gymnastics is riddled with such rules). Mina is in tears. Haley, up next, looks at Mina, and shoves her leotard shoulders down to reveal her own bra, runs full force toward the vault and lands standing triumphant on top of it. She scratches in support of Mina. Uberbitch Joanne follows and despite all character odds and the urging of her stage mom from the stands, catwalks down to the vault, touches it with one finger, and then touches her own butt in a sizzling, I'm-hot move. (With this evolution of Joanne's, the sibling competition and outright hostility played—comically— to the hilt between Haley and Joanne transforms to a cooperative one where aggressive competition is sublimated in favor of fighting for justice.) And so on—all the gymnasts scratch to insure that Mina will win the top place on vault. (Since nationally placed gymnasts train more than full-time for years making dangerous and all-consuming sacrifices, the chances of this actually happening is zero: we're in a deep fantasy now, and it's a satisfying one.)

It's actually Joanne, who until recently in the movie has always been at odds with Haley, the main protagonist, and competitive with virtually everyone in her peer group, who realizes they could band with the other gymnasts and pick the deserving winner from each category in advance (easy to do since they know one another's abilities so well from competing over the

years)—uneven bars, floor performance, and so on—and so take control from the judges and make the National about themselves instead of being judged by others. Truly a rebellious idea in gymnastics where every muscle position during almost-impossible performances is scrutinized and judged and (although the movie doesn't deal with this) anorexia is rampant and almost enforced in some gyms,[24] and so gymnast-judging becomes a striking metaphor for judging girls and their bodies and their strivings in general. This revolt also underlines that in the justice possible in cooperative while aggressive sibling play, girls and women have (as does anyone at the lower end of a given power hierarchy) a great deal to gain: this speaks to the special appeal for female viewers of fantasies of aggressive sibling play involving women. Since women are on average biologically smaller than men, then a struggle for justice played out through women using their bodies with strength and aggression can resonate as all the more powerful. In other words, physical force is not a means most women are used to employing in fighting for their rights.

As the fantasy plot of gymnasts rebelling unfolds, the girls and the crowd are exuberant, and then all is threatened by the quick strategic move of including an alternate, Trish Skillkin (played by former Olympic gymnast and bronze medalist Tarah Paige), who is an obedient, formidable, classical gymnast with a legitimate grudge against Haley whose bailing at the last World tanked Trish and the rest of the American team's chances at gold. But at the last moment even Trish gets won over to her fellow gymnasts' cause, and they complete their sweep of gymnast-chosen winners when everyone else scratches in almost every category. The siblings, that is, the gymnasts in the movie, team up against the parents and judges and win on the playing field

exactly where physical aggression fuels powerful moves (both forceful aggression and strength are needed in gymnastic feats although the feminized traditions of the girls' sport tend to hide the aggression; the strength though is impossible to hide even with the unhealthy standards of thinness). In *Stick It*, this physical aggression is expanded to include the exercise of aggression to live up to one's own standards and not others'. Such a fable carries great weight for gymnastics, for teenage girls, and for women judged by body image in general.

During the buildup of this rebellion, the viewer is also gripped by the interplay between the name athletes and the actors. Early on in the National drama, shortly after we've seen Trish interviewed by a TV journalist and witnessed her sickeningly sweet answers, we see a medium shot of Nastia Liukin (playing herself) walking with Maddy Curley who plays Mina. Nastia has a body type that could only be a gymnast's—super thin and super muscular. She's probably the thinnest of the regularly seen performers in the movie, so much more so than actors like Missy Peregrym (who plays Haley) that it's slightly shocking. But since we've seen her strength, too, her thinness is somehow not disturbing. Mina we know as one of the main characters, a supporting actress and acquaintance and sometime ally of Haley's from the Vickerman Academy. But we identify her early on as a former gymnast, too, even without necessarily knowing her background as an NCAA gymnast and winner of the Elite title at the 1999 U.S. Gymnastics Festival. She has a different kind of familiar gymnast body—also on the thin side but very muscled throughout, more so than fellow supporting actress (and nongymnast) Vanessa Lengies, for instance. Also, as effective and emotive as Curley is playing Mina in the movie, there's something inexperienced seeming about Curley's acting

that goes beyond even the naïveté of the character she plays. (In fact she studied acting at UNC Chapel Hill and had acted in theater before, but this was her first movie role.)[25]

The impulse of the viewer in making these distinctions is not so much one of defining and labeling as it is instead of trying to figure out where each girl comes from—gymnastics and/or acting—and how she relates sister-like to the others.

In fact, the actors did take on the athletes as kind of older-sister models, following in their footsteps in training, in body anxiety, in corporeal pride, even in injury, Bendinger reports.

The actresses trained six hours a day for four months, and we had them training with real gymnasts. They had so much to get comfortable with: the leotards, the grips, the chalk, the wedgies and having their rear ends exposed all day long, etc. It's a very vulnerable and potentially humiliating sport. Extreme strength and glorious pyrotechnics wearing this tiny costume. The contrast of it is just so rich for me as a fan and a filmmaker, but we had to throw the actresses to the lions, in a way. They had to swim in those crazy waters. It became a point of pride for the actresses: they wanted to do the sport proud. They so admired these athletes and recognized how little respect the sport gets.[26]

In addition, the sibling-like imitation was in the service of their own craft and selves. Bendinger continues, "The actresses knew they'd look like they were drowning if they couldn't pull off the basics. I am still in awe of how hard they worked. Missy and Vanessa (Haley and Joanna) were sore every day for four months and survived a fractured sacrum and myriad injuries. There was no way they wanted the viewer to be pulled out of the movie because they looked fake."[27]

For the viewer, there's a kind of social radar, which operates with curiosity and enjoyment, in trying to fit together these different types—athletes and actresses—who might not know

each other were it not for this movie. Nastia Liukin clearly is not a trained actress, so part of our enjoyment watching her on-screen is to see how she'll do—this unbelievably elite athlete trying something new, coming to her spoken lines as an amateur. Back to the movie: Nastia and Mina are walking together, Mina saying, "Your floor routines were amazing—you'll win the floor event finals for sure," and Nastia responding in frustration, "No, I didn't even qualify." Just as Mina gives her a sympathetic and shocked expression, Trish walks up from the other way, rudely cutting right in between the two saying, "Oh boo hoo, stop whining," with a coldly impervious look on her face. Right after she passes them, the two commiserate. "Di-vah," quips Nastia. "Dee-vil," replies Mina. Ah, we're relieved, Nastia pulled off her line, and director Bendinger gave Curley/Mina the more difficult punctuating humor/scorn line to close the scene. It's funny, and we're left with a feeling of warmth between Liukin and Curley, part scripted and part (we can imagine) not. For that brief moment, we can empathize with Liukin, an amateur, a (temporarily) ordinary person invited on a movie set to deliver a line.

Later on, though, we see Nastia Liukin in another world entirely. The plot line is that she's the one chosen by the other gymnasts to win the uneven bars, so we watch others scratch, and then a tightly edited, amazingly fluid and strong and almost unworldly athletic performance from Nastia. It is both a pleasure to watch and impossible to identify with. Her uneven bar elements are interspersed with shots of the other girls cheering her on, especially Haley; most of these look (appropriately) rehearsed and polished, even with their enthusiasm. But there's one reaction shot of Haley/Missy Peregrym right after Nastia completes her dismount that seems as if Missy is revealing

Figure 1.3
Cheering Nastia's performance on the uneven bars, Jeff Bridges as Coach Vickerman and Missy Peregrym as Haley, *Stick It*, 2006

completely unrestrained and unacted admiration and excitement (figure 1.3). Who knows whether it was consciously acted or not, but we experience it as genuine. Haley/Missy is thrilled. Then there are shots of Nastia high-fiving and hugging a whole row of gymnasts and actresses—this seems both full of good cheer and rehearsed as is to be expected (figure 1.4). And the process ends with a side-by-side hug between Peregrym and Liukin, where again we imagine some actual warmth, some camaraderie between the two. Our identification is back with the (comparatively speaking) ordinary Missy at this moment situated as a fan. I'd argue that some of our pleasure in seeing or reading into these scenes a warmth between different people brought together to act similarly but in key ways differently is

Figure 1.4
Congratulating Nastia, Nastia Liukin as herself and Missy Peregrym as Haley, *Stick It*, 2006

the pleasure of watching, identifying with, and recalling sibling interactions. Same but different, different but same. Watching intensely and closely the sibling relationships in sports stories is to continue to experience through representation the balancing of affection and aggression in distinguishing as well as connecting self and other.

The viewer's perception of the camaraderie throughout the film is supported, too, by Bendinger's report of interactions during filming, and it may be one reason why *Stick It* outperformed its box office expectations. As Bendinger recalls, "Nastia and Carly were in awe of the actresses and vice versa. The crew was in awe of the gymnasts, for sure. Isabelle Severino (Missy's double who we slipped in the movie [not as a double, but as

an actor] several times) definitely got the acting bug and Jeff [Bridges] soaked up a lot from the athletes as well. He was constantly asking the athletes what their coach would say or do. It was a very porous atmosphere and there was a lot of reciprocity going on and feeding the performances. The doubles and elites at the Vickerman Academy all lived together and had their different posses. The production assistants and stunt coordinators spent tons of time with the athletes and there were always barbecues and parties happening. It was a very warm atmosphere."[28] There is a collapse at moments in viewing *Stick It* between the sense of traditional movie watching and seeing reality TV: it's not exactly reality but still a sense of camaraderie in front of and behind the camera that's conveyed. Entering into the warmth, the viewer can feel inside that companionship. As the sibling-like relationships are balanced and unbalanced in the fictional plot, their hierarchies created and then turned on their heads and then back again, and are performed at various times to highlight love or competitiveness, a viewer's fluid identifications can follow suit and stir complex sibling-dynamic emotions.

Bring It On: Irony, Race, and "Speaking Fag Fluently"

In *Bring It On*, 2000, owning athletic aggression works hand in hand with owning the angry underside of ironic comedy—a double celebration of aggression.[29] *Bring It On* is a witty movie and a great spectacle where choreography from hip-hop to swing is put into the service of cheerleading. Although known for its wit and its occasionally *Maxim*-style display of the cheerleaders, it's also a brave movie, tackling racism and classism in its plot and homophobia in its subplot.

The main plot centers on Torrance Shipman (Kirsten Dunst) becoming captain of the Toros, the five-time national champion cheerleading squad at Rancho Carne High School (yes, Rancho Carne). But before this is achieved, the movie is introduced with a dream sequence starring Torrance as she leads the squad at an indoor pep rally. The routine displays spectacle, wit, self-parody (cheerleader jokes—"We jump but you can't hump"), and virtuoso gymnastics, and it is capped with the classic nightmare scene of Torrance appearing naked (to the high school pep audience but not the movie viewers). She wakes up screaming in her bed at home. This dream sequence sets the movie's tone of self-irony masking striving and pep covering impressive athletics, with anxiety and anger running throughout the film. The squad is introduced as sexy, cute, and dominant, and all Anglo except for one Asian American. The location is suburban southern California. Torrance is, of course, blond. There's a knowingness in the movie from the beginning, too, about riding the crest of the new wave of aggression, both claiming femme aggression and Girl Power and being self-ironic about it. "She puts the 'itch' in 'bitch,'" one cheerleader says to another about the departing captain Big Red. Still, Torrance is learning to be aggressive throughout, and it is part of her challenge.

Torrance's new leadership is quickly tested when one girl is injured during practice and must be replaced through cheerleading tryouts. Over protests, Torrance picks Missy Pantone (Eliza Dushku), a dark-haired, tough athlete with attitude who recently moved from L.A. and is only begrudgingly joining the squad; she can't in fact believe she's had to become a cheerleader since there's no gymnastics team at Rancho Carne. Missy and Torrance each are available as points of identification for the viewer—Missy as the newcomer to cheerleading as a

Figure 1.5
Arguing, Kirsten Dunst as Torrance and Eliza Dushku as Missy, *Bring It On*, 2000

seriously competitive sport and also to the suburban California culture, Torrance in her striving to mix aggressiveness with integrity and leadership, and also romance. Missy's brother Cliff (Jesse Bradford), who's into eighties punk and wearing black, is Torrance's main love interest (after she gets rid of a dishonest, manipulative one).

Having joined the squad, Missy next attends practice where she sees Toros routines that make her furious. She stomps off. Torrance follows and a verbal fight ensues (figure 1.5); Missy claims that the routines were stolen, and she sidesteps a physical fight by convincing Torrance to come with her to L.A.'s inner-city East Compton High School so she can prove it. Once there,

PLATE 2
Detail of preparing for the battle with Beatrix Kiddo, Lucy Liu as O'Ren
Ishii, *Kill Bill: Volume 1*, 2003

PLATE 3
Marlene McCarty, *Marlene, Jan. 1, 1975 (Marlene Olive, 353 Hibiscus Way, Marin County, California, June 21, 1975)*, one of six murals, 2003, graphite and ballpoint pen on paper, 10 × 14 feet, mural #1 of series. Courtesy of Sikkema Jenkins, Co., New York

PLATE 4

Natalie Malik (left) and Amanda Riecke (right) match at Chicago Golden
Gloves, April 17, 2009.
Photograph by Kate Gardiner

they witness the East Compton Clover cheer squad led by Isis (Gabrielle Union) do the routines Torrance is so familiar with—but better. Torrance is shocked and crushed—she had no idea the stealing had been going on. As she and Missy leave, they're confronted by Isis and the Clovers who tell them Big Red (Raggedy Ann, they call her) used to videotape their routines during games, and that they didn't appreciate seeing themselves later on in the ESPN-televised national cheerleading competition (which they haven't been able to afford to go to) "wearing blonde hair." Again, a physical fight is threatened as one of Isis's cheerleaders says, "Come on, let's beat these Buffys" (another example of a self-ironic reference to the new aggression, this time *Buffy the Vampire Slayer*). Isis stops the confrontation once she is persuaded that Torrance didn't know about Big Red's stealing, but she tells her that now that she does know she has to stop using—and winning cheerleading competitions with—the Clovers' routines. Isis is shown throughout the movie as regal, strong, proud, conventionally feminine (long hair), and, yes, aggressive—a positive yet two-dimensional stereotype.

The viewer next watches Torrance lose her footing in her ongoing attempt to have integrity while being a leader. When Torrance, dismayed, tells her squad about the thievery, she discovers that the majority want to continue to use the routines anyway because there's not enough time before the Regionals to change them and because the whole point is winning. From the inner-city indoor and nighttime shots of the last sequence, the scenes here are outside, grassy, and sunny—visual irony since the inner-city squad represents integrity and honesty while the suburban team still represents bad values, anything but sunshine. Torrance reluctantly agrees, setting her and the

squad up, in this morality fable, for their first public humiliation and fall.

The Toros are cheering at one of their home football games when Isis and three of her cheerleaders show up in the stands, and they do the complex routine along with the Toros—showing all at the game that they know every move—and then add an impromptu cheer, "You look like shit, we're the ones who're down with it." They walk off, having defended themselves and busted the Toros with a publicly aggressive display, and Torrance, embarrassed, finally gets her cheerleaders to vote for doing new routines.

The Toros have other problems. They hire a professional choreographer, Sparky Pulastre, who teaches them the ridiculous "spirit fingers" move (this move, arms out with fingers straight and wiggling, has since been quoted in other movies as a knowing compliment to the wit of *Bring It On*), among others. But the Toros find out at the Regionals when it's too late to change the routine that they have been scammed and that Sparky had sold the same routine to five other squads, too. Still, they get to go to the Nationals because they were last year's champions. Now it's do-or-die time leading up to the Nationals. Torrance survives an attempt to unseat her as captain, then inspires her squad to create a new routine for Nationals even though there's not enough time to do it. Here, of course, is the point in the movie where they learn to be creative—and to work hard. They study and borrow moves from swing dancing, thirties musicals, and martial arts, pastiche these together with cheer throws and leaps, and, we see later at the Nationals, come up with a terrific routine. The message is clear: pastiche is clever, while stealing whole routines is dishonest.

But it's the competition between the squads of different races that holds the viewer's interest. In an unlikely but plot-worthy sequence, (1) Torrance gets her father's company to sponsor the Clovers' trip to the Nationals (the Clovers placed well in the Regionals), and (2) Isis refuses the sponsorship and tears up the company's check. Instead, the Clovers raise the money from Pauletta, an African American talk show host modeled after Oprah; this is described as not-charity because Pauletta "grew up in the neighborhood." Although the viewer appreciates Isis's refusal to be patronized by an Anglo cheerleader and her father's corporation, there is also a discomfort in this sequence of events. It's too resonant, for me, of neoliberal preaching on the "culture of poverty," and the too-familiar and too-limited dictum that blacks (accompanying implication: and only blacks) ought to take care of their own. The trouble with this ideology is that it denies that we are all citizens and need to share resources and allocate them together among the entire citizenry; it ducks citizenship in favor of clannishness. And, by extension, it asks a "clan" overrepresented in the poverty ranks and underrepresented in the ownership of assets to take on a cure for a situation of inequality authored by the entire citizenship.

The movie's final series of scenes, the competition between the black and white squads at the Nationals is surprisingly moving—surprisingly because the movie in general is painted so heavily with irony that the viewer often maintains emotional distance. The empathic emotions signaled right from the beginning, but until now muted by irony, come to the fore, along with a heightening of spectacle. As in most Hollywood sports movies, it's the crescendo displays of athleticism—this time at a national cheerleading championship—at the movie's end

that provide the loudest, strongest, most edge-of-seat thunder. As with the tradition of movie musicals, these spectacles have stand-alone power and exist both as indispensable punctuations of and in joyous, physical excess to the plot.

Even before the final competition, Isis has a hard-hitting line, when she rejects the check, saying to Torrance, "What's this, hush money? . . . Oh, right, it's guilt money. You pay our way—you [get to] sleep better at night knowing your whole world is based on one big fat lie." Isis also delivers *Bring It On*'s main moral lesson, in effect switching the argument to one hitting the nerve of the long history of white success based on stealing from blacks' creations back to the realm of sports and sports ideology. "You want to make it right? Then when you go to Nationals, you bring it. Don't slack off because you feel sorry for us. That way when we beat you, we'll know it's because we're better."

Race relations smoothed and transcended through level-playing-field sports competitiveness is the message. Whether one believes that's possible or not, even locally, its existence in *Bring It On* advertises how deeply a belief in unleashed aggression, deployed within a context of fairness and functioning as a cure, can manifest, even in—especially in—girls/women and sports movies.

Sure enough, and unsurprisingly, in a close competition the Clovers win the Nationals, with a spectacular hip-hop dance and muscular cheer leap (so, mind and body) routine. The Nationals is set outside in sunny Daytona, Florida, and the visual cue is that the Clovers quite literally come into the sun and, yep, shine. Torrance and Isis have some captain-to-captain down-to-business exchanges during the Nationals, and at the end, when out of fifty squads, the Clovers place first, and the Toros second,

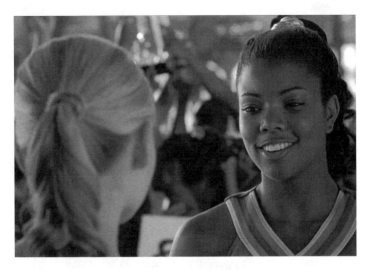

Figure 1.6
Captain-to-captain congratulations after Nationals, Kirsten Dunst as Torrance and Gabrielle Union as Isis, *Bring It On,* 2000

they trade congratulations. Isis, "You guys were good." Torrance, "Thanks—you were better." Isis, "Yeah we were, huh." And broad smiles (figure 1.6). Other than the routines, which are amazing, the end is predictable, but still interesting: the white team learns to lose with grace and to do creative pastiche instead of stealing; the black team learns to win with grace.

Throughout, the predictability of certain plot twists is leavened by great humor, almost nonstop one-liners. And the movie achieves its own original pastiche by adding on an unpredictable, anti-gay-baiting subplot, written by Bendinger and acted by the two male cheerleaders who are close friends with Torrance, Les (gay) and Jan (straight). Early on when Missy queries them as to their sexuality, Jan replies, "Well, I'm straight," and

Les says with smiling attitude, "And I'm . . . controversial." "You mean you speak fag?" "Fluently!" Throughout the male cheer-leaders are given the cool comebacks to the football players's unfunny homophobic taunting, and they're given the friend-ships with the great girls. They also look better and are in bet-ter shape than the football players, and while the Toros cheer squad is a national champion, the football team loses every game. Clear message—homophobes are losers. Les is sexualized, too, not just a safe-friend/gay-guy prop for Torrance; he has a happy flirtation at the Nationals with another gay male cheer-leader from a rival squad. This is all, of course, an intentional political move on screenwriter Bendinger's part. As Bendinger puts it, "Oh, you have to make bullies [here the gay-bashers] look dumb whenever possible and hope you are converting kids in the demographic. It's subversive deprogramming!"[30] And the movie has been very popular with its targeted age group. For ex-ample, the opening weekend exit polls for *Bring It On* signaled its great popularity with high schoolers, high school girls in par-ticular. Of the total audience members polled, 70 percent were under twenty-one, and 48 percent of the total were between thirteen and seventeen; 70 percent were female. The movie also drew a good ethnic and racial spread its first weekend—Cauca-sian, 56 percent, Hispanic/Latino, 18 percent; African American, 15 percent.[31]

Like the other sports movies discussed, sibling-like relation-ships are dominant in *Bring It On*. At the heart of most of the girls/women and sports movies is a female–female friendship, which incorporates both aggression and homosocial eroticism to flip back and forth between sibling-like competition/hatred/ suspicion and love and teamwork. This oscillation, then, is an-other potential function of sibling-like aggression.[32] Such love–hate sisterly reversals can perfectly and enjoyably be represented

with ironic humor (since irony is a way of negotiating opposites), and Bendinger excels at irony in her script. In *Bring It On*, there is witty sparring between the two main protagonists Torrance and Missy. The sparring never completely ceases (echoing actual sibling relationships in that manner) but evolves into a winning collaboration between Torrance and Missy—and the rest of the squad and in a way with the rival squad, too. Torrance and Isis are competitive sisters who respect—in the end— each other's similarities and differences, even while and because of the shared goal to outperform each other. This is a goal fully sanctioned in the world of sports, making it the perfect happy hunting and bonding ground for siblings. The movies highlight the related emotions.

However, in terms of sameness and difference between siblings and sibling-like same-sex friends and the intense emotions these relationships bring to the fore, the difference not directly dealt with in most girls/women and sports movies is sexual orientation. *Bring It On* is highly unusual in its direct protest of homophobia, but even then it's played out only in the male subplot, while the girls are portrayed as heterosexual and femme. For women, the Hollywood movies seem to bury the queer and queering potential (I mean, of course, not only in terms of orientation expansion and fluidity but the dissolution of gender boundaries) behind an almost uniform set of conventional visual signifiers for heterosexuality like long hair, earrings, and ponytails.

For professional women athletes, hetero-signifying ponytails are common, too. But not for everyone. Feminist philosopher Judith Butler has written about the challenge to rigid gender definitions posed by some "un-ponytailed" star players like Martina Navratilova. "Gender is a field in which a variety of standards, expectations, relations, and ideals compete with one

another, and for women, this fractious state of the playing field of gender works to our advantage. Martina [Navratilova] may not have known that her emergence on the international scene would precipitate a crisis in the category of 'women' as it is used in the field of 'women's sports' and its public perception." Butler sees a great benefit for the viewer, "but this is a crisis that only makes us more capable as the imagining beings that we are, as those who must live the very genders that we seek to understand."[33]

In contrast, Hollywood always markets the female stars of its latest wave of women and sports movies as heterosexual. Even the female protagonists in the unconventionally feminine sports movies like the boxing ones (think Michelle Rodriguez in *Girlfight*, 2000, and Hilary Swank in *Million Dollar Baby*, 2004) are marked as heterosexual. That said there are some subtle variations in these new sports movie heroines in the depiction of their femininity. Kirsten Dunst (Torrance in *Bring It On*), Missy Peregrym (Haley in *Stick It*), and Kate Bosworth (Anne Marie in *Blue Crush*) are no Martina Navratilovas. But although beautiful, they're not simplistically in the traditional feminine mold for U.S. movie stars either. They look strong and muscled even though slender. In fact, actresses playing protagonists in these movies usually have to gain weight for the parts. The casting of Missy Peregrym is bold in terms of the gymnastics world, too: she is too big, too tall, and too thickly muscled to fit the ridiculously thin and tiny body now the norm for elite gymnasts.

It could be argued, though, that the new standard for female actresses in sports movies is, despite a prettily made-up face with long hair to underline the femininity of the player, essentially the physique of a low-fat, muscled, young male torso (with the addition of very small feminine breasts). A skeptical viewer can ask if this is yet another mass-circulated, impossible body-ideal

image for girls and women. Perhaps what's new in recent decades is that this form is close to one of the impossible visual ideals for the male body now in circulation as well. To my mind, there are two main body-ideals now for men: one is the bodybuilder physique and the other the thin, boyishly muscled physique, which resembles the feminine athletic one. Although this resemblance could blend the categories of gender somewhat (girl blends into boi blends into boy), it's hard to see this as merely progressive. To the contrary, as sports scholars Leslie Heywood and Shari Dworkin in their astute 2003 study *Built to Win: The Female Athlete as Cultural Icon* warn: "Straight men have been sold the same bodily objectification to which gay men and women have long been subject. The codes are merging. According to Peter Arnell of the New York advertising agency The Arnell Group, 'the male torso reigned as the most powerful crossover image [of the '90s], appealing to men, women, gays, and straights alike.' The naked male torso is ubiquitous in ads, and men's magazines now focus on how to achieve the 'right look' in a way that parallels similar invocations in women's magazines and results in body panic parity."[34] This then is a dystopian opposite of Butler's utopian yearning for gender de-categorization: a blending of codes that puts everyone under pressure to achieve the (unobtainable, commodified) perfectly fit masculinized torso.

And yet, for this pressure to be seen as uniform, universal, and immutable it would have to be static. It's not. Even in the Hollywood movies that are the focus of this chapter and their visible new-stereotyped contribution to the male(ish) torso goal for the female athlete, there's a mobility and a partial dissolution of gender categories, which can be read as expansive for women. The promotion of culturally sanctioned aggression for women and what it can mean at this point in history is at the heart of this positive reading. In the female sports movies,

the main focus of the represented aggression is on winning, of course, but aggression also functions to enable female characters to battle fear, expand femininity, take risks, jar and push unequal relationships or societal structures toward more fairness, and, at times, play with and like boys. Again, it's the emphasis on justice that, to my mind, connects these movies to the broad, complex sphere of quotidian feminist politics.

However, psychologist Dana Crowley Jack reports that, among the women she interviewed for *Behind the Mask*, her book on female aggression, the acceptance of one's own aggression in sports doesn't necessarily encourage girls and women to accept their own display of a positive amount of aggression in close relationships.[35] Jack's admittedly small sample contrasts, though, with other findings cited, for example, in the President's Report on Title IX, which record increased self-esteem and self-confidence (including interpersonal) and decreased depression and anxiety for those girls participating in high school sports. The cautionary notes of that comprehensive report pertain mainly to elite competitive athletes who are more at risk for eating disorders and health risks associated with being underweight than high school athletes. But even if we justifiably are wary about overhyping the benefits of sports participation without also wondering about associated stresses, the plusses touted in the sports movies remain significant as utopian fantasies. In the sports movies athletics invariably bring blessings: the heroines stick up for themselves in friendships and the friendships improve; they get rid of undesirable, manipulative boyfriends; they use aggression to undergird their leadership positions in the face of opposition; and they employ aggression to fight discrimination based on gender, orientation, and/or race. They play aggressively.

I don't want to argue in this book that women in our social and cultural expression of aggression should simply imitate men in their traditional forms of aggression. In a much more nuanced way, it's possible to see aggression across the gender continuum as an essential ingredient in intersubjective health, in democratic action, in forms of survival. And I'd argue that at this historical moment it's precisely the explorations of aggression in social subsets historically denied a wide spectrum expression of aggression that can point the way for the expansion of these complex expressions—for the subgroup, for individuals, and within and across other subgroups of a society. There are the familiar motions and words of aggression (e.g., arguing fiercely as well as persuasively for a raise in the workplace, something traditionally "allowed" men but not as much women who today may do this but also pay a connotative price), and some of these will necessarily come into play, but there are also new expressions and deployments in the mix (a woman raising her voice and drowning out a man who's trying to interrupt her at a meeting, a seemingly mundane but yet still not commonly accepted practice). That said, in mass-distributed cultural forms like graphic design and Hollywood movies, to name just two, there's a necessary employment of well-known signs in order to communicate to large numbers of people. In the sphere of aggression, these signs, many of them, have been societally typed as masculine. For example, at this point in time, one referent or visual echo, if you will, of an image of a woman competitively surfing is still a man doing so; of a woman kicking a soccer ball, still a man; of the WNBA, still the NBA. So, a combination of signs—the WNBA player wearing a ponytail— can be read as gender-bending and as a part of a larger kaleidoscopic mix of signs newly available to and still being created by women deploying aggression. Interestingly, this new mix often

has a visual overlap with historically visual signs for lesbianism, one that can be read as liberating for viewers and (often) worrisome for advertisers. What I'd advocate for is an expansion of the signs of feminine aggression, not a censoring, since expansion for me signals exploration of the deeply democratic and individual-survival enhancing aspects of aggression in fantasy and everyday life.

Stick It begins—as does Spike Lee's *Love and Basketball*, 2000—with playground competition between boys that includes one girl in unintentional boy-disguise (in *Stick It* Haley wears a hooded jacket; in *Love and Basketball* the young female protagonist wears a cap over her hair) whose body language and aggressive risk taking means that her playmates/competitors mistake her for a boy. In each case, this is a gender tease for the audience. The amazingly talented athlete seems to be a boy in a play situation going full out—then hat or hood comes off and a girl with long hair is revealed. I take these gender teases to be historically specific: for all the girls playing sports out there, we're still at a moment when unbridled and uninhibited athleticism is normally gendered as masculine—and it has to be demonstrated (still) that a girl can do this, too—even and especially a femme one. More than that, though, is the pleasure of mixing gender signs in the realm of aggression, and the creativity and deployment this implies for the subgroup, here women, formerly (and still in part) denied expression.

The power of movie fantasies of female aggressive strength coupled with negotiating social spaces to achieve power and victory is considerable for female viewers. And above all it can encourage girls and women to fantasize about continuing and renewing—in a practice more usually associated with boys and men—the aggressive sibling play of their childhoods (shown

literally in *Blue Crush* and implicitly in the opening scene of *Stick It*) to fight for justice, space, corporeal strength, teamwork, and victory, and also against death, using their bodies. Title IX babies are fueling these movies—working both behind and in front of the camera. And they and their younger cohorts are the target audiences. But those of us who've built strength into our bodies as older adults through more individual pursuits like Pilates and weight training and running and hefting toddlers can also yearn to recreate the aggressive sibling play of our childhoods. We can get great satisfaction and, should we choose, inspiration seeing sibling aggressive play recreated in the fantasies of sports competitions and collaborations—in the women and girls sports movies. Beyond this, we need to question and create cultural representations of expanded expressions of aggression for midlife and older women, groups historically doubly denied—through age and gender—socially condoned aggressive actions.

2

AGING AND AGGRESSION

Blue Crush, Stick It, Bring It On, and other recent women and sports movies, *Love and Basketball, Girlfight*, and more—all star *young* women surfing, vaulting, cheering, dribbling, and boxing. What about images of aggressive older women? This is a tough question, one that needs to be explored in the larger context of depicting age and aging. In fact, in the diverse spectrum of U.S. mass culture, the majority of the comparatively scant set of midlife and older women images often function—inadvertently or not—to represent negative prejudices about aging. So, what kinds of images are needed, then, to counter these prejudices, and how might the new images function? In this chapter, I look closely at Helen Mirren's Jane Tennison character in the TV series *Prime Suspect* (created in Great Britain and shown globally including in the United States) as one contribution to a new stereotype of a complexly aggressive and sexual older woman. In general, my exploration flags the disparities among new representations of aggression—and also the potential for developing new, generative images related to certain subgroups.

There are demographic reasons why my questions are particularly timely. The primary one is that dramatic changes in life expectancy have forced a reconsideration of how aging and visual markers of it make a difference societally. According to the U.S. Department of Health and Human Services, Center for Disease Control and Prevention, for U.S. citizens born in 1900 life expectancy (all genders and races) was 47.3 years; for those born in 1930 it was 59.7; and for those born in 2002, 77.3—huge leaps.[1] Another is that civil rights and feminist activism have also raised awareness of ageism. For women over fifty, many not acculturated when growing up to act aggressively, aggression is needed to fight ageism, individually and in groups, in the workplace and when dealing with the health care and

insurance industries. Even interpersonally, aggression is needed to say no, set boundaries, and create change, key elements in interpersonal negotiations. And to assert sexuality, something society too often denies older women.

Against Serenity

Obligatory serenity can be dangerous. Frequently appearing as a still, beatific woman sitting cross-legged, yogic hands pressed together at heart level, eyes staring off into space, face blank—the image is all too seductive. From its repeated representation in the 2000s, this slack face, often artfully positioned gazing at an ocean or a mountain view, seems to be U.S. consumer culture's new mask for postmenopausal women. Could it be today's subtle but powerful equivalent of Donna Reed's required smile in the 1950s—one that so many women really wore, after putting on their lipstick and setting their faces for public display in preparation for leaving the house? If so, to be fashionably fiftysomething—or sixtysomething or older—today would be to be under the command of tranquility, to be under the dictates of calm. Like any domain of tight control, it would be an exhausting and impossible place to live. And as with other easy slippages from consumer image to facial convention to inner mood, tranquility would be a difficult expression to maintain constantly. Given the links between affect and facial expressions, it could also act as a repressive shroud over both the outward and inward articulation of other emotions.

Fear of mortality can drive the creation and perpetuation of uncanny and unappealing stereotypes of older people. Older women can function as symbols of a double fear: aging and nonreproductive feminine sexuality. So there already are, of course,

in the realm of older-women cultural stereotypes, alternatives to the serene woman: the hag, the shrew, the over-fifty bitch boss, the hysteric, the bag lady—all quite negative. We midlifers are starved for positive stereotypes, specifically mass-culture images of healthy women over fifty, and this has made us susceptible to the one of yogic calm. Even Eileen Fisher, founder and owner of the women's clothing company Eileen Fisher Inc. (1984–present) and sensitive to the connotations of her advertisements, bows consistently to this pressure. Fisher has long been a proponent of pangenerational clothing design and advertisement pitches, and her company's ads use models from ages twenty to seventy. But in addition to preaching comfort and simplicity—two of the company's consistent themes—the ads star the glaze-eyed, wrinkle-free aging woman on the beach much too often for my taste. Or comfort.

Here some counterarguments might be articulated: mainly, what's wrong with calm or its representation? I'd assert that as a norm it's a pitch for passivity and a repressive one at that. Forced calm, prescribed calm can wet-blanket a more proactive stance, one fueled partly by aggression and one of great necessity for women in general and for those over fifty in particular. Mass media images don't have to be taken as prescriptive, but we've seen time and again their cumulative sway. And it's worth asking what the blank, quiet stare might foreclose while working resolutely as its own kind of tranquilizer: in a word, power. There's a behavioral continuum from proactive to empowered that is energized by, among other things, aggression. We can't afford to flush aggression, or its representation, or its facial expressions, away.

It should be noted, too, that a persona of serenity can mask, and therefore mark, aggression; it can be a sign of passive

aggression.[2] By passive aggression, I mean behavior that attempts to manipulate through indirection and inaction instead of direct confrontation or communication. As a strategy, passive aggression has historically been useful and seen as "normal" for women in U.S. culture, but this behavior slips too easily into a situation of mutual deprivation. Passive-aggressive behavior often means depriving another person out of hostility, but depriving the other easily melts into depriving the self—that is, by introducing lack into the interpersonal context of the dynamic between and including both people. Self-deprivation in turn involves an inward-inflected aggression, already an overdetermined and often depressive stance for women.

In the last chapter we explored ideas, images, and myths of sibling aggression operating in sports teams. In this model, aggression is used socially and situationally to exert power and to win rather than (usually) to harm another individual. If there is harm it has boundaries and is usually the byproduct of the empowered move or series of moves to win, not the primary objective of the aggression. Aggression fuels power. Mere assertiveness doesn't kick a ball hard into a soccer goal or transform a quick feint into a drive for the basket: these are aggressive surges of action. For older women (and men) aggression in social spaces is needed to counter ageism, which creeps insidiously into workplaces, personal lives, and governmental action and inaction (e.g., think of the lack of national health insurance) on a regular basis. It's also needed, as with younger women, to enjoy the body, to enjoy motility of different kinds, and to enjoy life. Libido and aggression work together in so many, many ways.

In 1997, in one of her books on the politics of aging, *Declining to Decline*, scholar Margaret Morganroth Gullette explores how ageism occurs in the workplace when employees reach middle

age: "Aging into the midlife [and after] is supposed to mean a curve of earnings rising with age. Up to a point. . . . Wage-peaking over 54 is . . . the utmost privilege of the culture, available only to a small percentage."[3] Barry Bosworth, Gary Burgless, and Eugene Steuerle, analyzing Social Security Administration data for a representative group of workers born between 1931 and 1960, find that, "average earnings . . . fall sometime after age 45 or 50."[4] It's possible that for those employed after age fifty-five today, the peak wage picture may be improving (while the gender gap in earnings, while also improving slightly, remains alarming, especially as it adds up over the life course). For the first quarter of 2007, the Bureau of Labor Statistics (BLS), U.S. Department of Labor, reported peak earnings (based on median weekly earnings, unadjusted for seasonal differences) for men at ages 55 to 64 ($933/weekly), and for women at ages 55 to 64 ($685) and 45 to 54 (a statistically close $680). That's of the percentage of people who work full-time.[5] However, key to understanding that the story of the age-wage curve in the U.S. remains a grim one is the sharp drop after age 55 of labor force participation (in the civilian, noninstitutionalized population). BLS reports that for 2005 annual averages of participation, of men 45 to 54 years old, 84.7 percent were employed full-time, but of men 55 to 64 years old only 67 percent were, and of those 65 and older just 19.1 percent. Of women 45 to 54, 73.3 percent were employed full-time, but that statistic falls to 55.1 percent for women 55 to 64 years old and 11.1 percent for 65 and older.[6] There are various factors in addition to age discrimination at play here, of course, such as voluntary early retirement for a select population. Nevertheless, ageism could be a determinant in the falloff in employment. And the large drop in older workers' labor force participation is especially troublesome given that it

happens at ages around fifty-five when health care costs for individuals tend to rise. There is much to be angry about concerning ageism in the workplace, and much to lobby aggressively against in terms of age discrimination and unfairness.

In her essay "Against Wisdom: The Social Politics of Anger and Aging," Kathleen Woodward, a scholar of radical aging issues in culture and psychoanalysis, has argued for "the possible galvanizing effects of anger for stimulating personal and social change, and, conversely, the possible damaging effects of the cultural prohibitions of anger in older people, depression notably being one of them. Furthermore, the association of old age with wisdom as an ideal . . . often serves as a screen for ageism."[7] She cautions that "wisdom has almost always been predicated on a lack of certain kinds of feelings—the passions in particular, including anger." She advocates for "a wisdom that is feminist, or perhaps better put, a wise anger."

I'm more of a pragmatist though, and more demanding: I'd argue that anger, even wise anger, even feminist wise anger isn't enough: aggressive action is called for. And, again, that aggression when unleashed is messy: it can be directed wisely, or to achieve feminist ends, but it isn't pure and it isn't all consciously regulated. It doesn't always play by the rules of organized sports, to speak metaphorically. And it's this impurity, as Melanie Klein would argue, this ever-existing linkage to rage and greed that makes aggression (in representation and even more so in experience) a particularly effective counter to the stereotype of clean, flat tranquility. We try to control aggression—to a degree we need to in social spaces in order to relate to others and to achieve goals—but we can never control it completely. Aggression is, on one level, a drive, primal and dynamic energy. And this, stopping short of advocating violence, I celebrate. What makes my exploration in this chapter even more

satisfyingly and perplexingly messy is that I'm not a "pure" enemy of calm either. From lowering blood pressure (statistically even more a necessity for those over fifty than under) to simply providing respite, serenity, intermittent with other emotional states, has its place. But when it becomes a dominating stereotype and a mainly disempowering one for older women, then, well, it makes me aggressive.

One of my assumptions throughout this book is that stereotypes matter and are particularly interesting and potentially influential in areas where change is needed and is starting to occur. One example where cultural transformation is needed in the use of tranquil older women stereotypes is in advertisements that sell, literally, tranquilizers and related medications for menopausal and postmenopausal women. These raise questions about whether the medicines are always needed or instead might be used at times to conform behavior to this repressive image. As Angela Djurovic has argued, pharmaceutical advertisements aimed at the medical community urge doctors to target postmenopausal women for antidepressants as if their function is to enable patients to retain a pleasantly groomed and consistently calm femininity. This of course doesn't mean that doctors take these advertisements as gospel, but it's telling that the cultural context for postmenopausal women and medical care is so colored by the association of antidepressants with an "appropriately" serene femininity.[8] There are, at the same time, some livelier counterexamples to such images of dulled serenity. In certain recent images of older aggressive women complete with bark, bite, and sexuality, I see some signs of hope for changing negative images of women over fifty.

Shirley MacLaine (b. 1934) of late has become an emblem of often positive and always messy aggression in a number of her recent roles. Her outspoken Ouiser Boudreaux, an older

and resolutely unpleasing but also actively dating Southern woman in the movie *Steel Magnolias*, 1989, and her portrayal of the blunt and enjoyably pragmatic Ella Hirsch, grandmother of Maggie (Cameron Diaz) and Rose (Toni Collette) in *In Her Shoes*, 2005, can be interpreted as two of those signs of hope. In particular, the feisty, money-savvy, dating-again grandmother in *In Her Shoes* is of interest as an older woman visible and active on many levels. Her relationship with her granddaughters, although essential to the plot, does not erase her or reduce her to an exclusively nurturing role. As Woodward has argued, revivifying attention, both in psychoanalysis and in culture, to the relationships among three generations of women and not just two could be a key step to releasing older women from invisibility and powerlessness.

Less upbeat than MacLaine's usual roles, but perhaps in some complex ways more inspiring, is Helen Mirren's (b. 1945) detective Jane Tennison in the television series *Prime Suspect* (1991–2006).[9] Tennison is at once conventionally entertaining—as a smart, female detective who solves mysteries by seeing just that much more than the men around her—and unconventional for a TV character—rude and unsoftening with time. A midlife woman visibly aging and sexy at each stage, she is above all aggressive. Tennison uses force to create change—in her case, locally to capture murderers and structurally to fight sexism. And she uses aggression interpersonally to survive and negotiate. She has to. Her social context is an almost all-male British police force where female detectives are rare, and women with her status of detective superintendent inspector even rarer—in this fictional account, she is the first female DSI in Britain. (At the beginning of the series, she's a detective chief inspector, and we watch her over time gain promotion to DSI.) Her workplaces

are also mined with infighting and all-too-credible attempts by male colleagues to rob her of power and/or elbow her out of her job. A whistle blower, she is often seen fighting on multiple fronts against in-house sexism and police corruption as well as urban crimes. Tennison has become the template for a number of abrasive TV female detectives that have followed such as Kyra Sedgwick's Brenda Leigh Johnson in *The Closer*. Tennison's character was created by writer Lynda La Plante (b. 1946) who wrote the show's first three years (or episodes as the *Prime Suspect* TV years are called). I talked with La Plante about her decision to foreground aggression in Tennison's personality and actions. She explained that Tennison "had to confront her coworkers on her own level of frustration and aggression and say back off me. That also applied to her home life. Juggling so many hats for most women eventually builds to aggression at times—I think it's normal." Specifically about the interrogation part of Tennison's job, La Plante comments, "To get to the truth you have to be quite brutal. What people were not used to seeing at the time was a woman doing it."[10] Again, we have the theme of a woman using aggression to obtain justice.

Prime Suspect began in 1991 in the United Kingdom (1992 in the U.S.) when Mirren was forty-six and Tennison was supposed to be about the same age. Throughout seven seasons with some long hiatus periods, viewers watched Tennison age by about the same amount as Mirren; by the series' end Tennison was supposed to be almost sixty and Mirren's actual age at the time was sixty-one. We also saw Tennison's wisdom increase with her experience but remain awkwardly flawed, and never reach the plane of an idealized wisdom. And we witnessed her aggression going full force, usually serving her well, but definitely not always—it too remained messy and imperfect.

Frequently, Tennison's aggression functions to break the social contract of interpersonal etiquette based on common gendered behavior. She's a rude woman. This behavior grates in a particularly British tradition of hierarchical interaction ("Right, guv"), but the series is globally popular. The British Television Distributors Association reports that in 2004 *Prime Suspect* was distributed by Granada International in eighty-five countries.[11] Its phenomenal growth in global popularity is evident—ten years earlier, in 1994, Granada had sold the show in fifty-two countries.[12] And (as is directly relevant to this U.S.-focused book) *Prime Suspect* was quite popular in the United States. As one marker of its success, in 1993 CBS tried unsuccessfully to buy *Prime Suspect* away from PBS. Another is that in 1996 Mirren won an Emmy award for her lead in *Prime Suspect 4: Scent of Darkness*. This doesn't mean its British "accent" was lost over here, but instead that a reading in terms of U.S. norms is valid as regards its considerable American viewership.

A close look at *Prime Suspect 6: The Last Witness*, 2003/2004, reveals Tennison's aggression and its impact—here also read in the context of her being a recently postmenopausal woman at age fifty-four. In this episode and others, her aggression causes irritating disturbances for other people (Helen Mirren has said, "As an actress the thing I like most about her is her unlikability.")[13] But her aggression also—sometimes concurrently, sometimes intermittently with the problems it causes—combines with the libidinal energy of her fierce work ethic and even fiercer intelligence to aid her in solving the crime in question. The main plot of episode/season 6 concerns the murder of two Bosnian Muslim sisters in London by Serbs in order to cover up a massacre ten years earlier in Bosnia that they'd witnessed; the murders were committed to preserve the cover of the sadist

who'd ordered the massacre, and who'd also raped and tortured the sisters. The primary subplot, though, deals with Tennison's age. We see her early in the episode undergoing a medical exam, hear during it that she is on HRT (hormone replacement therapy), realize that she's lying to the doctor about her smoking and drinking, learn that her weight remains constant and that she doesn't believe she's under undue stress. The lighting is harsh and her body is quite unromanticized (she appears, e.g., to be wearing a simple sports bra underneath her professional skirt and blouse), and her matter-of-fact comfort with her body comes through nevertheless. Soon after the medical montage of her checkup, we see her endure, also in harsh if different light, her thirty-year review at which her age, fifty-four, and her stress level are emphasized and at which she's encouraged to consider retirement, which she's now earned, or other options to her command as detective superintendent inspector. Under her direction, we learn, are three murder teams consisting of a total of eighty officers, pursuing twenty-four investigations. She forthrightly defends herself against the threat of retirement and the not-so-subtle ageism of the interview by asserting, "I don't feel my age compromises my ability. I think my experience is an asset."

Elsewhere in the episode, age tension in the workplace also ricochets between Tennison and a younger female police officer, Lorna Greaves; between Tennison and Finch, a younger, ambitious male officer; between Finch and an older male detective, Simms. There are some oblique references to menopausal or recently postmenopausal symptoms as well. When Tennison confesses to her photographer friend she's not good company at the moment and that she stole the case from a younger officer, we wonder if her crankiness is related to menopause. At

another point in the episode, a deeply satisfying moment occurs where Tennison plays with and uses to her advantage a negative stereotype about menopausal women—that they're forgetful. When Tennison first goes to Milan Lukitsch's house with her colleague Greaves, and Tennison is unofficially interviewing Mrs. Lukitsch, the wife of the prime suspect, the DSI pretends, with a self-deprecating delivery, not to remember the date she wants to know Lukitsch's whereabouts for and confers with the younger Greaves to be reminded of it. We the viewers know she's pretending and using that menopausal/postmenopausal status and its fuzzy-memory reputation to her advantage, playing dumb to get people to spill more information.

Tennison repeatedly fails to reassure, stroke, placate, execute social niceties, and at times even respond to others' social efforts. The viewer, so accustomed to more nurturing stereotypes of older women, is often surprised, but reads this behavior usually as strength, although sometimes as off-target. It can also be seen to cause problems. It comes across as usually effective but also sometimes as a mistake—a mix of power and flaws that together with Mirren's formidable and mesmerizing talent as an actor goes far to explain the great appeal of the Tennison character. Watching Tennison in some scenes, the viewer thinks, oh, if she'd only been nicer to so-and-so she'd have inspired more loyalty and wouldn't be backstabbed later on. But in other scenes it's clear that if Tennison were to be placating, it would be a waste of time and energy and would interfere with the exercise of her authority. Tennison doesn't get to have it all—she makes mistakes and pays for them, and she's subjected to plenty of unfairness—but she roughs her way through. Flaws and all, she's more successful than not, including covering her own tracks when necessary. But she never thanks others and is rarely thanked herself.

Consider one fairly overdetermined scene about manners, wherein the "prime suspect," optometrist Milan Lukitsch, brings Tennison's new glasses (ordered earlier on a pretext to informally interview him) to the police station on his own pretext to visit. By this point in the episode she's convinced that he tortured and murdered one of the sisters, but the DSI has no proof yet. He is very charming, and this charm has already been played up in the script as a sinister, dangerous, and deeply deceptive part of his personality. Lukitsch presents the glasses to Tennison as a gift. She puts them on; he moves inappropriately closer and does her the courtesy of adjusting them to her face while she's wearing them. In response, custom demands she say thank you. She says nothing and instead merely looks at him through the new glasses (we as viewers understand that she, as well as we, see him even more clearly now, a clichéd moment saved from cliché by Mirren's intensity and subtlety as an actor). He heads toward the exit and on his way out stops, turns, and congratulates her on arresting a suspect for both sisters' murders. Here again custom requires a thank you in response to a congratulations. Tennison says nothing. Her gaze in both instances is aggressive. The viewer is rooting for Tennison as she performs her subtle rudenesses, and we interpret it as a refusal to play along with evil.

There is another time, though, when Tennison (by her own later admission) steals the investigation from Finch mainly for her own gratification—and only secondarily because of her stated concern for how, without her guidance, the case might play negatively in the press and so be used by politicians against the illegal immigrant community. We realize that her power play and overt rudeness set her up for future disloyalty and insubordination among some of the officers. When Tennison shoves the younger Finch aside, telling him the case "needs a

more senior, a more guiding hand" and not to worry that she'll "keep him on as [her] number two," he asks for an explanation. She raises her voice, gets short with him, and abruptly walks away. The viewer understands this exercise of her aggression as a flaw, a lack of talent in handling subordinates gracefully, and one that compounds static around her effective—but not always discriminating—ambition. This ambition we've come to expect from Tennison throughout the series, and we applaud her for it but also wince at some of the ways she realizes it as well as some of the (often sexist) friction she receives for both it and her personal style. In the very first show, *Prime Suspect*, 1991–1992, in what has become a famous incident since *Prime Suspect* achieved cult status, we see Tennison muscle into a legitimate power position in a charmless and, to some of her colleagues, offensive way. When a male coworker who'd been directing a murder investigation has a fatal heart attack, Tennison is in the office of their superior (and his friend) within the hour asking for the assignment (figure 2.1). This is a wince moment for viewers, but at the same time we're rooting for Tennison, whom we've already learned has been waiting—unfairly and, as is explained, for sexist reasons—over eighteen months to head her first murder investigation. She's just starting out at this hardearned rank, and she needs to force her way into the responsibilities she's in fact entitled to. Sensitive she's not. As La Plante puts it, "before aggression rises to the surface, you have frustration. Tennison is a highly qualified officer facing discrimination such that eventually it builds to anger. Only when she was able to confront on an aggressive level was she able to break through."[14]

Tennison's aggression has multiple goals, ones that include but are not restricted to advancing her career, and as the series

Figure 2.1
Arguing forcefully to be assigned the murder case, Helen Mirren as Jane Tennison, *Prime Suspect 1*, 1991

evolves and she gets older, she seems to become more idealistic and more vocal in terms of larger justice issues. That same overt aggression, however, plays out more and more through the lens of aging, so at times unspoken and often unfavorable cultural stereotypes of postmenopausal women linger in the background and prompt questions about how in control Tennison is of her aggressive displays and power. Mainly, though, her aggression seems to support her living by her principles. In *Prime Suspect 6*, we see her being admonished by Scotland Yard and ordered to leave Lukitsch alone, despite his being her main suspect for both the more sadistic of the two murders and having planned

the other, because he's useful to the British government as an informant. She briefly obeys but then reconsiders and arrests Lukitsch and brings him in for questioning. Her superior, furious, confronts her. Tennison raises her voice in response (no placating) and gives her most idealistic speech of the episode. (Ideals, as written by episode/season 6 writer Peter Berry, which not incidentally would play well in the worldwide TV market that the series had by then achieved, since they trumpet international issues of justice and asylum.) Says Tennison: "Those two sisters came to this country because they believed it to be safe. They thought it was a country where decisions about who went free and who did not were decided in open court and not behind closed doors." And she continues loudly with outrage and sarcasm in response to her supervisor's reminder that the murderer is working for the British government as an informant against vicious criminals: "Maybe turning a blind eye to [his] torture and murder would bring about bigger and better arrests. I don't know—I don't have any control over that. I can only deal with what's in front of me." She caps that speech with determination, not apology, when he asks her, "Did it ever occur to you you might be wrong?" She says with unwavering honesty and no shame, "Yes."

Later on, at a point in the plot when she's not yet successful and has even earned her removal from the case and been placed on leave, Tennison explains her actions to a skeptical friend and makes her baldest aggressive statement: "Well, they [the government] might not've wanted to look [at the torture and murder], but if I'd shoved it down their throats they'd have no choice." This is vintage Tennison—the viewer perceives that this defiance, although it doesn't always serve Tennison well, is necessary to achieve justice. The viewer knows too that Tennison acts

on her beliefs aided by her age and her understanding that little as she wants retirement, after thirty years of service she's already earned it and has that security at her back (in the event of the worst-case scenario, namely, getting fired from the Metropolitan Police).

Visually the episode is constructed to play up Tennison's age. As in (male detective) *noir* tradition, her weariness is also visible. The viewer sees that her body bears the costs of the work and the emotions associated with it. In episode/season 6 Tennison is often seen in raking daylight from a window or harsh artificial light, which emphasizes wrinkles, paleness, and a certain wear on her face. Some reviewers, such as John J. O'Connor in the *New York Times*, have even described Mirren as not wearing makeup to play Tennison throughout the series.[15] This claim, however, is visibly untrue—she is wearing makeup—but the mistake underlines the sense of age visibility (instead of masking) evident throughout the series.

Fascination with Aggression

Here it would be helpful to look more deeply at certain psychoanalytic theories about aggression we've inherited—and how these might impact the fascination with Tennison's character in *Prime Suspect*. In Germany in the 1920s there was a phrase "gefesselter Blick," which meant literally "chained gaze" and metaphorically a fascinated one. It's a useful expression because it reminds us of the potential tie between deeply felt, compelling instincts and a fascinated viewing. Beyond Mirren's wonderful acting, I'd argue that Tennison can provide a fascinated viewing, particularly for female viewers near her age, as an emblem of aggression and the viewer's longing and need for it. As much as

we may enjoy the specificities of the character and plot of *Prime Suspect*, what matters are the larger cultural issues connected to aging and aggression for which Tennison functions as a symbol. And more, I want to assert, the fascination with her and her aggression, viewed in light of these larger issues, signals a need for growth in the cultural production and circulation of other representations dealing with aging and feminine aggression, ones to further fascinate viewers, viewers close to Tennison in gender and age as well as a broad range of others.

Freud is still a primary referent in the contemporary psychoanalytic and critical discourse on aggression. I read Freud in that light but mainly as an historical text, noting his historically specific problematic attitudes toward women. Yet Freud's words on inwardly inflected aggression and the ego ideal are useful in my consideration of the potentially negative impact of the enforced-tranquil stereotype for older women. To quote Freud from his study *The Ego and the Id*: "It is remarkable that the more a man checks his aggressiveness towards the exterior the more severe—that is aggressive—he becomes in his ego ideal . . . [and] the more intense becomes his ideal's inclination to aggressiveness against his ego. It is like a displacement, a turning round upon his own ego."[16]

Freud's warning, read in conjunction with a belief supported by readings of Melanie Klein, D. W. Winnicott, and others that aggression is always with us, is a persuasive plea for the expression of aggression outward lest it rebound in self-punishment. This plea gains urgency when considering women over fifty who culturally are encouraged to adhere to models of serenity and to personify a narrowly defined wisdom and nurturance. As psychologist Dana Crowley Jack has argued based on her study of depression, interiorized aggression can result in depression

for women.[17] These cautions are particularly poignant for newly postmenopausal women, most of whom have experienced a reshuffling of hormone ratios such that testosterone has become more predominant with relation to estradiol (a type of estrogen) and SHBG (sex hormone-binding globulin).[18] Although there is much that is not known about how hormones function in postmenopausal women, some scientists believe that testosterone is related to aggressive behavior, while others contest this.[19] I'd assert that whether biologically determined or psychoanalytically achieved or culturally instigated—or all of the above—older women have and need aggression, and this aggression has to go somewhere. The need for environmental space; the urgency of sticking up for oneself in a culture of ageism and sexism; the necessity of employing power in the workplace; the pleasures of corporeal competency, motility, and self-confidence; and the need for intimacy with others are, to my mind, strong imperatives for older women to express their aggression.

Where and how, then, could the aggression go? Within an individual performing in everyday social spaces, aggression fuses with other emotions and is expressed in various forms—such as anger, competitiveness, and appetite—with varying degrees of self-awareness and to achieve a variety of goals. Some psychoanalytic writers such as Klein and Winnicott have discussed the tricky fusion and "defusion" functions of aggression—times when it can blend with libido to fuel the achievement of a goal, and other times when its inherent destructiveness comes to the fore and serves to create chaos or violence. The latter explosive function of aggression is called "defusion" in psychoanalytic theory, a term confusing for the layperson since colloquially "defusing a violent situation" means calming it down; however, this psychoanalytic use means just the opposite, or acting as a

catalyst for increased chaos.[20] But it's the fusion possibilities of aggression working with libido that are of primary interest to me. Klein describes a complex process by which the fusion of aggression and libido can cause anxiety and guilt, but also— and this is key—mitigate "the destructive impulses."[21] Winnicott builds on Klein's idea of fusion, in keeping with his belief that for the individual an excess of societal compliance hampers creativity and the enjoyment of life. So Winnicott appreciates the necessity of aggression in bursting through inner and outer boundaries, freeing the individual from the constraints of too much repression and laying the ground for play, in the lightest and most serious senses of the word—and everything in between. Winnicott is interested in the mitigation of destructive impulses and where the fusion of libido and aggression can take the individual, most optimistically how it can (along with other factors) enable play. For Winnicott with his expansive definition of play, to play is to be really alive.[22]

Such fusion, then, can lead to a bursting through of harmful repressions, but it's a potent and unstable mix, and, so as not to sugarcoat it, I'd assert again that the fusion of aggression with libido, in the main, functions to fuel the expression of force in order to achieve a goal, that is, to effect a change. What we do and how we do it with this force—that's the complex question. Throughout these chapters, I'm continuing to problematize the tradition of defining aggression exclusively as harm or the fantasy of harm to others. Instead I find it fruitful to define aggression more broadly as an instinct involved in the exertion of force or fantasies of it. Harmful actions, then, would be a subset of but not the entire group of possible outcomes related to aggression. Indeed the exertion of force (including verbal and other types as well as physical) is necessary for survival

especially as concerns spatial occupation, setting boundaries, and social interaction. As a practical matter, I see aggression, constructively exercised, as intertwining with libido—here I'm using the conventional understanding of libido as life-affirming energy, including but not restricted to erotic energy. Overall I see the potential and the necessity of aggression to be fruitfully, if messily, combined with libido for the accomplishment of goals, from access to a love object to inhabiting social space to personal safety.

Viewed through this lens of the necessity of aggression, the denial or suppression of aggression in women over fifty should be worrisome on a number of levels. As Jack has pointed out for women of all ages, aggression is needed to say no and to negotiate healthy conflict.[23] I would add that aggression, in combination with libido, is also needed to say yes. Forcefully. And because libido works to fuel all kinds of relationships, this could include a yes to, say, work goals, health goals, erotic goals, domestic goals, and so forth.

Aggression is also potentially useful in reestablishing a social sense of self and spatial visibility—expanding beyond the boundaries, way beyond, those of the camouflaged presence writer Diane Ackerman finds older women under pressure to inhabit (think muted colors and baggy clothes). Here the writings of Kathleen Woodward and of psychoanalyst Jacques Lacan are helpful in exploring a continuum from the literal possession of space—as exhibited in girls' sports and sports movies, discussed in the previous chapter—to an assertion of everyday social space by older women.

Woodward employs Lacan's work on narcissism and aggression in her brilliant analyses of the charged possibilities for intergenerational ambivalence, recognition, misrecognition,

separation, and love, asking key questions about when we see ourselves in members of other generations of our families and friends, when we refuse to, and how these individual acts cumulatively impact our own and our culture's attitudes toward aging.[24] Her work pointed me back to Lacan's 1948 essay on "Aggressivity in Psychoanalysis," in which he discusses the persistence and deep-rootedness of feelings of "aggressive competitiveness" with regard to the triad of the ego, the (love-) object, and other people.[25] To Lacan there is a kind of "aggressive relativity" in our deepest relations to desire and to being desired—inherent comparisons between the self, an idealized self, and others—which awakens the aggressivity of our narcissism, our self-love. Lacan argues that "if the ego appears to be marked from its very origin by this aggressive relativity . . . [then] each great instinctual metamorphosis in the life of the individual will once again challenge its delimitation, composed as it is of the subject's history and the unthinkable innateness of his desire."[26] Lacan analyzes the narcissistic moment of self-love and self-regard as inevitably containing both aggression and libido in that it always involves a relationship of frustration and desire with the idealized self. And Lacan usefully describes the recurrence of narcissism at different stages not only of childhood, the favorite haunt of psychoanalytic theorists, but also of adulthood. He also refers to stages within those stages, asserting that the "narcissistic moment in the subject is to be found in all the genetic phases of the individual, in all the degrees of human accomplishment in the person, in an earlier stage in which it must assume a libidinal frustration and a later stage in which it is transcended in a normative sublimation." He continues: "This conception allows us to understand the aggressivity . . . with each of the great phases that the libidinal transformations

determine in human life, the crucial function of which has been demonstrated by analysis: weaning, the Oedipal stage, puberty, maturity, even in the climacteric."[27] He concludes the essay by asserting the relationship between aggressivity and the socially mapped spatial field.

In reading the works of cultural critics such as Woodward, Gullette, and of course Simone de Beauvoir, who deal with radical concepts of aging, in conjunction with these psycho-analytic readings, and no doubt my own experience, I've been drawn in particular to thinking about the representation and experience of women in our fifties.[28] One's fifties seem to be a watershed decade for dealing with the new and about-to-be-long-lasting definition of the self as postmenopausal, which our culture reads in terms of the feminine self as aging. One is always aging, of course, but adult women are considered to rep-resent and visually symbolize aging especially in their years after fifty (or fifty-one, which in the United States is the average age of menopause). For most first worlders at this point in history that's many years indeed.

And this longevity focus brings me again to the exercise of aggression and libido/life-force by Helen Mirren as she plays Jane Tennison in the *Prime Suspect* series. Specifically, I want to look closely at the relationship between libido and aggres-sion in the four programs that together comprise episode/sea-son 1 of *Prime Suspect* (1991–1992). This episode is the viewer's first introduction to Jane Tennison who as played by Mirren is a walking combination of libido (here I'm using the word both in its colloquial sense—sexy—and in its psychoanalytic sense—more broadly as life-affirming energy) and aggression. We have no idea, of course, how the complex interplay between these two drives might work in a deep psychoanalytic way in Mirren's

life or her character's or writer La Plante's. But, in a functional and simplified way, we as viewers read Tennison as often fueling her authority and actions with both libido and aggression. And we're fascinated by the mixing, the combinations, the recombinations, when these function in her interest and when they don't.

Early in the four-program episode that comprises the series' entire first year, we're presented with Tennison as being quite, even inappropriately (or not? we wonder) aggressive. As we see introductory scenes of male detectives and police officers who are her coworkers racing to solve a mystery, we slowly learn that although Tennison was promoted to DCI eighteen months previously she has yet to lead a murder investigation, and we feel her frustration; it is also represented spatially in a scene where she is crowded into the back of the elevator by the men and ignored. The viewer senses her anger building and so is relieved when after pushing she gets assigned to lead the murder case.

We also register her insensitivity when she has that awkward confrontation with her boss so soon after her male colleague has died from a heart attack. Her insensitivity, though, as the case and episode wear on, becomes part of her appeal. There is a well-executed subtheme where Tennison's perseverance and brusqueness end up upsetting various men (the boyfriend of a victim, the father of the same victim, Tennison's own father—at his birthday party no less, and so on) from whom she wants something. With this, La Plante has deftly created a series of role reversals. The men are "overly" emotional, the woman is not. She is clumsy, she's consistent, she's direct, she's aggressive. It's a flaw and a strength. Sometimes it works and helps her achieve her goal, sometimes it doesn't. She is often shown as vulnerable, at times by spatially contrasting her petite size

with that of larger male officers. There's another elevator scene later on where we feel a male officer is intentionally crowding Tennison while seeming simply to reach for an elevator button; she stands her ground. As La Plante comments on that scene, "If you allow someone to enter your space you lose control. . . . If she had smiled at him, he'd have moved closer. Tennison says [through her aggressive stance and demeanor], 'Whoa, you're in my space.' [She has] to maintain it."[29]

In *Prime Suspect 1*, as in later episodes/seasons, Tennison has to expend a great deal of energy dealing with mutinous and possibly corrupt officers among "the lads" on her team. At the beginning of her assignment they are openly sexist, incredulous, and angry that a woman should be assigned to direct a murder case (apparently this was consistent with the reality of the Metropolitan Police in London in the early 1990s). More and more eventually come around, won over by her job proficiency, but their loyalty often feels thin. At one point in an ever-so-casual display of disloyalty (the viewer wonders, would the same have happened to a male DCI?—maybe, maybe not), the camera reveals several of her male detective subordinates in the foreground of the scene, whispering and gossiping about the likelihood of Tennison's being removed from the case, while she plugs on in the background, trying to lead a large group meeting. Tennison's aggression and the necessity of her aggression are both clear.

Libido is a larger category than just a person's public display of sexuality, but in television terms that public visual display of sexiness is primarily what the viewer receives as evidence of Tennison's libidinal energy. And Mirren, as usual in her acting, does not disappoint. Her physical presence is mesmerizing, sometimes with an energy conveyed by something as simple as her

strongly erect posture. Her beauty is unconventional for TV and movie stars. Who knows whether Mirren has had plastic surgery or not—I don't—but her appearance is of someone who hasn't: visible wrinkles, legible under-eye bags, a nose larger than the WASPy nasal norms of U.S. stardom. Mirren portrays Tennison as working too hard, smoking and drinking too much, and, as the script narrates, attending to her personal life too little (she loses a boyfriend in this episode, in the viewer's opinion, unjustly; he doesn't like coming in second to her job). She doesn't seem worn down though; instead, her eroticism seems real and part of her everyday life. Mirren leaves no question that Tennison enjoys sex (though she's often too busy for it), and even Tennison's platonic friendship with a male colleague Terrence (whom she requested to be added to the case team) has an erotic dimension.

How is Tennison's libidinal nature linked, in the broad terms of television, with her aggression? In this first episode/season she is less involved with active refusal than later on, as in episode/season 6, and more into grasping, burrowing, gaining, and getting. She has a lust for the hunt, in other words, combining libido and aggression. At one point she says of her "prime suspect," "I want him dragged out of bed, I want the shit scared out of him." We see her eyes literally light up when she progresses in her hunt. She displays aggression meant to harm, in this case, her suspect, as well as aggression meant to achieve her more lofty—but intertwined with the hurtful actions—twinned goals of achieving justice and doing her job. Thus mixed with a fight for justice and a work ethic, her aggression is permissible; she does what she needs to do to get the job done, and the viewer cheers her on, as eventually will her coworkers. The broad social acceptability of her aggression is underlined by the

fact that she is avenging slain female victims, and she articulates this vengeful goal as one of the rare emotional involvements she allows herself in her cases. At the same time her aggression is shown again and again as over-the-top and clumsily chan-neled, as when, for instance, she has to be stopped from badger-ing the father of a victim. (The viewer can be pleased, though, even with that effort of hers, since the father was being sexist to her, and instead of allowing his rudeness or excusing it due to his extreme distress about the death of his daughter, Tennison argues back; she's not one to be polite, solicitous, or stroking, and we like her for that. Very much.)

Tennison is appealingly flawed, and the messiness of the boundaries and functions and motivations of her aggression, all executed with her quasi beauty intact and her libidinal energy close at hand, are particularly appealing to us women viewers in the workforce, who are socialized to keep a tight rein on our ag-gression but need to exercise it regularly nevertheless to get our jobs done and done well. Mirren/Tennison's libidinal energy is key because it speaks to her erotic power: she may lose some things in the exercise of her aggression, she may even (and fre-quently does) lose her boyfriends, but she never relinquishes her libidinal energy. It is evident in the square of her shoulders, the eroticism of the way she moves within her otherwise unre-markable professional clothes, the shaking out of her hair, and most of all the intensity of her eyes. And new lovers are always just around the corner, surfacing inevitably in the next episode.

It's understandable in cultural terms why Mirren's portrayal of a midlife woman exercising libidinal aggression is so satis-fying to watch for middle-aged women and women in general. Midlife and older women are too often culturally defined, ever more so as they age, as being without desire and being

undesirable. Jane Juska's 2004 memoir *A Round-Heeled Woman* and Jill Nelson's 2003 fantasy novel *Sexual Healing* followed by Nelson's 2009 *Let's Get It On* are counterexamples of public assertions of feminine aging and eroticism, but noteworthy in being among the exceptions so far. Too, these books each attest explicitly in their zesty and erotic content to older women's challenges of fighting off the undesirable/not desiring stereotypes.[30] Aggression is needed to cut through those dismissive and repressive stereotypes and lend force to the assertion of the lust and desirability women of all ages are entitled to own so erotically.

Individually many women over fifty are often aware of this need for aggression of course, but find it rarely represented in culture. *Prime Suspect 6*, though, banks on shared if not always stated knowledge of this need. When Milan Lukitsch taunts Jane Tennison about her weakening eyesight, for instance, he says "another chink in the armor," and those of us who are her same-age female viewers expect and are satisfied with her aggressive refusal to be baited. But when, implicitly or explicitly, we're preached at to maintain a calm serenity, this can function cumulatively—on top of long-held and repressive behavioral norms for older women—as an insidious denial of our quite human need to intersperse calm moments with aggression and other emotions. In 2007, for instance, Eileen Fisher clothing advertisements showed women on a beach asking repeatedly, "What if simplicity is all you need?" I wanted to answer: "Well, what if it's not?" I prefer a kaleidoscope of emotions and experiences. Visually, they're too empty, those windswept, dulled faces on the beach, and the ideal they're based on leaves out too much, especially aggression. The repression of aggression makes relationships at home and at work and in political arenas harder. We need at times to be pushy.

We need both libido and aggression to be pushy. Their intertwining can be found in Dana Crowley Jack's summarizing of the etymological roots of the word "aggression": "Its positive and negative possibilities can be seen in the Latin *aggredi*, which means 'to go forward, to approach.' Its root is *gradi*, which means 'to step, walk, go.' Shipley (1967, 198) notes that 'the basic root (through Sanskrit *griddha*, greedy) is Aryan, *gardh*, to desire, hence, to step toward.' Thus aggression, in origin, includes desire and movement toward an object of desire."[31] Older women need desire, and to use energy aggressively to articulate and pursue it for the self, as opposed to performing the culturally approved stereotype of suppressing the self in favor of nurturing the desires of others.

Where culture can matter in this arena is not by merely celebrating the cartoon version of biff-bam-pow aggression but in portrayals, like La Plante's/Mirren's of aggression's complex mixing with other emotions and behaviors. A psychoanalyst like D. W. Winnicott might argue that such representations could aid the female viewer in her embracing within herself the culturally colored "dark" emotions like aggression in combination with the more sanctioned ones involved with eroticism.

Winnicott, a pediatrician as well as a psychoanalyst, wrote with great sensitivity about the challenges of maturation and health at various life stages. Ironically, it was in an essay on adolescence that he gave some of his most moving statements about later adult maturity. He asserts, "It takes years for the development in an individual of a capacity to discover in the self the balance of the good and the bad, the hate and the destruction that go with love, within the self."[32] An acceptance of one's own aggression is necessary then for an acceptance of the self, including the evolving self at different ages.

Having needs, having desires involves an acceptance of a certain ruthlessness in the self even if then tempered or partially tempered by conscious actions, not to mention ethical considerations. Unlike Jack, I don't divide aggression into positive and negative functions; instead, I see these as inseparable (although a given aggressive act can be categorized as positive or negative or described as having either positive or negative attributes dominant). Aggression—as psychoanalytic theorists J. Laplanche and J.-B. Pontalis summarize it—is "a radical force for disorganisation and fragmentation."[33] As discussed, it is also in functionality often fused with other instincts, such as libido, and emotions, in varying proportions. In particular aggression and libido work with different objects and aims and in different proportions with respect to desire; their fusion can facilitate acting constructively on desire; their defusion can lead toward violence and/or chaos. Sadistic and/or masochistic sexual acts are obvious mixes of the two instincts, but we needn't restrict at all consideration of the fusion of aggression and libido to these. Instead, I see the mix of these two in most relationships and actions between people, between the self and the body, between the self and space—pervasively and commonly, in other words. And without aggression, its acceptance and deployment, a killing impotency in each and any of these areas is all too possible—a danger especially to the gender trained to hide its aggression: women.

Lust and Aggression—and Back to Jane

Let's consider libido, aggression, and aging further, going deeper into the example of Tennison and analyzing the character's arc throughout the series. In terms of sexual energy, Tennison

is a good and believably imperfect example of its representation. Mirren plays Tennison as having sexual energy ready at hand—in a not always successful formulation with aggression. There are the rather crude and work-related ways Tennison ends up in bed with men: a former lover and criminologist who's in town on a book tour—and married; a former lover who was a photographer in Bosnia and can advise her on immigrants' past histories; a married boss in Manchester; an underling at a conference. These liaisons are almost all ill-advised along conventional lines (we viewers know she's not "supposed" to do it with the boss, with a married man, etc.), but blatantly enjoyed by Tennison, at least for a short while. In terms of television writing and production, these mutual seductions fit compactly and conveniently into the plot and are, the viewer supposes, not so much endorsements of getting it on in the workplace as a way of entangling Tennison in an affair without breaking the stride of the investigation—keeping some sex in the story. There is a more complex subtext to her "misbehaving" lust, however, one that involves aging and a not-politely-bounded sexuality: middle-aged Tennison always has her sexuality locked and loaded beneath her extremely professional veneer, and the viewer, even a quite sexually liberated one, will feel some surprise at Tennison's openly pleasure-seeking behavior and how she fits it into odd moments between surges of work. Her lusty energy pours into her work but it isn't all sublimated there; it is also at the service of her corporeal desire. That a number of her affairs are unsuitable, particularly those with fellow coppers, is in keeping with the overall portrait of the Tennison character as flawed. And it's part of the continuous tension between Tennison's lust and her aggression; they are effective but not completely controlled or controllable by her—or, the viewer

can well think, by anyone. It's a welcome relief from the über-responsible ways that older women are usually portrayed on TV and in movies (think Angela Lansbury as the never-wrong detective in the TV series *Murder She Wrote* [1984–1996] or angelic Sally Field playing Julia Roberts's kidney-donating, keeping-the-family-together mother in the movie *Steel Magnolias* [1989], as two of so many examples).

For those of us who are not fictional characters, acceptance of our own aggression organized and fused libidinally is, I would argue again, key—along with the acceptance of all the other kinds of fantasies, including lustful ones, that libido can inspire. As Winnicott puts it, "Sexual maturity needs to include all the unconscious fantasy of sex, and the individual needs ultimately to be able to react to an acceptance of all that turns up in the mind along with object-choice, object constancy, sexual satisfaction, and sexual interweaving."[34]

It's far easier, however, to accept sexual and other libidinal fantasies—even aggressive fantasies for that matter—than one's own aggressive actions and their impact. The vast range in potential for aggressive action initiated by the self is frightening. This fear and some of these potentials are movingly portrayed by Mirren as she performs Tennison's near downfall in the most controversial episode/season of *Prime Suspect*, the last one, *7: The Final Act* (2006). Throughout this episode Tennison's aggression is out of control even while her great intelligence and drive seek to channel it and fuse it with more libidinal or life-enhancing energy and actions. The aggression strikes inward in the form of her self-destructive alcoholism, and we painfully watch her black out, drive drunk, walk out of AA meetings, lie to her supervisor about her drinking, deny help, use drunken misjudgment, and drink vodka for breakfast. With Mirren's incredibly

strong acting, distance from the character is unlikely and empa-
thy (even for viewers without alcohol problems) is strong—it's
the self-defeating behaviors related to the body, all the more
vulnerable due to (visible) aging, that are the general points of
identification and anxiety. Out-of-control moments of aggres-
sion snapping outward occur when Tennison verbally demeans
a loving niece, and when she strikes at and, we suspect, pro-
vokes deadly violence in a suspect. As if the script didn't crackle
enough, there are also instances of over-the-top aggression di-
rected at Tennison, as when the murder victim's father (also a
suspect) asks her repeatedly and derisively what kind of a (read:
cold and bitchy) person she is. He even spits in her face. (In-
stances of people Tennison interrogates asking her in outrage
what kind of person is she, moments found regularly through-
out *Prime Suspect*, are for me annoyances. The fact that she's a
tough woman who does her job matter-of-factly doesn't seem,
at least today, so shocking gender-wise as to merit those kind of
repeated questions in the scripts—perhaps my reading these as
out of place is due to a cultural difference between the United
States and Britain regarding acceptable feminine demeanor in
the workplace.) And then there's that aspect of aggression that is
interwoven with the others but trumps them all, and fuses with
libido, rather than acting as an internal "defusing" (as in ex-
ploding) force: the stream of Tennison's aggression that she con-
trols beautifully to fuel her perseverance in pursuit of suspects.
Against all odds of challenging detective work and her own
inner battles, she keeps her workplace drive—and triumphs. Job
well done.

Here's the story of *The Final Act*. In it, the viewer meets
Jane Tennison again (recall that there were two real-time years
between the release of *Prime Suspect 6* and *7*—a production

reality of stops and starts unevenly experienced throughout the series that allows the writers and directors to deal graphically with Tennison aging through different stages of midlife). She's now almost sixty and her retirement is one month away. From the start, when Tennison embarrassingly reveals at work that she completely forgot an emergency telephone call in the middle of the night, viewers know she had an alcohol-induced blackout, and we see her alcoholism is full-blown. As the episode proceeds, her drinking is revealed to have other frightening results as well, with near collisions in the car when driving, gratuitous hostility (always in the past Tennison's bite, whether politic or not, had seemed justified; here at times it flares beyond reason), and the odd bits, completely out of character, of unprofessionalism on the job. Shown originally in two parts, the episode runs approximately three hours total and was written by Frank Deasy, himself a recovering alcoholic; perhaps for that reason the episode, though quite dark throughout, feels as though it ends on a hopeful note, signaling that Tennison is likely to come to grips with her alcoholism and stay sober. But that hope is elusive throughout much of the episode and has led to controversy about whether or not it contains unnecessary or excessive degradation of a strong and much-loved female character.[35]

The pacing and script are tense and gripping, with much of the tension derived from the range of aggressive behaviors demonstrated. One question these raise is: will Tennison's aggression implode in the kind of suicidal behavior that is one of the professional pitfalls of retired detectives with long and bloody histories on the force? As Tennison's supervisor explains to a younger detective, who is supposed to look after her during her last case, "Old school, that's Tennison. On the force,

what, thirty years, battered, burnt out—dinosaurs. And what do they do when they retire? Drink themselves to death. Just stay close to her." Another tension: Will Tennison's aggression explode outward in a way that hampers her job, the main focus of her life, and harms those she's investigating? Or will it—a more hopeful thought—be sublimated to her always ferocious intellect and fused libidinally to achieve her desires, at least the workplace ones? It's noteworthy here that Tennison's desire for familial love, and by extension a kind of self-love related to nurturing, is both brought out and thwarted in her complex—and unprofessional—friendship with Penny, a high school friend of the episode's young murder victim. However, to interrogate, to detect, to pursue, to apprehend the murderer, these workplace-focused actions are palpably involved with aggression, an aggression psychoanalysts might say is fused in a constructively effective way with life-instinct libido.

The overriding tension of the episode, the one that most thoroughly involves the viewer in all its complexity, remains whether Tennison will be able to leave sober, her case closed and head held high, or whether she will succumb to her alcoholism. In psychoanalytic terms, will defusion win—the chaos and destruction of self-destructive aggression in the form of alcoholism—or will fusion triumph—the fusion of aggression with libidinal drive and intellect to achieve her goals? Literary critic John Leonard, writing in *New York Magazine* about *The Final Act*, commented: "What again astonished was the way she listened, as if her whole body were an exquisite ear, as if intelligence were a passionate, sexy sonar."[36] As she does her detective job, Tennison is listening and analyzing and perceiving and calculating all at once and taking action accordingly; this is her version of powerful aggression fused with life-enhancing libido.

Outward-focused aggression wins, she wins, we cheer. Tennison avoids her cheesy retirement party in the end and walks off under her own steam, quietly, with chin out, and purposefulness intact. The viewer's gut feeling is that Tennison is not going because she just doesn't feel like dealing with the sentimentality and the predictable bad taste—we're shown an unappealing male stripper getting ready for the party. She has her sober self back and her aggression and force at her own healthy service. But, the viewer is glad to note, Tennison's aggression is not overly tidy. After all, she's quite rude, in her own interest, to not attend her own farewell party. In the end—at the end—*The Final Act* reads as optimistic and deeply respectful—an older woman managing her aggression to make her own choices.

3

VIOLENCE: *KILL BILL* AND *MURDER GIRLS*

As much as I prefer to talk about the positive functions associated with aggression, I have to admit that it also fascinates me because it is never completely controllable: defusion and an outward-thrusting explosion are so often possible. In the last chapter on aging and aggression, we closed by thinking about Helen Mirren's performance at the end of *Prime Suspect* as a woman on the edge of but pulling herself back from imploding from alcoholism. We're familiar with the long history of cultural depictions of imploding or self-destructive women and exploding or violent men. Again, though, conventions are shifting and there's a new array of images, in film, video games, on TV, and in art, of women whose violence is externalized. In thinking about aggression exploding as violence, what could the new images of violent women mean to us? And why are some of them so mesmerizing? These questions in turn encourage us to think about aggression and its representation in the broadest spectrum—and why in fact it's urgent to do so.

Aggression, as discussed, is an essential ingredient in effecting messy but constructive change. It's also key to representing and exploring sexuality, to forcefully asserting the self within social spaces, and to re-creating in adult lateral relationships those healthy sibling rituals of mutual and highly complex recognition. Violence spoils all this. Interpersonal violence is when aggression boils over, is so excessive that another person is no longer recognized as an empathy-inducing subject but instead an object to be destroyed. Violence is destruction without boundaries. It's beyond the pale, and beyond my own sense of what's ethically condonable. But, two things. One is that because the possibility of violence is ever-present in emotional mixes involving aggression, its existence demands a concern that aggression stop short of violence. This recognition can in

turn help in intersubjective spaces to aid acknowledgment of the other and to set boundaries. At the heart of this complex maneuvering is the necessity to recognize that there are desires within the self to commit violence. The other thing, apropos of this study dealing with images, is that the representation of violence acts on the subject in very different ways than actual violence. It is representations of violence, particularly of women and girls committing violence, and what they might mean to the spectator and how she might use them I'm interested in here. This chapter focuses on two prime examples, director Quentin Tarantino's *Kill Bill* movies, *Volume 1*, 2003, and *Volume 2*, 2004, and artist Marlene McCarty's drawing series *Murder Girls* (1995–present). For the viewer they are two sides of a coin marked with very different issues about accepting violence. Together they also provide the opportunity to discuss how differently distributed cultural productions—here, mass-distributed movies and smaller-audience gallery art—seen in different arenas might impact viewers differently.

Kill Bill

Why is Uma Thurman's murderous Beatrix Kiddo so appealing to watch as she slays, beheads, scalps, knives, slices, kicks, and bites her foes in the *Kill Bill* movies? And how might this appeal connect to recognizing the viewer's own capacity for violence and/or capacity to fantasize about committing it? The stylized murders in *Kill Bill: Volume 1* and *Kill Bill: Volume 2* have been compared to tightly choreographed samurai films or equally unreal violence in video games and comics. Never one to hide his homage to other movies, Tarantino included in *Kill Bill: Volume 1* an anime section, which tells and safely encapsulates one of

the most emotionally loaded backstories for a warrior charac-
ter, one in which warrior O-Ren (Lucy Liu) at age nine watches
her parents being murdered and then at eleven serves herself
up to the pedophiliac murderer to get him alone and kill him.
With such aesthetic distancing, whether through watching an
anime section, enjoying elegantly choreographed violence, or at
times comfortably recognizing nods to movie action traditions
of Eastern and Western male action films, it's possible for view-
ers of the *Kill Bill* films, without much risk, to explore their own
publicly verboten emotions associated with bloodlust and mor-
tality (figures 3.1 and 3.2).

Granting this aestheticized distance, what can be further
theorized about the particular appeal to women? What is our
pleasure in seeing a female protagonist wield the killing sword?
In the most sweeping contextual terms of female viewership,
it's key to note here that women on average are the physically
smaller gender; this biological fact can condition attitudes
toward violence and fear. There are other fears and anxiet-
ies in social spaces common to women as well, not necessarily
linked to small size, but rather to social dynamics. In general,
we can consider that fear could heighten the pleasure in watch-
ing protagonist Beatrix Kiddo, who is portrayed as a righteous
avenger, kill her enemies. As social critic Paul Duncom has sum-
marized, "Research indicates that people who are fearful of
being victims of violence are more likely to be drawn to retal-
iatory violence. . . . They take pleasure in justice being done."
This connection points to an added investment for women,
and Duncum and others argue for the appeal of "justified"
violence in plots. He points out that "on primetime U.S. tele-
vision violence is nearly one-third more often perpetrated by
protagonists than antagonists."[1] Justification is heaped on the

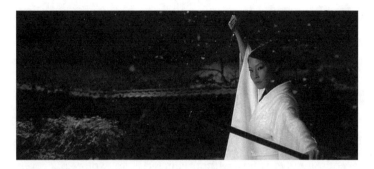

Figure 3.1
Preparing for the battle with Beatrix Kiddo, Lucy Liu as O'Ren Ishii, *Kill Bill: Volume 1*, 2003

Figure 3.2
Preparing for the battle with O'Ren Ishii, Uma Thurman as Beatrix Kiddo, *Kill Bill: Volume 1*, 2003

character of Beatrix. In *Kill Bill: Volume 1*, Beatrix is referred to as "The Bride." (The *Kill Bill* movies were initially conceptualized by Quentin Tarantino and Uma Thurman together around the ideas of doing a revenge movie and focusing on the character of The Bride.) Viewers are introduced to her at the time of her attempted escape from her boss and lover Bill's violent world to marriage to a decent guy in a small church in a small town in Texas. At the church, we see Bill and his assassin team murder all involved in the would-be wedding including the preacher, the preacher's wife, and the organ player. We then learn that The Bride improbably survives in a coma at a hospital, where she is repeatedly raped for profit, in a hideous scheme run by a hospital employee. The Bride has earned her right to retaliatory violence—and then some. As communications scholar Dolf Zillman argues in his essay "The Psychology of the Appeal of Portrayals of Violence," *"any gruesome retributive killing has to appear just, and this appearance has to be prepared by witnessing the party to be punished perform increasingly despicable heinous crimes.* This is to say that escalations in the portrayal of righteous, enjoyable violence necessitate escalations in the portrayal of morally enraging, evil, and distressing violence."[2]

Zillman also argues against simplistic assumptions that a viewer simply identifies with a protagonist, taking a broader view that someone watching entertainment occupies a fluid witness position. This position is one in which viewers can feel affinities with the multiple characters they are watching; its theorizing acknowledges a range of affinities for, say, protagonists, antagonists, relationships, and so on, instead of overemphasizing direct identification with one character. We've already seen in *Stick It* and other women's sports movies the potential for multiple identifications and the involvement with group

dynamics to which these can open the viewer. Zillman's theory is sensitive to a field of emotional responses—for instance, viewers rooting for some characters, decrying others, and feeling mixed emotions about others, all at the same time. By delineating the fluid witness position Zillman as well places the viewer within the context of the film and the context of being in the audience simultaneously. As we've noted when considering issues of women, fear, and violence, these contexts can add up convincingly to amplify the emotional charge generated by watching righteous, retributive violence.[3]

And, yet, the hitch in applying Zillman's theory of retributive violence to the *Kill Bill* movies is that Beatrix Kiddo isn't all that righteous. Aggrieved? Yes. Mightily transgressed against? Yes, that too. Purely righteous? No. She inhabits a righteous position, but the girl has a past and she's done more than her share of evil. In *Kill Bill: Volume 2*, Bill's alcoholic brother Budd, a former assassin and a current down-and-out bar bouncer, says to Bill, "That woman deserves her revenge. We deserve to die but then [laughs] . . . so does she." Before her attempted escape from Bill's world, Beatrix had been a mercenary, an assassin for money. She has a deep past of transgressive, even inexcusable violence; it's only her victimization in her recent past that seems to justify her present of righteous violence. At the end of *Kill Bill: Volume 2*, it is spelled out for the viewer that Beatrix is no pure avenging angel, but instead someone who—in addition and still—enjoys killing. Bill says to her, "All those people you killed to get to me felt damned good, didn't they?" She answers, "Yes." Bill pushes, "Every single one of them?" "Yes!"

I would argue that for the female viewer watching Beatrix kill, this blurring of righteous and transgressive violence or a shadowing of the righteous present with the transgressive past

opens a door for the viewer, bearer of her own impure desires concerning violence, to feel an intimate affinity with the excess of Beatrix's violent acts. Not only could the viewer feel a range of emotions watching the field of players in the *Kill Bill* plots, but also she could feel a complex set of emotions specifically watching Beatrix. This could provide closeness or identification with Beatrix's joyous as well as justified violence. This complexity is lightly hung within a very simple framework of rooting for the protagonist in the morally black-and-white plot of her murder spree the *Kill Bill* movies roll out—the whole organizing bent of the plots is merely a list of justified kills Beatrix accomplishes and checks off one by one. The relationship to the protagonist afforded the viewer by Beatrix's blurred relationship to violence, that is, transgressive as well as righteous, as an aggregate is one that presents an interesting acceptance of excess, the excess of violence in the movie. Perhaps it also aids an awareness of one's own potential for violence as an excessive outcome of the self's ever-present aggression. (There is also, especially in *Kill Bill: Volume 2*, a theme about Beatrix's maternal instinct and her reunion with her four-year-old daughter B.B. To me though, that narrative thread seems saccharine, unconvincing, and much paler than that of the protagonist's violence and its attendant emotions.)

From a Kleinian perspective the subject needs an acceptance of aggressive excess in her fantasy world; an acceptance of her desire to kill that in turn is mediated by remorse, reparation, and love. In short, she needs to accept the existence of both her own love and her own hate in order to negotiate between the two. This is not an absence of guilt, on the contrary; in Kleinian theory, feelings of guilt (as well as fear of retribution) are the

incentive in unconscious and conscious fantasy for making reparation, and, to generalize, moving toward or recapturing love in relationship to the other. Klein writes about the importance of this negotiation, which includes an acceptance of aggression, in everyday mental health. For instance, in her coauthored book *Love, Hate, and Reparation*, she explains, "Most of us feel an elation which is pleasurable on overcoming an obstacle, or on getting our own way. This *pleasure* that is apt to be closely linked with aggressive emotions explains to some extent why they are so imperative, and difficult to control. It is also evident that aggression in certain forms plays a considerable part in the struggle for existence. In all fields of work, and in pleasures, too, we recognize clearly that people who have not enough aggression, who cannot assert themselves enough against obstacles, are deficient in a valuable quality."[4] Klein goes on to assert, "We can in fact say that both the self-preservative and 'love' instincts need a certain admixture of aggression if they are to attain satisfaction, that is, an aggressive element is an essential part of both these instincts in actual functioning." Klein, in this text, writes about the key roles of aggression in psychic health.

Likewise, Juliet Mitchell is interested in internal negotiation with aggression—even and especially in its most extreme form—and its acceptance as key to healthy maturation. As noted, Mitchell recognizes the early decision not to kill one's siblings as the turning point in maturation in accomplishing the realization that self-preservation is interdependent with preserving others as well. This acceptance is quite complex in Mitchell's theoretical explorations and involves potential reversals and translations.[5] "The intense jealousy, rivalry, and envy among siblings (and later, schoolchildren) are reversed into demands for equality and fairness." And less idealistically and more pragmatically, it appears in the everyday: "Because each

sibling evokes the danger of the other's annihilation, siblings are going to want to kill each other. This murderousness is forbidden and must be transmuted to aggressive play and healthy rivalry."[6] In order to make those decisions and to reverse aggression for a sense of mutual, fair preservation, and/or to translate aggression into aggressive play, I'd argue that aggression must be seen and accepted in its full range, including the power and desire to murder. Without this acknowledgment within the self, there could be potential for splitting, for projecting outward aggression and guilt, for the all-too-familiar acting out of passive aggression; all these unproductive, and ultimately unfair, options are too easily exercised. For the healthy subject, then, that is one defined most broadly in terms of the Kleinian definition of being able to negotiate internally in favor of love, acceptance of aggression within the self, even and especially in its most potentially excessive and murderous form—violence—is a necessity.

It's yet another question how representation can fit in, and here examples of righteous violence in movies are helpful. I'd assert that in our culture a framework of righteous violence in a movie can allow us to connect to our internal desire for violence and—dangerously in its courting of excess without negotiation—even celebrate violence. In the *Kill Bill* movies, Beatrix's blurred morals allow viewers to operate along a spectrum that allows for individual viewer choices in connecting in an intimate way with feelings related to our own desires to kill. If Beatrix were merely all-good as, say, Lara Croft is portrayed in the *Lara Croft* movies, then she'd be harder to relate to when she kills.

Whom does Beatrix kill? Not, as it turns out, until the very end of the two movies does she murder her father figure and lover Bill. Instead what the viewer watches over and over—and

exclusively in *Kill Bill: Volume 1*—is Beatrix slaying her "siblings," that is, characters who function like siblings. Mitchell cites Freud in the *Interpretation of Dreams* as declaring that he never met a female patient who had *not* dreamt of killing her siblings.[7] Freud explains, "Many people ... who love their brothers and sisters and would feel bereaved if they were to die, harbor evil wishes against them in the unconscious, dating from earlier times; and these are capable of being realized in dreams."[8] And then he continues with a gender observation: "In none of my women patients ... have I failed to come upon this dream of a death of a brother or sister, which tallies with an increase in hostility."[9] In *Kill Bill: Volume 1* there is the sibling-murder fantasy brought to life, or at least to the movie screen, by Beatrix in elegant movement, with a feminine, toned body, and righteousness alleviating any guilt. Whereas in *Kill Bill: Volume 2* a lot of Beatrix's background story is given, such as her martial arts training, in *Kill Bill: Volume 1* it's almost nonstop sibling kills. No wonder it's so satisfying to watch.

Kill Bill: Volume 1 is a revenge movie. It starts with a graphic of the proverb, "Revenge is a dish best served cold," and every time, bar none, Beatrix tracks down one of her enemies to kill, Tarantino presents viewers with a flashback of The Bride in the church looking up at this individual as one of her tormentors and would-be killers. Lisa Coulthard and other critics have pointed out that this grounding in The Bride's victimization is part of a long and problematic tradition of rape-revenge films that, in providing an action resolution, serve to normalize the rape as "fixable." I think this is a point well taken. What's interesting to me, though, is how superfluous certain elements of the plot are to the affective viewing of the film. I disagree with Coulthard, for instance, about the importance of the maternal ending to *Kill Bill: Volume 2*. In my own repeated viewing

of the *Kill Bill* films, for instance, the tacked-on maternal ending is something I mainly ignore: it seems not so much normative as silly. The shooting and rape scenes are more impactful, though, and as a refrain are a presence in the movies that can't be ignored.[10]

Early scenes in *Kill Bill: Volume 1* show The Bride's face brutally beaten and then Bill's almost-successful attempt to kill her as she lies on the church floor. The viewer is filled in, too, about the discovery of the massacre and about Beatrix's almost-dead body left with breath and spit in it; her lying in a coma in a hospital; and an aborted attempt to kill her in the hospital (this is key to the revenge theme—Elle Driver is about to lethally inject Beatrix, but is stopped by phone by Bill who dictates that this death does not befit a warrior; Elle tells the comatose Beatrix as she leaves that Beatrix had better never wake up; the viewer understands that if Beatrix does, the team will attempt to murder her—there would be no live-and-let-live option in the future). After four years, Beatrix snaps out of the coma; we watch her kill her hospital rapists and will her leg muscles back to life; fleeing in one of their cars, The Bride is finally escaping—not yet to a new life but to finish unfinished business.

Interspersed with these early scenes, too, the Deadly Assassination Viper Squad is defined with titles and images: O-Ren Ishii (played by Lucy Liu), Vernita Green (Vivica A. Fox); Elle Driver (Daryl Hannah); Bill's brother Budd (Michael Madsen). Bill is only present in *Kill Bill: Volume 1* through his voice and his hands. The Squad all participated, it's made comic-book clear, in the killings in the church.

The sibling theme is ever-present but not explicitly defined throughout the movie. There are notes of familial intimacy often, though. For instance, each time Beatrix locates one of

her enemies and faces off with her, there is a shared exchange in the midst of warrior-talk that shows the two go way back. With O-Ren it's even childish; "Silly rabbit," says O-Ren to Beatrix, and then the two in tandem say, "Trix are for kids." Right at the beginning, accompanying the visual recounting of the church massacre, Sonny Bono's eroticized sibling song par excellence plays: "Bang bang, you shot me down, bang bang, I hit the ground. . . . You were five and I was six, we rode on horses made of sticks, you wore black and I wore white, you would always win the fight. Bang bang. . . ."

The majority of *Kill Bill: Volume 1* is taken up with Beatrix's tracking down and killing of Vernita and O-Ren, with an Okinawa side story about Beatrix's obtaining a Hanzo sword and further practice and many samurai movie references thrown in, as well as the anime section and more background on O-Ren. Of Tarantino's assorted regressions expressed in the *Kill Bill* films, the most troubling is the focus in *Kill Bill: Volume 1* on the triumphant killings by white, blond-haired Beatrix of African American Vernita and Japanese-Chinese O-Ren. Harking back to the traditional U.S. entertainment exploitation of pitting races against each other and having the white protagonist win, for example, in such mainstream movies as *Rocky II* (1979), where Stallone beats his African American adversary, this is an overdetermined racism. Not all film citations are "just" film citations.

In *Kill Bill: Volume 2*, as Beatrix works her way up the list, she gets to her more powerful enemies, who are white, another unnecessary bit of pandering to traditional racial hierarchy. In her fight to the death with Elle, though, it gets interesting and campy to see the white-on-white, blond-on-blond duel as the two are visually twinned and given similar moves—and earlier in the plot similar erotic/incestuous relationships with Bill, who

we hear at different times profess sexualized love to each. These are sisters in an incestuous triangle. And in fact the enemies (except Bud and Bill) are all occupational sisters. With each face-off it's made clear that the women know, respect, loathe, and are kinship-tied together; they are a family of warriors.

The sibling "play" in the *Kill Bill* movies, then, is the other side of the coin from that portrayed in the women and sports movies. In *Blue Crush*, Anne Marie may've accused Eden of trying to kill her, and Eden may've even wanted to, admitting to a murderous envy when the two were smaller, but in the end they work it out. Anne Marie's victory is seen as Eden's as well, and celebrated with hugs all around. Specifically, in the sibling dynamics in most female protagonist movies, whether violent in the *Kill Bill* films or collaboratively victorious in the sports movies, there is a focus on sisters: for women the real or imaginary other who is most like the self.

To further explore why the idea of killing sibling-like characters might appeal to adult female viewers, I want to revisit ideas of women's interactions in social space—in other words, lateral and other relationships in adult lives and places. The ability to interact in a social space with others, Mitchell claims, starts with the repression of that desire to kill aided by the birth of empathy, the understanding that seeing the sibling as a subject is akin (literally) to the sibling seeing oneself as a subject, and that a prohibition on killing him or her is also a prohibition on being killed by the sibling—it's a preservation of the self. Following this idea, I'd assert that a healthy maintenance of social space precludes the delusion that aggression and its attendant possibility of violence can be absent from this nurturing. What would a lack of this acceptance mean? Without aggression and recognition of the other, the specter of narcissism floats as one

of the saddest and loneliest and most dangerous states for a self. The inability to see an other, the fantasies of omnipotence, the killing rage when these fantasies are threatened by the existence of others (or even the aging of the body), these foreclose interactions in a social space; they foreclose love. For mutual recognition in a social space, both parties must do the work of seeing and being seen.

In the abstractions of psychoanalytic theory, though, are missing historically specific sociological mechanisms and the cultural anthropology of how issues are commonly negotiated in everyday life. Broadly put, in U.S. culture, I can hypothesize that in the majority of its cultural subsets, it is women who usually are or feel they are most responsible for the negotiations of social interactions—between themselves and men, between themselves and other women. If we look laterally, as Mitchell urges us to, at adult relationships as frequently functioning as stand-ins for sibling relationships, it's the sisters who are organizing the social calendars, so to speak. Women traditionally handle the niceties of discussions, and the diplomacies of social interactions, to foster connections. But perhaps women need a break from this work as well: we need not to be trapped in total narcissism but still our moments of narcissism, of the pleasure of self-love. We need to be able to travel in and out of temporary narcissistic states. For although narcissism can be a disease, in that it can describe in its extreme state someone incapable of seeing an other, it can also in a more commonly functional way describe a moment of retreat, protection, self-love, willful blindness—spacing out the existence of others for a time, only to reenter a space of mutual recognition shortly after. We all have those moments. Perhaps we even need them.

So, here's what I'm wondering about the pleasure of watching *Kill Bill*. First, I take as a given that social space doesn't much exist in the movie; that is, there isn't a plausible representation of relationships that involve love or friendship, so there's no guilt in violating such a space. Second, there's no obligation to feel an affinity with a female character negotiating to maintain those spaces—because Beatrix does not negotiate. Third, Beatrix acts with utter narcissism (one culturally condoned by revenge and revenge based on feminine rituals interrupted); she acts again and again with deadly force to eradicate others in the interest of preserving her self. She kills her siblings, and she ignores intersubjective space. She is a regressive dream. She has license to kill. And she does. There is joy in witnessing her doing it.

How can this experience of viewing regressive violence in entertainment be folded into other aspects of everyday life? How might it function? The channeling of aggression into a goal— whether a sports victory or a negotiated sibling-like friendship, isn't a full admittance of the forces of aggression, unless the power and danger of its excess is embraced—conceptually and emotionally. Visualizing violence can function as an aid to doing that, depending on context, degree of excitation, and so on—there are strong possibilities of becoming overloaded, disgusted, turning away, and those are all important, too. Accepting the existence and representation of violence doesn't have to mean endorsing being violent. A large set of writings on connections or lack of them between viewing violence and doing violent acts exists, but I'm not concerned with that connection here. Instead my focus is on something more basic and internal: the acceptance of the *possibility* of violence, namely,

excessive aggression generated by the self. For U.S. women, this acceptance, this acknowledgment, has not historically been culturally condoned, and I think this has been a psychic disadvantage. Now with female action heroines in mass culture like Xena, Warrior Princess, Lara Croft, and Beatrix Kiddo, visualization of feminine violence (in an idealized, stylized way) is growing more common, although some of the characters have more emotional impact than others. I'd argue that along with the growth of this new stereotype of the righteously violent woman comes the possibility of imagining one's own full and messy and excessive potential for aggression. It can connect female viewers, too, to an acceptance of moments of narcissistic, regressive pleasure.

Again, it's particularly this righteousness that allows Beatrix to kill without remorse and viewers perhaps to imagine righteous aggression without guilt; it's at the very least a reversal of the too-long tradition of women being depicted as victims (from Bette Davis's roles with their frequent sacrifices to more recently romping and rebelling Thelma and Louise who had to die at the end of that movie). Watching a female protagonist act with righteous aggression can be a welcome antidote to seeing too many female characters as victims in past movies. Beatrix is victimized at first and then she gets revenge, over and over and over. To heighten the appeal, these are beautiful kills. Snow falls on a Japanese garden as Beatrix and O-Ren duel to O-Ren's death when blood arcs artfully red across the white. In sibling terms this idealization could elicit an emotional memory or even just a feeling from the very early days of grandiose narcissism before the recognition of the interdependence between the sibling's survival and one's own. (For only children, this may come with the recognition of the subjecthood of

same-age friends and playmates.) Can we really remember that emotion, those of us who aren't stuck in complete narcissism? I'd argue yes, and that fleeting moments of narcissism are common for most of us in daily life—when eating, when exercising, when lost in self-love. Surely at least we can feel affinity if not absolute identification for a figure that in a retributive context kills without remorse. In summary, acceptance of one's own aggression is key to a healthy, constructive social interaction with others; it is also key to regressive narcissistic moments, likewise part of happiness.

However, acceptance of aggression and its potential excesses is only a start. For social as well as individual health, internal mediation of the desire to commit violence is also a necessity. In the spectrum of emotions and psychological states associated with aggression, non-remorseful violence is only one small part, though. If acceptance of aggression is key, then so is the acceptance of the emotions beyond the grandiosity that can accompany it, and in fact important for healthy nonviolent negotiations in everyday life. Melanie Klein examines how constant emotional negotiation is in everyday life and in unconscious fantasy. Although there are tragic exceptions, most of us don't kill—not (in the Kleinian baby metaphor) our mothers when they temporarily deprive us of milk or attention, not our siblings (as in Mitchell's theory) when their existence threatens our very identity, not annoying people in high school or in the workplace. That negotiation Klein roots in an infant stage she termed (rather confusingly) as "the depressive position," one in which guilt and remorse for imagined violence against the mother leads to fantasies and feelings of reparation toward and protection of the other. That mechanism of remorse and desire for reparation in Klein's theories is difficult to represent, while

also acknowledging the coexistence of aggression. (There are many representations of repentance—for example, the movie *Heathers*, 1989, where Veronica [Winona Ryder] acts out her violent fantasies, egged on by Jason [Christian Slater], resulting in murders, but then repents, renounces the psychosis of murder—and of Jason—and saves the entire population of their high school from Jason's mad bomb threat. But I'm looking for something more complex than simply repenting and renouncing violence, i.e., the acceptance of aggression combined with an acknowledgment of the emotions the self uses to negotiate with it.)

We need represented the full complex range of feminine aggression in our culture: in the case of violence, not only the cartoon-like celebrations common in contemporary mass culture, but also complex expressions of desire and remorse. For this reason, I want to explore in depth the artwork of Marlene McCarty and her positioning of the viewer in relationship to her *Murder Girls* drawings. McCarty's series is one of the most powerful addresses I've seen of the remorse involved with killing, the too-lateness of murder, the closing off of the possibility of reparation, while at the same time stirring fantasies of violent potential, especially against family members—and I give here a personal as well as an analytical reading. As a participant in the art world through my training as an art historian, my published writings on art and visual culture, and my professorship at an art school, I recognize that art persists for me as a realm to feel and deliberate about difficult emotions—as well as more palatable ones like pleasure. While I read the *Kill Bill* movies through a scrim of irony, viewing McCarty's work has more impact on me. So McCarty's art becomes in my own life a "test case" for affect, an example of a series of representations about violence that has moved me—and generated in-depth questions. Other

realms, and cumulative, multiple realms, of culture impact different individuals variously. This is one instance of my being stirred in an art context to feel always-present, complex emotions related to the possible overflow of violence in women's aggression—and in my own desires.

Before turning to viewing possibilities in the white-walled gallery space, though, let's consider the physical context in which many saw the *Kill Bill* films: the movie theater. Distributed by Miramax, both *Kill Bill*s were extremely profitable in theaters. Gross statistics are as follows: (1) first weekend gross, *Kill Bill: Volume 1*, $22,089,332 and *Kill Bill: Volume 2*, $25,104,949; (2) U.S. gross total, *Kill Bill: Volume 1*, $70,098,138 and *Kill Bill: Volume 2*, $66,207,920; (3) worldwide, *Kill Bill: Volume 1*, $70,098,138 and *Kill Bill: Volume 2*, $150,907,920. Viewership has continued to grow of course with at-home DVD watching.[11] But the all-encompassing, crowd-inclusive, black box of the movie theater, it's been theorized, can lend a special intensity to movie viewing, especially when viewers share the experience with many others in the case of a popular, mass-distributed movie. Susan Buck-Morss writes of the anestheticizing that occurs in this overwhelmingly passive viewing experience: in particular, the separation of so many of the body's responses from viewing shocking images. She also writes of the unique experience of viewing Hollywood stars as filmic montages created throughout the duration of a movie.[12] I'd argue that the star-viewing experience is a significant constant in the reception of the *Kill Bill*s, even more so than with other genres of movies since so much else has been emptied out of the movies except for the display of violence by its star Uma Thurman. Part of the relatively relaxed nature of viewing these movies, even the violence, is the ever-present knowledge that this is a choreographed

Uma Thurman performance. So much distance contributes to the kind of selective emotional response discussed here. In contrast, the subjects of Marlene McCarty's series on feminine violence are not famous. Further the ways their forms are represented allow for ambiguous affective readings. And the viewer's position in the gallery space, usually standing and possibly moving, choosing a point of view, opens the door for a different kind of corporeal involvement as well. The viewer can easily move closer—to read the wall texts, to examine the images' sinuous lines, for emotional reasons—or move further away—to view the whole installation, for emotional reasons.

Marlene McCarty's *Murder Girls*

In Marlene McCarty's *Murder Girls* drawings, the face of rage is not a snarling one; it is a deadpan, teenage visage, and on that face the viewer, if so inclined, can project her own feelings of aggression. Safe in the realm of representation, she can feel the danger, fear, and excitement that attend her own inner faces of rage. But viewing these drawings is not a therapy session. I'm interested in the complex possibilities for the viewer's response to these oversize portraits of girls who have murdered as art. And I'm interested in the roles of language—of the written words accompanying the drawings as wall texts and also my own act of writing as a means of processing the related emotions. It seems to me that each layer of representation associated with the *Murder Girls* works—the matter-of-fact wall texts, the looming portraits, and the cultural criticism—carries its own ambivalence and allows for its own oscillation of feelings between safety and danger. In the wall texts, compelling mixtures of adult journalese and adolescent diary writing that describe the girls' crimes,

the semi-intimate writing style draws focus away from the crimes; the narratives return it. And the drawings carry their own push and pull. In them, McCarty's draftsmanship attracts and distracts the viewer with its stunning sinuosity. As for my words about McCarty's work, they allow me to explore—my own and the Murder Girls'—feelings of violence, and they also buffer me from these emotions.

In *Marlene, Jan. 1, 1975 (Marlene Olive, 353 Hibiscus Way, Marin County, California, June 21, 1975)* (figure 3.3), McCarty presents three versions of her chief protagonist among the *Murder Girls*, Marlene Olive. In this work, Olive appears as she ostensibly looked six months before she and her boyfriend murdered her parents. The three figures seem to be three different versions of Olive studying her own adolescent poses in the mirror; yet they are combined by overlapping body parts and shared lines in a way that marks their locale as a fantasy space as well. The three figures are wrapped up in each other. The one on the viewer's left sprawls on the lap of her almost-identical self in the center; the other on the right leans against the central figure's back. Their faces are calm, looking ahead, almost expressionless. Their bodies are slumped, hanging out. But their long hair is anything but passive—it charges whip-frenzied and strangely intertwined, figure to figure. Two of the Marlenes share a braided strand.

In this oversized drawing, the self-consciously high school self-portrait drawing style McCarty employs has been taken over by the artist's virtuosity. The figures' bell-bottom jeans, platform shoes, loose hair, bare nipples, slouched postures are drawn in tightly spaced ballpoint pen and pencil lines. But, oh, the lines! Flowing, alive, inventive, seductive, ethereal, powerful, liquid, and active. Both conventional and excessive. These lines

Figure 3.3
Marlene McCarty, *Marlene, Jan. 1, 1975 (Marlene Olive, 353 Hibiscus Way, Marin County, California, June 21, 1975)*, one of six murals, 2003, graphite and ballpoint pen on paper, 10 × 14 feet, mural #1 of series.
Courtesy of Sikkema Jenkins, Co., New York

entrance the viewer, even more so than the more heavy-handed gesture of the central figure baring her hairless pudenda. The emotional impact of the piece—the aggression and longing and power and confusion of the Marlenes (i.e., the three Marlene Olive figures and in some way, the viewer might suppose, the adult same-named artist herself)—this is in the lines.

This section is about artist Marlene McCarty's portraits of girls who have committed murder, in most cases, of their mothers—an ambitious ongoing project for McCarty since 1995. I particularly want to explore what it means to view the *Murder*

Girls, as McCarty calls the portraits, in the realm of representation and art, and how the works leave more questions than answers about aggression. (In fact, in most of McCarty's works in this project, the girl depicted is usually the murderer, but in a minority, as with *Sylvia Likens—October, 1965* [1995–1997, graphite on paper, 96 × 55 in.], she is the victim.) I'm thinking about the murders, about McCarty's representation of girls who've committed matricide, about Klein's writings on love and hate felt toward the mother. In interpreting my own responses to the *Murder Girls* as a writer, I'm wondering, too, about symbolization of my own translated into representation and how critical writing can work to construct a narrative of entwined and contradictory emotions.[13]

I don't want to give away the end of the mystery here. Suffice it to say, for myself and I suspect many viewers, looking at and thinking about the *Murder Girls* is a way of achieving a feeling of safety and a lessening of anxiety as concerns violence— much as the reading of a good detective story with a female protagonist can provide a comfortable and comforting bedtime read. And yet, after viewing McCarty's *Murder Girls*, since they refer to actual killings, there remains a difficult residue unlike the emotional leavings of a novel. The feelings and curiosities they tap—and the impact of the visual as McCarty deploys it— resonate with the critical words. And linger.

I keep coming back to the very mixed emotions the *Murder Girls* raise for me. They are touchstones of violence and sadness, I suppose in relationship to my own mother, myself, my femininity, my adolescence—who can trace these things exactly? And because the feelings last powerfully, along with more joyous ones of loving the grace and complexity of creating and responding to and deciphering representational scenarios—these

works stand out to the degree they invite the great pleasure of using the mind to explore never-closed and always-evolving emotions.

McCarty's realistic drawings are of girls who have murdered—and not in self-defense. In the majority of the cases, their victims were their mothers. On a deep level, I suppose, I could admire their acting out their rage. Who hasn't, at one time or another, felt a killing rage toward her own mother? On another more socialized and evident level, though, the girls are pathetic. Their acts of murder are stupidities, failures, and unethical acts of the most unimaginative kind. For most daughters, moments of killer rage quickly dovetail into a complex weave of actions and emotions involving issues of love, hate, independence, interdependence, and so on—a weave in progress throughout their lives. For these girls, not. McCarty spells out their stories in the texts that accompany her large pencil drawings. Some had mothers who disapproved of their newfound sexuality, of their clothes, of their breaking curfew, or of their new boyfriends. Some had mothers who were more seriously abusive, literally locking their daughters in closets. But murder as an out? Pathetic. Disapproval, however, is too easy, and in my initial reactions to these works and their narratives it covers up a sadness and a fascination I feel when I spend further time thinking about the girls and McCarty's portraits.

Time is a key element in both the production and reception of these staring portraits. McCarty freezes the girls in time, usually before the murders, a time when (the viewer imagines) it's still possible to negotiate the inevitable mixture of love and hate for the mother—and for themselves. A time when death is suggested and foretold, but not yet evident. And then—so the wall text tells—it's over: the mother is dead; no negotiation

with the actual parent is possible. (Time figures, too, in the lag between looking at the drawings and reading the accompanying text—again a buffer that reminds the viewer she is in the relatively safe zone of representation, not to mention living several decades after the crime itself.)

As I look at and read McCarty's repeated stories of matricide, Klein's writings on aggression toward the mother—and internalized images that represent her—again come to mind. For Klein, ego development stems from the processing of love and hate felt toward the mother. The dynamic between love and hate is echoed by and complexly mixed at various stages with other pairs of positive and negative emotions that are love and hate's close kin—desire and aggression, gratitude and envy, reparation and destruction, compassion and guilt—and suffused throughout with anxiety.

Klein's words become another key—and another distancing mechanism—for wondering about the *Murder Girls'* emotions—and the viewer's own. How might the murderer feel today, long after the crime? If the murdering daughter is still alive, she might be clotted with depressive guilt. It seems likely that with matricide a Kleinian integration inside the self of those feelings of love and hate toward the internalized mother would be hampered, and such integration, Klein would say, is necessary for dealing with other types of ambivalence, for mental health, and for a vital sense of self. So there's a potential (for the murderer, for anyone identifying with her) for death of part of the self as well. It is depressing. And yet, except for the textual reminder of the daughter's punishment (most wall texts accompanying the drawings state the amount of prison time the girl received; this doesn't close off the narrative and instead leaves the viewer wondering about the girls, now women, in the present), the

daughter post-murder is not an explicit part of the exhibited story. Instead the artist and the viewer are—we live on. Klein would assert that we are all, through the forming of our own egos and the separation from our mothers, post-matricide (for most of us of course symbolically not literally—and my leaping back and forth between these two here in critical language is intentionally provocative). In terms of viewing the *Murder Girls* as art, the viewer is the vital and present continuance of the representation and its emotional scenarios.

There are subseries within the larger *Murder Girls* series. One group that speaks powerfully to the sense of emotional relationships developing over time and then coming to a violent halt is the one whose first mural we've already considered, called *Marlene Olive, 353 Hibiscus Way, Marin County, California, June 21, 1975*. It consists of six 10 × 14-foot drawings, each showing different versions of one of the murdering girls—Marlene Olive—over time. As mentioned, some of the murals—four to be exact—illustrate three different Olives side by side. The boyfriend Chuck appears in one, as does Olive's father at various times, and her mother Naomi appears in another at a range of ages, including the age Naomi was when Olive was a baby. This series taken together is for me a metaphor about the unfurling of emotional processes—and their dead stop. Yet the processes are alive in the field of representation and in the viewer's experience of the works.

And then, on a seemingly mundane level, another emotion I feel when looking at these penciled faces is nostalgia . . . for high school art class. Drawn with the careful details and shadings of the naturalistic life drawing so many of us did in high school, McCarty's portraits return me to that time as I recall the effort and pleasure that went into the drawings—a process

that, not incidentally, took me away from (or, as psychoanalysis would say, helped me sublimate) my own adolescent anger, at least temporarily, and as much as, say, sex or reading. In the present, I want to redo parts of these drawings, too. McCarty has made the girls' clothing transparent where their pubescent sexual development is occurring—nipples and pudenda—and this annoys me. Okay, I think, we get that the works and the stories are about the girls' budding sexuality—that's apparent. But does the representation have to be transparent, too?

But I like the pieces overall—they make me think and feel in complex ways about loving and hating the mother and the self, and even about what art can accomplish in our culture, although these days I have tended in my criticism to turn more often to mass culture (or at least to mass-distributed culture) for signs of hope and change. McCarty's *Murder Girls* draw me back to the art world, to the space for contemplation and feeling it can provide.

Artist and designer Marlene McCarty (b. 1957) is perhaps best known for her design work. As a cofounder of Gran Fury with Donald Moffett and others, she created AIDS-activist graphics for New York demonstrations by ACT UP (the AIDS Coalition to Unleash Power) and for other venues. In *Read My Lips (boys)* (1988, offset lithographic poster and T-shirt), Gran Fury turned George H. W. Bush's familiar phrase on its head by running it across a photographic image of two sailors kissing and adding a headline beneath, "Fight Homophobia: Fight AIDS." The same year, the group created its *Sexism Rears Its Unprotected Gear* poster that showed an erect penis and announced "Men: Use Condoms or Beat It." The text continued, "AIDS Kills Women," and followed with a call for "Spring AIDS Action '88: Nine days of nationwide AIDS related actions and protests."

In the early 1990s, working with designer Bethany Johns, McCarty created activist designs for Women's Action Coalition (WAC), posters that drew support for demonstrations—and looked good enough and bold enough for television. For example, the WAC logo, *WAC Is Watching*, cocreated with Johns in 1992, is a take-off of the CBS eye. In a cut-out circle, a close-up of an eye stares out at the viewer; covering the eye's pupil is "WAC/Women's Action Coalition" and around the outside of the cut-out circle are the words "WAC Is Watching/Women Take Action." From close up, all the words are legible; from far away, perhaps to a TV camera scanning a protest, the eye and the words "WAC Is Watching" are still easily read.

In 1982, McCarty and Moffett began the design firm Bureau in New York City, which took on corporate projects such as their 1990s promotional work for Clinique and also created film titles for directors including Todd Haynes and Cindy Sherman. In some cases such as the Sherman film titles, McCarty's interests in feminism, politics, and representation came to the fore, while in others perhaps the main connection was that the design work, in addition to paying for her bread and butter, also funded her art practice.

McCarty, who had been educated at the University of Cincinnati and the Basel Schule für Gestaltung, began exhibiting her artwork in group shows in 1990–1991 at venues including Simon Watson Gallery and White Columns in New York City. In 1993 she showed "bad girl art," as it was then commonly termed, at Metro Pictures (which represented her from 1990 to 1995) and in 1994 in the New Museum for Contemporary Art and UCLA Wright Art Gallery *Bad Girls West* exhibition, among other shows. The untitled works exhibited at Metro Pictures foregrounded slogans written by McCarty like *Suck Mine, You're*

My Slut Bottom Suck, Cunt Wallow, and *Smell It Fiddle with It Don't Wash It*—most in curlicue, biker-decal script. They were large works (e.g., 72 × 82 in.) covered by heat-transferred lettering on canvas in gray, black, and white. The erotic taunts, ironically or not, seemed to glory in a crude possession of the lover: objectifying her through language, naming her, daring her, desiring her with mixed lust and aggression. They were to mark the beginning of what has and continues to be a formidable exploration of feminine aggression in McCarty's art. Some of the canvases didn't just shout sex talk; their lettering also parodied various avant-garde styles often found in current design—minimalism, De Stijl, etc.[14]

In 1995, McCarty began her pencil and pen on paper *Murder Girls* portraits (most at least 8 × 4 ft. large), but her then gallery Metro Pictures refused to show them. The series, no doubt due to its difficult subject matter, went unexhibited until a 1998 show at the Swiss Institute in New York City. After that, though, the *Murder Girls* series has been frequently exhibited—for instance, the six oversized drawings of Olive's family, which evoke time-lapse photography and/or filmic montage, were included in the Istanbul Biennale in September–October 2003 and at Brent Sikkema Gallery in New York City in January–February 2004.

Olive, a figure of repeated interest for McCarty, was the subject of one of the first *Murder Girls* portraits McCarty drew, *Marlene Olive—June 21, 1975* (figure 3.4), sitting cross-legged and staring into space. Her top is transparent so her nipples show and her pants are unbuttoned so the top of her pubic hair is visible, but otherwise the drawing could be based on a standard snapshot. Olive's makeup, long hair, and jewelry are carefully rendered. Only her sullen gaze gives a hint of trouble. In these portraits McCarty bases the drawings of the faces on newspaper

Figure 3.4
Marlene McCarty, *Marlene Olive—June 21, 1975*, 1995–1997, graphite on
paper, 96 × 60 inches.
Courtesy of Sikkema Jenkins, Co., New York

photographs that were published alongside reports of the girls' crimes—or, as in Olive's case, police mug shots. But the bodies are drawn from pastiches of fashion magazine images and sometimes Jock Sturges photographs to create fantasy images. As such they are likely more attractive than average girls' bodies, but McCarty draws them in awkward poses that make them ring true in a high school context.

In text accompanying the image, McCarty gives Olive's story in a journalistic tone, adding some projection (in a more diaristic tone) and editorializing. By referring to Olive by her first name only, McCarty emphasizes intimacy and the sameness of their two names, the implied blurring of their identities:

Marlene wrote poetry. She dreamed of being a rockstar or a model. She toyed with the occult and tried to convince her friends she was a witch. She liked David Bowie, platform shoes, hip hugger jeans, and lots of sparkly makeup. Her mother did not. Her mother kept the curtains in their struggling-to-be-upper-middle-class house tightly closed. Her mother spent a lot of time in bed or feeding her tropical fish or collecting and storing bath towels. In anger and jealousy, the aging overweight Naomi Olive called her only daughter slut. Stormy mother-daughter turmoil would be followed by intervals of calm desperation as the two females tried to make up. Inevitably the peace was short lived.

Jim Olive, her father, adored her. He ran his own struggling business, but his most important job was peacemaker between Marlene and her mother.

Marlene had been a chubby well-protected child brought up in strict Ecuadorian private schools until her parents moved to Marin County, California. Freed from school uniforms she found herself to be a young woman that attracted the other sex. She liked that. Her mother didn't. Her newfound sexuality yielded power and control. She liked her new boyfriend, Chuck Riley, because he would do anything for her. Jim liked Chuck because he thought Chuck was a good influence on Marlene. Chuck, known and loved around the neighborhood, was also covertly a

minor drug dealer. He liked coke and pot, which he generously shared with Marlene. Marlene began to test the boundaries. She stayed out at night. She stole things. She was caught and taken into detention. At home, curfews became stricter and stricter in an effort to exert parental control. Finally she was grounded. She secretly met and talked to her boyfriend in a pathway between the neighbors' houses.

One afternoon her father was out. As her boyfriend snuck into the house, Marlene took a hammer and bashed her mother's head in while she was sleeping. Chuck opened the bedroom door to horror. To the teenager's [sic] surprise Marlene's father unexpectedly returned home. In desperation and panic Chuck shot Marlene's father dead.

In a blind fury, the teenage couple gathered the two adult corpses and the bloodied mattress, stuffed them in the car and traveled under the cover of night into the California forest. The teenagers burned the bodies in a deer pit deep in the forest. The next day a ranger found the smoldering fire, kicked the ashes and saw what he thought were deer remains. Later, the bones proved to be human.

Marlene eventually told a girlfriend she had killed her mother. The police were notified. Marlene was apprehended. Marlene claimed Chuck committed both murders. He was also apprehended. The court found Marlene guilty of murder. She was sent to juvenile detention where she was incarcerated until her 18th birthday. Chuck was also found guilty but because his 18th birthday had passed he was tried as an adult and received life imprisonment.[15]

In an October 20, 1997, visiting artist lecture at the School of the Art Institute of Chicago, McCarty explained that she selected each story to avoid simple cause-and-effect explanations for individual girls' actions such as violence and/or suffering extreme physical abuse. In Olive's, as in other stories McCarty employs and produces in various media, Olive had not been hit. She had displayed some rebellious behavior but not pathology. Of course given the scant visual and textual information in McCarty's portrait of Olive, there's no way for the viewer to ascertain whether or not Olive was a psychopath. But the point is

that McCarty represents her as "normal," with typical dress and posture and typical signs of developing sexuality. McCarty explains an inarticulate rage she sees in common in many of the stories:

These women harken to a particular moment of dis-ease that we don't want to know about, hear about. . . . Most of these girls wound up in these situations because they were not able to articulate themselves. . . . I don't think they were psychopaths. I feel that if they'd been in a different situation at a different time these [murders] would not have occurred.[16]

The majority of the *Murder Girls* works represent eruptive tensions between mother and daughter (or girls and another girl). In the matricide works, the viewer can take the position of the mother or daughter or both—or simply the voyeur. McCarty's revealing of the pubescent girls' sexuality by making their clothes partially transparent or open at erotic zones reminds the viewer of the girls' emerging sexuality and puts the viewer in the position of a voyeur. For the female viewer this partial revealing of the girls' bodies possibly provides a point of identification as well. But what is there to make of these themes of eroticism and violence when applied to the mother-daughter relationship? There is, of course, the classical Jungian idea of the Electra complex, which Jung defined as a fantasy where a girl desires her mother dead so she can claim womanly sexuality and the father for herself. McCarty's girls can be considered Electras, as they have been, for instance, by critic and psychoanalyst Josefina Ayerza.[17] This seems, though, only one layer of interpretative response to these complex and creepy works.

For me McCarty's works raise a number of other, less standard questions and thoughts about woman-on-woman violence, ones that aren't governed by the relationship to the father. One

observation has to do with aggression and the fear of retribu-
tion, returning us to Klein's writings on the close interaction
of love and aggression in the relationship between mother and
infant. To generalize: the infant sees the mother (or her breast)
as an object of nourishment at times and of deprivation at
others, and so feels both love and rage. Klein writes eloquently
of the infant's fear, while enraged, of a maternal reprisal that
could derive from even a baby's fantasy of violence toward the
mother. And what critics have not yet discussed with regard to
McCarty's work is this idea of reprisal. In fact, most of the *Mur-
der Girls* portrayed by McCarty are either imprisoned or dead.
In terms of the girls who committed murders, their portraits at-
test to their crimes but also their reprisals from the justice sys-
tem. Surely this realization is part of the discomfort the viewer
feels when identifying with McCarty's representation of a narra-
tive of female rage, violence, and punishment. In other words,
if the viewer of a given drawing identifies with the girl's rage,
the viewer is also implicated in the narrative of punishment and
by extension could feel the potential shame and entrapment of
punishment as a shadow of the more satisfying feeling of rage.
This is, of course, in addition to the larger shadow and its corre-
sponding emotions—the horrors and desires of matricide. And
"shadow" is not a random metaphor here: most of the drawings
loom so large (say, 8 × 4 ft.) that the viewer herself is in the po-
sition of the shadow that could be cast by one of the girls, were
she to materialize into three dimensions.

One other mother-daughter question wonders what this
ongoing project has to do with McCarty's feelings when she
adopted (with her partner Christine Vachon) a baby girl from
China in 1999, a short four years after starting the series. I asked
McCarty if there's a connection—if this work involved looking

at the darkest aspects of the mother-daughter relationship in order to extend the whole subject for herself far beyond the saccharine terms usually enclosing it and perhaps, as well, deeply within her own complex emotions. McCarty replied: "Possibly the fact that I spent so much time for four years on the [relationships between] mothers and daughters made me open to the idea of being a mom. I had to revisit aggressions and tensions between mothers and daughters—I had to settle some of those issues."[18]

A more easily established personal connection is the style McCarty uses in the drawings. McCarty had the idea for the series months before she could figure out the medium. It wasn't until visiting her parents' house and rediscovering a pencil-drawn self-portrait she'd done at age sixteen or seventeen in typical high school drawing manner that she found the medium and style to realize the idea. However, McCarty began the portraits at approximately 8 x 4 feet, much larger than the usual high school drawing size, thus signaling their status as art objects and positioning the girls as larger than life. More recent works are even larger, mural size—10 x 14 feet—and leave questions about what the expanded figure size connotes: heroism, nightmare, horror film?

To Melanie Klein, symbolization and an understanding of it aids integration, and integration is exactly the opposite of committing a crime; instead, it is the underpinning of mental health. Klein tends to write about art-making as a transparent process of realizing symbols, but I see it as a much more self-conscious exploration of representation and display. Still, though, as with any visualization process, the creation of symbols is involved. Framing the topic of parental murder so definitively within representation—in fact, as art—would in Kleinian

terms link it to the forming of symbols, a process Klein so eloquently argues sublimates anxiety and rage.

At times, I want to turn away from the excess these larger-than-life drawings illustrate. I am tired of reading the stories accompanying them about stabbing, strangling, shooting, burning. Matricide. Too dark, too grim. I'm really more interested in the everyday occurrence of female aggression—in how and why and in what context it is articulated. Why focus here on these sad, inarticulate murderesses then? Well, they are the flip side—or at least a different side—of the same issues. In their excess they recall all that is negotiated daily to feel rage and *not* to murder; they remind the viewer of feelings of love and hate that are negotiated and, when possible, integrated in mother-daughter relationships. But they do so by referring to the fatal outside of what is common.

In fact, very, very few teenage girls commit homicide today in the United States. The Bureau of Justice Statistics, part of the U.S. Department of Justice, reports that in the entire country in the year 2000, for example, sixty-two white females aged fourteen to seventeen and fifty-nine black females of the same age were found guilty of murder (BJS divides its statistics by race). (That's a rate of 1 per 100,000 in the white teenage girl population and 4.9 in the black teenage girl population.) Teenage boys are much more likely to commit murder: the rates for 2000 are 7.9 for white male teenagers and 62.8 for black male teenagers (actual numbers: 514 and 795, respectively).

In the eighteen to twenty-four age group for the year 2000, white females committed 179 homicides, black females 253, white males 2,549, and black males 4,048 (rates were 1.8, 12.6, 23.9, and 205.8, respectively). In general, looking at homicide

statistics for all ages from the years 1976 through 2000, it's clear that most victims and perpetrators have been male: 76.4 percent of victims were male, as were 87.9 percent of offenders. And looking at gender-to-gender crime pairings, the most rare are female offender/female victim—only 2.6 percent of all homicides in those years reflected that relationship (as compared to 65.2 percent for male offender/male victim). For women who killed someone of either gender, 29.8 percent of their victims were family members. In terms of method, for all murders committed by women, poison was the most common means used: 37 percent of murders by women were effected using poison (as opposed to only 9.6 percent using guns).[19] What the statistics reveal is that across the country, female-on-female face-to-face violence resulting in murder, with the perpetrator being a white teenage girl, is rarer than a hen's tooth.

That's in the real crime world. By contrast, in fantasy, murderous rage, female-on-female and otherwise, is more commonplace. Representations of this and analogous female rage are less so, although these are growing more frequent in art and mass culture. In this context, we've considered Uma Thurman's role of Beatrix Kiddo as a murderous, vengeful female warrior in the *Kill Bill* movies. Bea has rationality and reasons, as well as pleasure, when she kills, but Go-Go, the seventeen-year-old girl bodyguard of one of her antagonists, is mad for violence. Go-Go (*Kill Bill: Volume 1*) dresses in a Japanese schoolgirl's uniform and giggles while she enjoys her murders. What—in the cultural world—is the representational function of teenage perpetrators? Perhaps adolescence functions as an allegorical site for risk, turmoil, the threat (to self and other) of the irretrievable effects of violent acts, and the loss of reason. For adults, whether creators or viewers of these representations, adolescence is a place to go

to recover rage—and in the case of the *Murder Girls*, the fantasy of matricide.[20]

Particularly in mass culture, there has been a turn to positive portrayals of women's aggression, as we've seen. From the 1980s spread of grrl culture to recent movies like *Lara Croft: Tomb Raider* (2001) and *Lara Croft Tomb Raider: The Cradle of Life*, 2003) starring fighting women, the representation of aggressive women has gained an increasingly (although unevenly) positive slant. Instead of the traditional narratives about aggressive women being punished in the end, our culture is now serving up stories in which aggressive women are rewarded (as in the movie *Erin Brockovich*, 2000).

In this context, Marlene McCarty's portraits of *Murder Girls* look strangely retro. (It is worth recalling here that the girls' crimes date mainly from the 1970s and 1980s, with Marlene Olive's from 1975. McCarty graduated from high school in 1975 and college in 1979, and she is just a few years older than her subject Marlene Olive—so harkening back to the 1970s as she does with the Olive crime story is also a return to her own late adolescence.) In general, the *Murder Girls* are not depicted as exhilarated fighters like Xena or Chyna or Lara Croft. They are not shown in the act of aggression. Usually they slump or hunch (as in the portraits of Theresa Bickerstaff and Karin Aparo). But, although passive, they are not pictured as dejected. Rather their postures illustrate everyday teenage girls' self-consciousness and unease.

Their poses are mundane but their crimes are not, yet they're presented in a matter-of-fact way to stress the quotidian possibility of their violence. What is it that is compelling about the seemingly everydayness of these aggressions? Dana Crowley Jack's book *Behind the Mask: Destruction and Creativity in Women's*

Aggression, for which she interviewed sixty women about their aggression, was published in 1999. Most of her interviewees had difficulty expressing their aggression in constructive ways. This publication date is a useful reminder that while animated Powerpuff girls and buffed Angelina Jolies are punching out enemies on the screen, most women are still expressing their aggressions indirectly, as they were socialized to—through gossip, nonparticipation, interiorizing, hiding, manipulating, and as always fantasy. Women are above all still turning their aggressions in on themselves—through gorging, anorexia, self-mutilation, and other forms of self-destructive behavior. Men need fantasies of outward aggression too, but it could be argued that women need them more. Or viewed more in terms of power hierarchies than gender, it could be argued that whoever is not at the top of the pyramid particularly needs fantasies about acting aggressively, and at this point there are more women than men in that not-at-the-top category.

But the girls depicted by McCarty committed extreme violence and whereas in reality their harmful acts brought them jail time, we are meeting their portraits in the realm not of prisons but of art-world representation. In this realm their actions are mediated by McCarty's symbolization of them through drawings and words. The artist—and, by extension, the viewers—are the survivors, processing these works and related feelings while standing in cool, white-walled galleries or sitting in comfortable chairs reading illustrated books like this one. For McCarty's subjects, negotiations with a parental figure are stopped by murder—and the internalized process of integration is hampered too, we suspect; for the viewers, symbolically it is not. The viewer is privy to a fantasy of aggression and reminded at the same time of her own ongoing processes of aggression and

integration. Olive is a particularly tragic figure (as are each of her parents!) because she and her boyfriend murdered her beloved and loving father as well as her hated (and possibly verbally abusive) mother, so her loss is a palpable part of her story. But the destruction of any parent is profound, plunging the (imagined) subject into the depression of annihilating the parent without an escape from guilt into reparation. And this is the story/fantasy McCarty returns to again and again and we viewers with her, but through the acts of viewing and symbolizing, we are *not* held in the prison of guilt.

Let's consider further what Klein has written about integration and symbolization. Most interested in the infant's relationship to the mother and its subsequent impact on emotional development, Klein describes an early process of ego development that starts with and always contains a negotiation with ambivalence. For the infant, fantasies of destroying the breast and fears of retaliation or being devoured by it (or losing the good breast along with the bad due to its own imagined destructive powers) are easily introjected. So from early on, aggression is experienced as something that can be directed outward and/or inward. Through different phases, rage is felt—with fear, mixed with guilt, as the spur for reparation, or along with a desire for reparation—but it is never entirely absent. Rage (an integral emotion Klein links with variously hate, aggression, and envy) can be balanced by love, by a compassionate understanding of the other as neither demon nor deity, by gratitude, by reparation. But rage never completely disappears.

It is Klein's emphasis on the never-ending processes of negotiating boundaries and of balancing persistent rage and aggression with love—indeed on the coexistence of love and hate

in the heart—that makes Klein's work so attractive and so applicable to experience. Her writing about infant development becomes a compelling metaphor for the everyday emotional negotiations of adults—with the introjected mother, with the self, with other people in general. We fear our own rage because in its most murderous form it could deprive us of the metaphoric good breast along with the bad, for they are one and the same.

Olive's crime fits well into this Kleinian ur-story. We might see Olive's mother as symbolizing the bad breast and her father the good one, but the two together are the combined parent of Kleinian theory, the focus of love and hate. The good and the bad are killed together. This layer of interpretation is alive in the pathos of Olive's story. But reading through the lens of McCarty's words and drawings, we see McCarty's presence as also alive for us in the emotional process of viewing and interpreting—she is the one who at the most concrete visual level is representing and symbolizing.

Not surprisingly, Klein relates symbolization to anxiety. As Juliet Mitchell explains, Klein "proposed that anxiety produced the movement within the development of symbol formation. Anxious lest its negativity destroy an object, the infant moves to another which thus relates symbolically to the one left behind."[21] For Klein, the primary object is the breast/mother (even the penis can function as a substitute for the breast). Klein writes in her 1930 essay "The Importance of Symbol Formation in the Development of the Ego":

Side by side with the libidinal interest, it is the anxiety arising in the phase that I have described which sets going the mechanism of identification. Since the child desires to destroy the organs (penis, vagina, breast), which stand for the objects, he conceives a dread of the latter. This anxiety contributes to make him equate the organs in question

with other things; owing to this equation these in their turn become objects of anxiety, and so he is impelled constantly to make other and new equations, which form the basis of his interest in the new objects and of symbolism.

Thus, not only does symbolism come to be the foundation of all phantasy and sublimation but, more than that, upon it is built up the subject's relation to the outside world and to reality in general.[22]

Psychoanalyst and critic Julia Kristeva, writing about Klein, emphasizes the connection between matricide and symbolization:

It is by separating from the mother, to which the self was once linked through an initial projective identification that the self learns to engage in reparation. At that point the self can rediscover the mother, but not as it once knew her. On the contrary, the self never stops re-creating the mother through the very freedom it gained from being separated from her. . . . Pity and remorse, which accompany the reparation of the lost object, carry the trace of the imaginary and symbolic matricide that reparation constantly evokes.[23]

An artist's representations are not simply translations of unconscious symbols and symbolization to paper though. Still, it is not too much of a leap to see in McCarty's repeated portraits of girls committing matricide and other murders—and in fact in my own writings about them and in the art world's exhibitions of them—an anxiety about as well as a desire for a matricide that would transform through symbolization into representation. Yet McCarty's focus is not on the acts of murder but on the girls themselves. Ultimately, the works provide a release of anxiety derived from fantasies of matricide because the focus is on the one who survives, who represents, who tells the story. McCarty is the detective and the narrator of the murder story.

While Olive has stepped over the line into destruction and murder, McCarty has not. She—and, at her invitation, the

viewer—is still involved, by contrast, in processing, in integration, in fantasy. (Olive, wherever she is, may be as well, but her present self has been effectively erased from the representational scene—and replaced by McCarty.)

To return again to the subseries within the larger *Murder Girls* project entitled *Marlene Olive, 33 Hibiscus Way, Marin County, California, June 21, 1975* is to return again to the ever-evolving, ever-remembered emotions of parental murder (whether in actuality or, by far more common, in fantasy). But in this subseries, unlike psychoanalytic theories such as Klein's, linear narrative is denied even as family drama is evoked. It's confusing—purposefully so. The date of the murders was June 21, 1975. The first drawing, with the three Olives as described, is subtitled *Jan. 1, 1975, New Year's Day*, almost six months before the crime. The second, which presents the father in a suit, seated in the center, with Marlene and her boyfriend Chuck on either side, all three with their genitalia showing through their clothes as if those areas had been x-rayed, is subtitled *Dec. 21, 1974*, as if capturing a harmonious gathering on the couch just before the holidays. The third mural-sized drawing, showing three younger Olives, is dated *Aug. 18, 1973*, almost two years before the crime; the fourth, with three explicitly teenage Olives, is labeled *June 17, 1975*, only days before the crime (here Olive wears the same flat expression as in all the drawings except on one of the three faces, where she has her mouth open as if yelling). The fifth (figure 3.5) is dated *June 20, 1975*—one day before the murders—but it shows a younger mother Naomi holding a baby Marlene along with a teenage Marlene and, the viewer supposes, Naomi at the age of her murder. The last mural, of two teenage Marlenes and one younger one, is dated

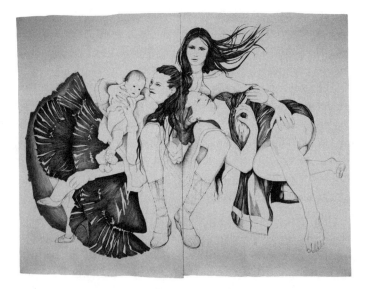

Figure 3.5
Marlene McCarty, *Marlene, Naomi, June 20, 1975 (Marlene Olive, 353 Hibiscus Way, Marin County, California, June 21, 1975)* one of six murals, 2003, graphite and ballpoint pen on paper, 10 × 14 feet, mural #5 of series.
Courtesy of Sikkema Jenkins, Co., New York

March 26, 1975—a few months before the murders. The continuation in time of a family drama of love and sex begun much before the murders seems to be a theme. But equally any logic in such a narrative is forbidden by the juxtaposition of almost nonsensically precise dates with shuffled time sequences implied by the figures' ages and the out-of-order drawings' subtitle dates. And the passion! Again, it's in the lines. In drawing #5, the lines marking the full spread and energy of Naomi's long, pleated skirt arching upward and to the viewer's left balanced by

teenage Marlene's hair flying to the other side provide intensity, balance, and conflict—above all, emotional impact.

The sexuality of the teenagers is emphasized in these figural montages. Although the younger as well as the older Marlenes all have visible nipples, the adolescent Marlene and her boy-friend are more eroticized through their poses and what they reveal. These figures contrast with the less eroticized parents as well as the younger Marlenes. A connection between lust and aggression is never subtle in the *Murder Girls* portraits and stories.

But what is the connection? Lustful adolescent hormones fueling violence? Or a Kleinian dialectic between lust and aggression (itself growing out of the Freudian belief in eros and Thanatos as our two most basic drives)? Or is the teenagers' lust set in opposition to the mother's (verbal) aggression—as McCarty's texts often suggest? What seems so visually obvious, even overstated by the transparency of nipple and genitalia coverings, reads, in this more contemplative montaged viewing of the family dynamic over time, as a more complex process. In McCarty's works involving time, there is something undefined and jerky in her depiction of her subjects' progression to sexual maturation. Only the wall texts link these visuals with violence. Here, a generalization by Laplanche and Pontalis is helpful: "Psycho-analysis has gradually come to give great importance to aggressiveness, showing it to be at work in the early stage of the subject's development and bringing out the complicated ebb and flow of its fusion with, and defusion from, sexuality."[24] There is a relationship between the subjects' lust and aggression, but it seems open-ended.

In everyday usage, lust connotes libidinal energy and also wanting and getting (as opposed to desire, which can have the connotation of merely wanting the unobtainable). Lust

connects to agency, to goal-oriented action: I want therefore I go after therefore I get. And the "going after" as often as not involves aggression, specifically the aggressive acquisition of power, to whatever degree. One of Dana Crowley Jack's interviewees, Maria, a minority rights lawyer, is quoted in *Behind the Mask* as saying: "Aggressive means strong to me. I don't see it in a negative sense. I see it as a positive attribute that I want my daughter to have. To me, it's a positive thing, it's good if you're aggressive. I don't think we should dress it up and call it assertiveness or whatever. I think we should call it what it is."[25]

I agree, but I wonder, why not "assertiveness"? I think one reason is because assertiveness (while requiring a degree of aggression in its motivational mix) implies standing up for oneself within existing rules and boundaries, whereas aggressiveness implies a willingness to step over the line and the power to do so. In a circumscribed world where, for instance, women still earn significantly less than men do in comparable jobs, effective agency involves stepping over the line, violating that inequality in pay scales and other structures—in short, aggression.

Easier said than done. As Klein explores, even while aggression (and therefore its potential fueling of action) is always with us, so is fear of retaliation. The fear is of retaliation from either the inside or the outside of ourselves—or both. Because of the possibilities of retaliation and loss, we are afraid of our own capacity for rage and violence. Adolescence, in the realm of representation, becomes a fascinating, allegorical state of being where aggression is volatile; where stepping over the line can slip into violence and even murder; where a coming into agency can mean a coming into violence; where retaliation is prison; where symbolization and the potential for representation of this state is elusive (hence the expression "mute rage"), particularly

for teenagers, but where control of rage and its fantasies can be found for adults (the artist, the viewers).

It is important that the girls McCarty chooses to portray in the *Murder Girls* series did not kill in self-defense. Journalist Patricia Pearson in her book on women who murder, *When She Was Bad*, shows that cultural myths of women as victims, beings who don't kill except in self-defense against others' threats of violence, are prevalent and function as a denial of women's agency and responsibility.[26] If women are not always to be cast, culturally and experientially, as victims, then we must own up to—and, to put it plainly, own—our aggression. But owning it means also accepting that aggression does not always (or often) come in neat packages—it can spill into unjustifiable violence. Yet, in some cases where McCarty portrays a daughter who has killed her mother, the viewer suspects if not assaultive abuse on the mother's part then indirect abuse, and the corresponding texts underline this suspicion with tales of girls locked in closets and other overly severe punishments. So there is, in some of the stories, still an element of self-defense. Still, we can say that the remorse that is missing in the *Kill Bill* movies and seemingly (at least in McCarty's telling) in the original true-crime stories behind the *Murder Girl* series is present for the viewer.

McCarty in her *Murder Girls* works insists on a connection between ordinary adolescent unhappiness and brutality. As allegories, they function strongly and effectively. In addition, the *Murder Girls* portraits lead me to think about and feel my own rage and accompanying emotions but at the safe distance of viewing art. They remind me, too, of mystery novels, which I read often. Detective novels as a genre, it is said, function to allay anxiety about death—the murders usually happen offstage, early in the book, and to relatively underdeveloped

characters, whereas the protagonist, the detective, whom we as readers get to know well, conquers death and evil through reasoning. In these books there is a splitting between the murderer (evil) and the detective (for all his or her foibles, good) and we identify with the detective. There's usually not a lot of ambiguity. In McCarty's project, though, we often identify with the murdering girl; self-idealization is not allowed and the internal scars of matricide fantasies and of aggression in general begin to throb. But we still displace anxiety, this time through identifying with the artist's symbolization and representation. Our conscious fantasies are articulated, so too perhaps our unconscious fantasies, depending on how deep our involvement with the works; we see and feel the dynamic between aggression and love in play, but we are safe on the other side of representation.

Safe, but not as distanced as when viewing the comic-like *Kill Bill* movies, and definitely not comfortable. Again, the reference points in the *Murder Girls* works are not fictional—they are not novels, they are true crime stories. I can't forget Marlene bashing her mother's head in with a hammer. The more I believe these details of female-on-female violence, the more they remind me of the intertwining of rage and sorrow. This is not the cutting-loose, no-guilt revenge enjoyed by the female murderers in the *Kill Bill* movies. These emotions are closer to home. The viewer feels uneasy in her body. The rage powering fantasies of matricide also comes with remorse at the mere thought of losing the mother. Emotions—particularly around matricide—are complex and roiling. To Klein, fantasies of killing the mother are inseparable from desires for reparation and reunion with the mother. Safe at the end of the visual and verbal storytelling of true crime, then, means a reminder of the comfort of reparation. But reparation itself always bears the scars of matricidal

fantasy. There is no purity (not even with the reassurance that the viewer is not the killer and the woman murdered is not the viewer's mother, because the viewers' own murderous fantasies have been tapped). No pure comfort. No pure discomfort for viewers either, because the fantasy of reparation is tapped as well. But we are left with the aggressive and integrative power of symbolization—and the embrace of ambivalence in love.

4

UNBUTTONING
SEXUALITY:
ZANE AND
KARA WALKER

In exploring the layered, affective reception of Marlene McCarty's work on violence, we landed strongly on two points: the power of symbolization and the power of the artist to raise a wide range of emotions in and around aggression and to function as a point of identification for the viewer. These places are apt launching pads for a consideration of Kara Walker's art and her address of aggression, desire, memory, and a shared racial imaginary.

First, though, I want to raise a broad cultural context that includes Walker's work and that has, however, been neglected by her critics. It is also a fruitful one for the sequence of large questions posed by this book. In the last chapter we questioned how a full acceptance, through engagement with representation, of one's own aggressive capacity could function for the viewer. In this chapter we push further on issues of fused libido and aggression to combat internal and external cultural taboos—in this case, about the articulation and representation of feminine desire. And with this exploration we raise issues of aggression as it pertains to the historically specific subgroup of African American women.

From the 1990s through today among a far-flung set of African American female producers, there has been an aggressive reclamation of public self-expression of sexuality, fantasy, and related representations. To a much greater degree than in previous historical decades, African American female artists and writers have been creating new sexualized images and word-pictures of African American women. These producers work, display, and exhibit in an extremely diverse range of cultural subsets. Their eroticized images and words have been celebrated and decried, have garnered major audiences of African American women and others, and raise significant questions.

Aggression is a key factor in these cultural questions. A primary one is: do African American (and other women in like, although in historical terms, differently determined circumstances) need to self-consciously articulate and deploy their aggression internally as well as externally to break carefully taught and internalized cultural taboos? What, then, does the representation of sexual fantasies and works related to the erotic in public forums have to do with this, and conversely how does it go beyond, far beyond, such a therapeutic function? In groups where those taboos have been particularly repressive, does the success—in distribution, in the impact of the communication, even in money earned—of imaginative sexualized images, generated by and for members of the group help unleash that aggression and break those internal seals? At the very least do these new images contribute to new stereotypes that are more permissive for women? Do they also or alternatively provide imaginings and raise issues in excess of and not translatable into new stereotypes? What might the benefits be in terms of individual and/or subgroup energy, force, ambition, and survival of an increased dimensionality in the public articulation of sexual fantasy? Is aggression involved in differentiating these new representations from already existing sexualized images of black women? Larger than this reactive question, what are the potential functions, for a given subgroup and, in general, of public self-representation as aggressive and libidinal?

These questions touch on the work of producers as diverse as Kara Walker, artist; Zane, writer of mainstream erotica written for African American women; Tricia Rose, critic and author of *Longing to Tell: Black Women Talk about Sexuality and Intimacy*, 2003, and other books; and Jill Nelson, journalist and author of such nonfiction books as *Volunteer Slavery* and *Straight, No*

Chaser. In 2003, Nelson published her erotic first novel, *Sexual Healing*; in 2009, her second novel, *Let's Get It On*, was published, a series of adventures about black women founding bordellos staffed with men to sexually pleasure African American women. The popularity of these cultural producers matters as does their representations, particularly in the context of a group, African American women, who historically have so often expressed their feelings of invisibility. In contrast, these producers and their representations—in very different ways—of African American female sexuality are highly visible. The producers derive primarily from the "post-soul" generation, those born, as critic Mark Anthony Neal puts it, between the 1963 March on Washington and the major legal challenges to affirmative action starting in 1978.[1] Rose was born in 1963, Zane in 1967, and Walker in 1969. But they also include women from other cohorts: Nelson was born in 1952, and a number of black female dirty rappers like members of Yo! Majesty were born after 1978. Still, the post-soul generation is a useful historical marker for the criticality and self-reflexivity of a range of producers creating now. They share an awareness of a mass media culture protean in its forms and distribution—and a creative skill in exploiting its possibilities.

It's not clear though why such an (unofficial, not termed as such) movement among black female producers concerning the public self-expression of sexuality and related issues rose to prominence in the 1990s. One possible reason for this cultural turn may have been a pushing against the prevalence of misogyny among mainstream black male rappers, an argument most easily or at least most directly made about early female hip-hop artists like Salt-N-Pepa, still perhaps a general influence too at present. These female rappers intend to use a strategy of

self-representation as sexualized for the purposes of their own pleasures and as a counter to the sexism of some music and videos by male rappers. (Debated, of course, is how much overlap there might be between the two types of representations.) But for most of the prominent female producers in this erotic-exploring context, the stated motivations are expressed as positive more than as negatively reactive. As Zane puts it with proselytizing zeal, "Well, quite honestly, I believe that sex is the area most women feel uncomfortable talking about [or] to be demanding about in their lives. . . . And I feel I can liberate women sexually and once they become more liberated and ask for what they want in the bedroom, that ought to help them career-wise, family-wise and everywhere else. That's what I believe."[2] Not all the producers under discussion in this chapter explicitly state this motivation—certainly Kara Walker does not—but all raise a related set of issues, as we'll discuss.

While to naysayers, the fact that the sexual content in the work of these female artists, writers, and musicians likely helps it to sell so well might take center stage, sharing that stage and that central position for many African American women, however, is a goal of sexual liberation. That is, sexual liberation both in fantasy, picturing to oneself without excessive censorship (hence the issue of deploying aggression to break internal taboos), and in experience, generating and also asking a partner for what one needs and wants sexually. As book editor and African American bookstore manager Blanche Richardson has explained, referring to Zane's erotic novels:

The novels play an active role in brushing away the cloud of conservatism that shadows black female sexuality. . . . We have been denigrated in terms of our sexuality since slavery, when we had no control over our bodies. . . . That's a legacy that has stayed with us until today. We've

been hesitant to speak openly about our sensuality even though we know everybody does it. On us it looks a little different. We're looked at as easy, bad, sluts. We tend not to verbalize it or reinforce it in our literature lest we play into those stereotypes.[3]

There are, of course, precedents before the 1990s among cultural activists in countering this repression. In a landmark 1984 essay, Hortense Spillers declared: "Black women are the beached whales of the sexual universe, unvoiced, misseen, not doing, awaiting *their* verb. Their sexual experiences are depicted, but not often by them."[4] She refers to the long history in the entertainment industry and elsewhere of eroticizing and sexualizing black women for the male gaze. And it's hard to separate this objectification from black women representing themselves sexually since there are cross-influences concerning who is performing for whom (such questions have often been raised with a range of female performers who explore feminine sexualities, Madonna, being a prime example; I'm not interested in untangling this perhaps welded-together knot—objectifying the self for public consumption versus or even along with being objectified differently by others also for public consumption—though, and instead in focusing on how these new representations might function affectively for their producers and audiences).

There are forerunners to those African American women currently concerned with self-representation of sexuality in public: blues singers such as Bessie Smith and authors including Zora Neale Hurston and Audre Lorde and critics like Spillers. However, as a widely shared priority, self-created, freewheeling, publicly expressed sexual fantasy has only come to the fore since the 1990s in a broad spectrum of African American female cultures, appealing to an impressive range of (at times overlapping) audiences—for instance, churchgoers, art museum attendees,

criticism readers, erotica fans, and journalism/memoir readers. In 2005 Oprah produced, and Halle Barry starred in, a TV movie of Zora Neale Hurston's 1937 novel *Their Eyes Were Watching God*—no accident that that plot, celebrating its protagonist Janie's coming into her own sexually after a bad but respectable marriage and only by rebelling against the peer pressure of respectability, was revived during this cultural wave. As *Chicago Sun-Times* columnist Mary Mitchell asserted when the movie was aired, "Hurston wasn't afraid to admit that black women, like all other women, need to express this side of themselves. . . . black women need fantasies too. . . . Black women don't talk about sex enough."[5] Although the reader sex survey has for decades been a staple of major white-oriented women's magazines, *Ebony* didn't publish its first one until 2004.[6]

In the newly coined images, African American women are aggressive about articulating and imaging their sexualities and works dealing with complex issues of their sexualities. In doing this they are creating ones that trip and break the respectability wires many feel are installed so tightly inside and outside, so to speak. In two large studies, funded by the National Institute of Mental Health and executed in 1984 (involving 248 women, ages 18–36) and 1994 (involving 905 women, ages 18–50), psychologist Gail Wyatt (the first African American woman to be licensed as a psychologist in the state of California) found in her detailed sex surveys of African American, Latina, and white women, that of the African American women polled the majority came from homes where sex and sexual education were not discussed beyond the prohibition, "Don't do it till you're married." Typically, silences and prohibitions went further than the subject of intercourse as well, Wyatt found. Speaking of the African American women she and her colleagues interviewed,

she reports on the topic of masturbation: "A majority of the African-American women (90 percent) did not recall their parents saying anything about masturbation during their childhood. Those who grew up in a home of two parents rather than one were more likely to remember being told not to masturbate, 8 percent received a negative message, such as 'It is a sin' or 'This is something that you just don't do.' No one recalled their parents saying that masturbation was allowed in their home. The remaining 2 percent were told something other than the above."[7] (As with psychologist Dana Crowley Jack's material analyzing her interviews of women of different races about their aggression, I include Wyatt's here as a reminder of the differences between theory—often functioning in academia as expansive, rapidly changing, and abstract—and psychological data, also subjective and interpreted, about lived experience—often less easily negotiated than theory, certainly more corporeal in its challenges and pleasures.) Comparing black and white teenage girls' experiences, when women were asked to recall their motivations for the first time they had sexual intercourse, Wyatt found, in this study published in 1997, the top reason for African American teens had been "curiosity and the desire to find out what sex was all about," whereas for white teens "having sex with steady dates" was the most common. For both groups the average age for losing one's virginity had been sixteen-and-a-half years old.[8]

It is worth emphasizing here our shared knowledge that the United States is only a handful of generations past the time of slavery. As scholar Patricia Hill Collins and others have discussed, the labeling of African American female slaves as wanton and hypersexual was used to justify commonly perpetrated rapes by white men, shifting the "blame" to female slaves'

supposed proclivities.[9] In the decades after Emancipation, this hypersexual stereotype persisted and continued to be used to justify sexual crimes against black women.

As a result, African American cultural efforts to represent African American women in public as having the utmost respectability were seen as essential to survival and to warding off violation and violence. For instance, in the early twentieth century, influential black church movements and African American women's clubs quickly moved to promote images and comportment of respectability among and for African American women; this was done to counteract the obviously dangerous myth of sluttishness with the embodiment of virtue and thereby uplift the race. Collins describes how in the first half of the twentieth century "middle-class Black women, especially those within the Black Baptist church and within the Black Women's Club Movement, refuted the controlling image of the jezebel by advocating a 'politics of respectability' characterized by cleanliness of person and property, temperance, thrift, polite manners, and sexual purity."[10] While it's relatively easy now to decry the straightjacket of respectability that was placed on African American women, one that created societal limits difficult for many decades of women to extricate themselves from, it must be stressed how historically it was also an effective weapon and protective setter of boundaries that aided black women. Consider the large number of African American women from Emancipation up to World War II who worked in domestic service (in 1920, e.g., 46 percent of employed African American women worked in domestic service whereas only 20 percent of all employed women did that year). "Domestics" of color tended to work in white people's homes—that is, relatively unprotected and invisible private workspaces—placing them in situations where they were

vulnerable to sexual as well as economic abuse. In this context of sexual vulnerability, the black church-grounded admonitions to button up and thus visually identify as respectable (as directly opposed to hypersexual and available) can be understood as legitimate and useful.

As Jill Nelson and others have reported, while the civil rights movement of the 1960s and 1970s opened up more economic opportunities for African American women, negative stereotypes and the reactive and strictly enforced politics of respectability still persisted. However, during these years repressive dicta were at times in new forms—for instance, in the Black Nationalist prescriptions for women to perform a covered-up subservient role.[11]

The post-soul generation, though, was raised by civil rights–era parents, and they and other cohorts producing in the 1980s and 1990s creatively explored a public expressiveness that movement had ushered in (albeit in different ways than the first wave of civil rights activists). At the same time, the commodification of black, urban, male hip-hop culture became a global phenomenon, and with it a clichéd, misogynist representation of black women as hypersexualized accessories to the male artists. Counter to this (with some slight overlap as well) and perhaps influenced by the indie grrl black rappers and in general the Girl Power movement of the 1980s and its consumerist spread in the 1990s, African American women sought to expand boundaries of their own public sexual fantasy and articulation. As a result, an explosion of erotic representations by female African American producers occurred in the 1990s.

In this light, it is possible to see (as we did in chapter 2) a specific cultural function of aggression, as it works with lust and sexual fantasy to burst through cultural prohibitions. Aggression

can also work together with libidinal energy to combat interiorized taboos, and of course internalized negative stereotypes. In Freudian terms, aggression can be of great use to the id, a help in fueling lust, in unleashing lustful fantasies, and even in reaching out and connecting with the object of lust, in conjunction with the reality-negotiating ego. Aggression can help the id at times overrule the superego. As Freud has observed about the superego, "it becomes the vehicle of tradition and of all the time-resisting judgments of value which have propagated themselves in this manner from generation to generation."[12] So the superego is the place of not only individual conscience but also traditional cultural enforcement. In opposition, libido fused with aggression can internally combat these negative cultural pressures to unleash conscious desire in new ways. Earlier, we considered some functions of aggression internally and externally in breaking through negative cultural stereotypes of older women of all races as asexual and undesirable—specifically, the traditional African American personification here, as many commentators have noted, would be the asexual mammy figure, yet another disempowering stereotype. The hypersexualized black woman is the other side of the same negative stereotype—either way, black women are represented as functioning in service to (historically white) male desire as opposed to a self-expression of sexualities and desires. And these expressions are not simplistically mirrors or confessions or in the main self-portraiture, but instead complex and publicly displayed representations. To consider their functions, their different viewing and distribution contexts must be analyzed as well. Accordingly, and to explore these complex questions in depth, I focus here on the work of two provocative producers—one from mass culture, Zane, and the other from the art world, Kara Walker.

Zane

Zane's erotica is playful and inviting. I'm interested here in the ways Zane's writing encourages play, in D. W. Winnicott's sense, as creative wandering and dreaming in a transitional space between public and private, for the reader. In her books, Zane describes scenes and, a particularly visual writer, she pays great attention to her characters' attire and of course the graphics of the erotic encounters. Her novels are not about intricate portrayals of personalities and emotions. They are quick, entertaining reads, whose sketchiness and suggestiveness leave room for the reader to imagine and play. In thinking about the relationship of play in Zane's work to public and private sexual self-representations, the psychoanalytic writings of Winnicott are helpful.

Play for Winnicott is a very serious matter, the cornerstone to a full life and to creativity:

It is assumed here that the task of reality-acceptance is never completed, that no human being is free from the strain of relating inner and outer reality, and that relief from the strain is provided by an intermediate area of experience . . . which is not challenged (arts, religion, etc.). This intermediate area is in direct continuity with the play area of the small child who is 'lost in play.' . . . we can acknowledge our own corresponding intermediate areas, and are pleased to find a degree between members of a group in art or religion or philosophy.[13]

He continues, "This intermediate area of experience . . . throughout life is retained in the intense experiencing that belongs to the arts and to religion and to imaginative living and to creative scientific work."[14] Significantly for the larger discussion here about the public representation of a sexualized self (and issues related to the private, sexualized self), play as a transitional

space for Winnicott between the me and the not-me can be seen as a space of mediation between the private and the public. The intimacy of reading shared and popular stories of sexualized characters, then, can function in certain cases as a kind of play; with regard to Zane's work, for the African American female reader, her primary intended audience. In Zane's case, the content of her books often includes play as well. But it's not solely the fact that Zane is playful or her characters sometimes are that matters, but instead that these quick and graphic— while also absorbing—reads leave room for the reader to play, wonder, and daydream. It's hard to say because I'm not a member of the target audience, although I enjoy Zane's work, but I'd hypothesize that Zane's characters are too two-dimensional to encourage deep identification. Instead it's the romp, the relationships and sex between the characters, the possibilities and suggestions, the jokes shared with readers that combine to open a space of suggestion and play. There is a social aspect to reading Zane: in contrast to erotica to be read only in private, Zane's books can be read on buses and at the workplace. The covers are steamy but not revealing, and her reputation although clearly linked to erotica is also mainstream. To carry her books around Chicago, for instance, while reading them, is to receive friendly comments from other women, mainly African American, fans of Zane's.

There are so many areas where reading Zane opens up transitional space, in the Winnicott sense: (1) her characters are acutely aware of creating some kind of mediation between their very different public and private lives; (2) her protagonists (eventually) carry off new erotic creativity in between their public professional lives and their private long-standing habits, which is, I think, a big part of why Zane's work is so popular;

(3) reading Zane leaves and opens space for playful wandering in the reader's own mind; and (4) there are social spaces available online and in person for Zane readers to share a celebratory attitude about an activity—reading erotica—commonly considered private.

And what might these layers of play in the spaces between private and public mean in terms of the reader's relationship with herself? Winnicott emphasizes (to parents of children, but this can also be applied to the relationship of the superego to the ego in the self) how important it is not to challenge or repress entry into and play in these intermediate areas.[15] I'd argue that at times aggression is needed to protect these crucial play areas of the psyche and also times of playing. In play, aggression pertains as well to other emotions—it's part of the mix of energies available to playing, in other words. And again, play can't take place where repression rules too harshly. Play is creativity, among other things, and the aggressive expression and protection of this transitional space can conserve or enhance creativity in the individual as well as be of societal importance for a group.

Consider the world of Zane's *Shame on It All*, where the stories of three sisters, Harmony, Bryce, and Lucinda (Lucky) Whitfield, are intertwined, along with those of their boyfriends and Bryce's best friend Collette. The characters are broadly and visually drawn. Their clothes signal the paths they're on when the reader meets them. Harmony, the oldest, who takes care of everyone and runs her own business, an employment agency, is introduced with her nails and hair freshly salon-done, wearing a new, black designer pantsuit, gold hoop earrings, and black pumps.[16] She is well-groomed and the image of classiness. (This is a recurring theme with Zane's heroines—they have to earn

their own, financially and in other ways, and their class status is hard-won and self-anointed, evidenced internally by their conduct, values, standards, and job success, and externally by their attire and self-styled grooming.) The middle sister, Bryce, who works at an investment firm, and is socially the wildest of the three, wears a tight white bodysuit reminiscent of blaxploitation movie character Foxy Brown.[17] It is significant that Bryce's sexual adventures and self-presentation are self-selected and under her control as well as imaginative; her costumes and her actions are creative, including her sex play. She's the self-designated one happily into freaky sex, role playing, sex toys, and so forth: she is playful. Bryce is contrasted with her friend Collette, who is sleeping around almost indiscriminately and whose clothing is also slavishly and inappropriately styled according to slut fashion. The reader first encounters Collette wearing "leggings and a crop top leaving little to the imagination."[18] The youngest sister, Lucky, is a medical student (expenses paid by Harmony, to be paid back by Lucky in the future) and is politically idealistic, specifically, the sister who is most into honoring her African American heritage; the viewer first sees Lucky clothed in a "Negro League baseball jersey with black wide-legged jeans."[19] Both Harmony and Lucky are at first shown as more sexually repressed (although not all that repressed) than Bryce, so we readers understand that's where they're going to grow in experience. Bryce's character is broadly drawn as slated for emotional growth.

In addition to the kind of quick but absorbed read invited by Zane's books that in itself can open up space for fantasy play, play is evident in both conventional and unconventional ways in the plot and characters of *Shame on It All*. There are overt games; the sisters compete to tell the freakiest sex stories. Less

conventionally for erotica/romance novel writing, play is also the sisters' avenue to creativity even when angry: later in the plot, they join forces to realize an elaborate revenge fantasy, including costumes, against a medical school dean who was sexually harassing Lucky. There is sex play, especially in scenes initiated by Bryce. In *Shame on It All*, there's another layer of playfulness in the book on Zane's part, when she inserts commercial breaks in the narrative for "Niagra," her ghetto-ironic version of Viagra. In contrast to these different levels of play, external reality intrudes in ways that are often threatening or painful: Bryce's original boyfriend cheats on her; Harmony becomes seriously ill. But there are also romantic novel/chick lit aspects to the plot such as when good men enter the picture as love interests. Bad relationships are never absent from Zane's books, but they are usually replaced by good, loving ones in which freaky sex continues, expands, and joins with dreams of love and marriage.

Zane's own story is one of aggressive development and control of her writing and publishing career—and of delivering her political messages. She breaks taboos by preaching sexual liberation to African American women; she uses her fame in the erotica publishing industry to provide a launching pad for strongly pitched warnings about domestic abuse and the dissemination of resource information; and she proselytizes against drug and sexual addictions.[20] More subtly Zane advocates women expressing a very wide range of sexual needs and wants and imaginings without succumbing to externally prescribed "hoochie" dress and behavior. She courts respectability in her protagonists— they almost all work hard and go to church—while also flaunting the "buttoned-up" tradition of (the image of) respectable churchgoing African Americans in making sex a high, visible,

creative, and bold priority in their lives—and talking at length about it.

A graduate of Howard University in chemical engineering, Zane is the child of a theologian and (now retired) elementary school teacher. At age thirty in 1997, when working in sales in North Carolina and living as a single mother, Zane (her for-a-long-time-secret birth name is Kristina LaFerne Roberts, but she uses her married name, which is still not publicly known) began writing erotic short stories and emailing them to friends; their responses and sending the stories around to others encouraged her to open her own site, eroticanoir.com, and eventually in 2000 to self-publish three of her novels including *The Sex Chronicles*, which as reported by Gina Bellafonte in the *New York Times* sold 108,000 copies at $22 each.[21] Zane carefully guards her privacy but shares some biographical details with journalists, especially those that seem guaranteed to enable her to perform as a mainstream point of identification for her readers. Only broad strokes are known. In 2000 she let her readers know she was living as a married mother of three and stepmother of one in a Maryland suburb of Washington, DC. In 2006 she wrote about her ex-husband's drug and alcohol addiction problems, and a couple of years later she referred in print to their finalized divorce.[22]

Her publishing history, though, is fully detailed public knowledge. In 1999 Zane founded Strebor Books International LLC, and in 2002 it became an imprint of Atria Books/Simon and Schuster (itself owned by Viacom). As of this writing in 2010, Zane continues to act as Strebor's publisher and through it publishes her own books and those of other African American authors she is interested in promoting. In addition to erotic fiction, Strebor has published explicit message books including *Breaking the Cycle: A Collection of Short Stories Surrounding Domestic Abuse*

and the Turmoil It Causes, 2005, edited by Zane, and the nonfiction sex advice book by Zane, *G-Spot*, 2007. Zane's stories have also appeared on television: "Zane's Sex Chronicles" debuted on Cinemax in September 2008.

Addicted is the story of Zoe Renard, businesswoman and married mother of two, who is a sex addict. Zoe represents a good girl/bad girl split, and is the kind of character often seen in Zane's writing, one who struggles to integrate and harmonize these two sides. With these split characters Zane deftly brings up issues of guilt concerning black women's sexuality. As critic Tricia Rose, author of *Longing to Tell: Black Women Talk about Sexuality and Intimacy*, has put it, "There is a stigma around black women's sexuality, which is often used as a marker of morality within the black community, where the church is so dominant. . . . It creates a squeamishness and discomfort around open sexual expression."[23]

Zoe's dual behavior, married and respectable on the one hand, and promiscuous and addicted on the other, has parallels in some other Zane books. In *Nervous*, the main character Jonquinette/Jude even suffers from a split personality disorder. In addition to providing for numerous sex scenes, and the opportunity to promote therapy to readers, this dualism is the strategic entry for women readers with sexual fantasies but who feel ambivalent about them or perhaps just the wildest of them. Boundaries, sanity, desire, madness, adventure, the relationship between ego and id—are tested and explored with these seemingly simple plot and character devices.

In *Addicted*, the reader encounters Dr. Marcella Spencer, a psychiatrist who appears in other Zane novels as well. It's one of Zane's recurrent messages that getting therapeutic help is an appropriate and useful thing to do, especially when dealing with, as is revealed about Zoe in *Addicted*, adult problems due

to childhood abuse. Dr. Spencer is a classic Zane heroine and is clothed accordingly: "She wore an olive green business suit, accentuated by a sexy split up the back of the elongated skirt. The suit was even more alluring due to a cluster of overlaying matching buttons. A silk floral scarf worn around her neck added an air of class, and gold earrings gave the outfit a polished look."[24]

These images of impeccable professional-class feminine grooming are pivotal in Zane's work, part of her complex and purposively only partial rebellion against what critics including E. Frances White have called the "politics of respectability."[25] Zane's positive characters may look to one degree or another respectable, they may and often do attend church regularly, but they are also capable of directing their own actions toward a sexual freedom that is the cornerstone for other freedoms as well. They are responsible in the work world and playful sexually. Their control and authorship of this sexual playfulness is often the main psychic tension of the stories. Tricia Rose has persuasively argued that "the sustained and multidirectional erasures/distortions of black female sexual subjectivity in American culture calls for the *creation and support of more female-narrated and controlled, sexually empowering and, if so desired, explicit materials.*"[26] However, as Rose notes, given the history of African American women stereotyped for *dis*empowering reasons by others as hypersexualized, it's a tall order for current African American female cultural producers. Zane's hybrid characters are one example of doing it well. Her characters sacrifice neither their professional personae nor their erotic pleasure and creativity.

The montage of behaviors in Zane's characters is complex. Their sex acts are ones that might be considered wild or even

beyond the pale by some. Zane shows these going hand in hand with the character's own high standards of friendship, work, self-love, spirituality, and love, as these too take creativity and courage to maintain. And occasionally Zane's sexually open or opening protagonists are involved in community activism, usually through their jobs (e.g., Zane's protagonist Tempest, who works in a teen pregnancy center, in *The Heat Seekers*, 2002). Some of the sexual adventures are mild but told in tension with the character's otherwise careful demeanor, they become freighted with meaning about power and control. In *Afterburn*, 2005, for instance, a dutiful bank employee, Rayne, invites a man from church to dinner and meets him at the door wearing only skimpy lingerie. Rayne, the daughter of an alcoholic, promiscuous single mother, has made her own way through education and work out of poverty and into respectability, then decided to write and direct, so to speak, her own scripts for sexual and loving pleasure.

In *Addicted*, however, Zoe is conflicted. Her loving marriage to a childhood sweetheart, who is a successful architect to boot, is sexually unfulfilling, and her attempts to express her needs to her husband go unheard. Another recurring Zane message to her readers: yes, there are too few employed and therefore "marriageable" black men (according, of course, to a conventional concept of marriage), but that doesn't mean that if you do marry one you can't also demand that your needs be met within the marriage. Zane's sexual politics are a power imbalance corrective in this sociological context.

It's not anything goes, though. These are carefully constructed composites (good/bad, in control/out of control), and the plot development delves into these slash lines. In *Addicted*, Zoe takes three lovers outside her marriage, and in case the

reader has any doubts about the moral inadvisability of this behavior, violence, potential violence, and even the threat (resulting in a close call) of murder follow. Zane's books are fables and their messages are unambiguous. What works for Zoe by the end of the book is therapy; what doesn't work and is revealed—after at first functioning as titillation—as dangerous is cheating on her husband. Again and again. In the therapy-driven end, Zoe's needs get expressed and met and even enhance love within her marriage. Conveniently, Zoe's sex addiction allows for numerous graphic and erotic scenes along the way, some of the most exciting scenes of the book. As with the viewer of the *Kill Bill* movies, the reader gets to have her cake and eat it too, so to speak, under the guise of a moral message. With *Addicted* the reader enjoys voyeuristically the pleasures of dangerous promiscuity as a warning subtext of the main message of respecting monogamous marriage.

In *Addicted*, Zane, at one point in her protagonist's promiscuous phase, creates a scene between Zoe and a female bisexual lover—although until 2008 when Zane published *Purple Panties*, an anthology of lesbian erotica, nonheterosexual scenes were very rare in Zane's work. It's a testament to Zane's power in the heterosexual erotica world that this publication of *Purple Panties* immediately stirred controversy, and it's evidence of her commitment to sexual freedom, whether resembling her own sexuality or not. She has subsequently spoken out against homophobia. Writing about a national chain that canceled a signing of *Purple Panties* and a book club service that had carried her other books but refused to carry this one, Zane issued a statement that traveled rapidly around the blogosphere:

This saddens me because I have now gotten a glimpse—just a tiny, miniscule glimpse—of the discrimination that homosexual and bisexual

people face in the world; especially in American society. Eleven years ago I set out on a quest to liberate and empower women—both sexually and overall. To know that we still have such a very long way to go is disappointing. I am not a lesbian but not because I have anything against it. I am just attracted to men. However, I now consider myself an 'honorary lesbian' because I am pissed off at the injustices directed towards them and their gay male counterparts.[27]

In the majority of her work, though, Zane delivers hot sexual images primarily starring and for heterosexual African American women. Viewed in the larger context of mainstream, heterosexual pornography, this focus on heterosexual African American women's pleasure is unusual. I am defining pornography very broadly (and nonjudgmentally) as representations intended to inspire sexual arousal in viewers/readers. Although erotica is often contrasted with pornography as being a category of words and/or images that are titillating but also usually involve character, narrative, and a range of emotions, particularly tender ones, I consider it a subset of pornography for reasons of cultural criticism and specifically to consider the workings of aggression and libido. I don't dismiss pornography, but instead find pornography in general of value to consider. I also don't see the expression and realization of sexual fantasies to be exclusively an exercise in individualism. Instead, especially for members of a group whose public expression of such key explorations has historically been curtailed, it can be considered to be of broad-based public political import as well.

A good example of female-oriented foreplay pleasure is Zane's description of the following scene between Rayne and Yardley in *Afterburn*: "I braced my hands on his shoulders as he pushed my breasts together and licked and sucked back and forth between the two. He worked them over for a good five minutes."[28] In the same sex scene, Zane continues:

After placing me on the bed, Yardley whipped out a jar of maraschino cherries from somewhere, placed a folded towel on the bed underneath me so as not to ruin the sheets [definitely a detail added for the gender who usually does the laundry], and then spread my legs open. He dug a cherry out the jar with his finger and placed it right in the cusp of my vagina. He lobbed the cherry around with his tongue and then slipped it as deep inside of me as he could get it. The cherry felt cool against my insides and I giggled as Yardley proceeded to dine on me for the next fifteen minutes or so. Then it was my turn to reciprocate.[29]

Zane's work is available in mainstream bookstore chains such as Barnes & Noble and Borders, and online on Amazon and other sites, and in African American–owned independent bookstores, her longtime supporters. They are read in public as well as private. Their radicalism is in their inclusiveness (as in: eroticism and the right to sexual satisfaction doesn't belong only to "hoochies" but to all African American women, including and especially workplace-respectable ones) and their absolute focus on the erotic pleasure of African American women, still to this day a rare focus in widely distributed U.S. culture.[30] Zane represents respectability and rampant libido together in her African American female characters. The imaginative, eroticized space she sketches between public and private, within the characters' worlds in the books and for her readers experiencing the books, is a welcoming one for play, fantasy, and daydreaming.

Kara Walker

The world, as seen through Walker's eyes, is tragicomic, pornographic.[31]
—Matthea Harvey

If Zane's work is about breaking certain limits on the public expression of pleasure and play, Kara Walker's art in contrast is

about representation and its affect. Walker creates and re-creates images based on a racial and historically derived imaginary, a collection of disturbing fantasies, erotic and violent. Even though her panoramas and other work stir the viewer emotionally, it is the artist's position vis-à-vis her representations that again and again draws the viewer's focus. As with Marlene McCarty's art, the viewer's attention is occupied by Walker's work, but even more so, I'd argue, it is absorbed by issues of Walker's own power and aggression in creating and exhibiting the work.

In artist Kara Walker's panoramas, cut-out black paper silhouette characters populate her episodic visual scenes, communicating anger, irony, knowingness, naiveté, wit, bad taste, and fantasy. Walker also creates moving image pieces (usually viewed with some intimacy in small rooms in an exhibition space) and drawings, but I focus here on the panoramas and their riveting but discomfiting mix of fantasy images spread narratively across large public spaces in museums and galleries. These powerful pieces can be read as contemporary fantasies of desire depicted through reconstituted yet familiar figures in Southern antebellum clothing. Walker's figures are often involved in sexual and/ or violent acts, and the viewer is positioned (by scale, by vignette placement, in some cases by her own shadow) so as to almost be part of the panoramas, by extension to be, if she so chooses, implicated in the morally ambiguous ways these actions are presented. The viewer who engages through her body and through her interpretive involvement can become complicit, to one degree or another, in the rampant sexuality of America's long-held and still-present racial stereotypes. There's the shame, shock, playfulness, crudeness, and sexiness of the images, which even though manipulated by Walker are so easily read in silhouette form that this ease attests to a shared multiracial fantasy space

about the sex, passion, rage, pleasure, and violence in U.S. racialized and often racist cultural history. By ease, I don't mean that these are simple or linear narratives but instead that each figure, or the composite parts of the surreal combined figures, is legible. Very legible. The images, even the most fantastic ones, are familiar, or seem familiar, from a common strain of U.S. culture. It's one of bigoted jokes, of darky collectibles, of racialized mass culture objects considered out of date but still available and mass-distributed (e.g., *Gone with the Wind*)—a tawdry, racist strain that is still prevalent in the United States. And it's also a set of cultural images, words, and objects less clearly defined as racist but also prevalent—the quick judgments about all of hip-hop as if homogeneous; the cross-racial "flirting" by ironically quoting past racist tropes (as in calling a white person's desire for a black person "jungle fever"); the endless comments, earnestly or ironically said, about butts. Engaging with those, really engaging through provocative art, engaging not only intellectually but with the affect of that recognizable culture and its reprocessing by Walker, these are the discomforts of viewing Walker's art. Walker's work brings to the fore the ambiguous tensions among social respectability, fluid aggression, and a trove of highly eroticized racial stereotypes that are little acknowledged but always present in U.S. culture.

In the art world, Kara Walker represents Eros and aggression through the lens of antebellum and continuing racial stereotypes against the white walls of respectable (buttoned-up, for sure) museum and gallery settings. She adapts these stereotypes, but her making up new mythologies and laying them over old racist ones, with desire as the repeated theme, is a forceful example of how complexly representations of racially loaded passion can stir U.S. viewers today. Walker describes that passion in

her visual work: "There is all this giving over of self and stealing and taking of others. I think it is born of a kind of passion, but you know how passion can be confused with love and can inspire all kinds of political acts."[32]

Neither Walker's black figures nor her white figures behave properly in public. In full view, they shit, fart, murder, sodomize children, fellate, have sexual intercourse in all kinds of ways and across all kinds of boundaries, participate in broad-handed minstrel-esque humor, and in general run amok. Such scenes arrayed throughout her panoramas comprise not only deeply engaging art but also, framed as they are in the white-walled context of art-world display, a statement of the artist's own power. Each panorama is an unruly narrative installed piece by piece on the walls anew for each exhibition, so the viewer through this and other ways is strongly aware of the artist's presence as the creator of the fragmented story. This art-world power in the context of the highly contested social rules for the exercise of power by an African American woman in contemporary culture is something Walker is well aware of:

As a black woman seeking a position of power I must first dispel with (or at least reckon with) the assumption (not my own, but given to me like an inheritance) that I am amoral, beastly, wild. And that because of this I must be chained, domesticated, kept, traded, bred. And out of that subservient condition . . . I must escape, go wild, be free, after which I have to confront the questions: How Free? How wild? How much further must I escape all I've internalized?[33]

Walker (American, b. 1969) began to exhibit in the early nineties, and her first one-woman show was in 1995 at Wooster Gardens/Brent Sikkema gallery in New York (April 6–May 6). In 1997 she received a MacArthur Fellowship, and her work has been honored with major retrospectives including one at the

Tang Museum at Skidmore College and the Williams College Museum of Art in 2003 and "Kara Walker: My Complement, My Enemy, My Oppressor, My Love" at the Walker Art Center, traveling to the Whitney Museum of American Art and the UCLA Hammer Museum in 2007–2008.[34] As of this writing in 2010, Walker teaches visual arts at Columbia University in New York.

In the critical controversies around Walker's work, ones overtly about art and race, can be read a subtext about libido and aggression. With respect to the history of African Americans representing the race as (publicly) de-eroticized in opposition to explicit sexual stereotypes, Walker's work has hit a nerve. Yet, at the same time, in its popularity it can also be seen as part of the recent reclamation of public representations of sexuality by African American women. The controversial part of Walker's reception has been well documented, most notably the accusation in 1997 made by artist Betye Saar that dismissed Walker's work as pornography and pandering to white racism.[35] However, at this point in time, it's become almost de rigueur for critics writing about Walker to defend her against this now-dated accusation and then go on to praise her work. I find most interesting those who appreciate Walker's work for its self-conscious embrace/critique of sexist and racist aspects of the collective racialized imaginary. As cultural critical Sander Gilman asserts, "Walker's images are indeed sexualized, confrontational, and racist, because the entire Western world shares these images in our waking dreams and nightmares."[36] Gilman defends Walker's work as art that depicts sexual acts but is not pornography and defends her character in that the representation of fantasy should not be interpreted as some kind of autobiographical mirror. While I agree that Walker's fantastic imagery cannot be read as confessional, I have a different take on the pornography/

art question. I argue that exactly because Walker's work is so powerful in stirring emotions and desires related to sex that Walker can be considered, and should in an important and respectful way be considered, both an artist and a pornographer. Not only is Walker's work representation about sex, but it is also (in far less obvious ways than Zane's writing but still) at times sexually affecting. Again, I define pornography broadly as sexually explicit representations presented in such a way as to cause sexual arousal. It's the potential complicity and titillation, however subtly it might be experienced by individual viewers, that interests me. It's a very mediated titillation, one that directs erotic attention to a shared, evolving, and reused racially loaded set of erotic images, feelings, histories, collectibles, movies, other cultural fragments, and current fantasies. The emotions of different viewers are necessarily different and influenced by race and gender and past individual as well as group experience, in addition to erotic predilections and relationships to the realms of art and other public fantasy spaces. "Pornography" though, is a useful word because it reminds us of the impropriety of some of the possible (even if muted) titillation. I want to push that connection an absorbed viewer might feel, even with conscious ambiguity, and think about Walker's work as it intersects with issues and fantasies of sadomasochism and its mobile aggression. Such racialized sadomasochistic fantasies and their cultural manifestations have deep historical roots. Moments in the history of minstrelsy are just one example, one pertinent here in terms of its performances of caricatures.

In recent American studies work on the history and legacy of nineteenth-century minstrelsy with its humorously drawn yet often cruel caricatures of pickaninnies, Uncle Toms, Jim Crows, dandies, sapphires, mammies, and so on, there is a reclamation

of what might have happened in the margins of these performances, particularly by blacks doing blackface.[37] Although minstrel songs could be debasing, abolitionist or otherwise rebellious content could at times also be worked in, thus partially transgressing the negative racial stereotypes.

In psychoanalytic terms, sadomasochism in the blacks-doing-blackface minstrelsy tradition is easy to see as a performance of abjection. However, it could also be viewed in the ambivalent context of parading and the subtle reconstituting of stereotypes. Further, certain minstrel performances could be considered as creating roles that have some mobility along the sadomasochism axis. Likewise, it is precisely, I'd argue, Walker's representations of the mobility of positions, the potential for desire throughout contemporary fantasies about the antebellum power hierarchy that matters here. Imaging the power structure of victimizer/victim as fluidly reversible (if also historically inaccurate) prevents a simplistic depiction of African Americans as victims only from appearing again in contemporary culture. It is also key, though, that Walker's panoramas not be read as an attempt to rewrite history, but instead as a performance and representation of sexual desire and many kinds of power outside narrow confines. Walker's exploration outside what is publicly common today to enunciate about race, at least in art and educational settings, opens her work to multiple points of involvement, some of them uncomfortable, many fascinating, for contemporary viewers.[38] Fantasies of power, desire, and race in the crudest, raunchiest, most racist ways still reverberate now outside stories told in museums, galleries, and universities (Walker's current forums). Such images, most viewers know, are to be disapproved of. But viewing Kara Walker's art in, say, the Whitney Museum of American Art with its high-culture

sanctioning is to be positioned to look at such imagery with the ease of simple disapproval denied. Viewing images representing racist mythologies or others done in protest is an emotional and recurrent event for most people living in the United States. And such emotions can be evoked in viewers of Walker's art. Given the history of U.S. slavery and slavery's continuing echoes throughout our contemporary culture, politics, and economy, representations of sadomasochistic scenes involving stereotyped African American and Anglo American characters can involve the viewer in his or her emotions related to a racialized sadism and masochism. In other words, we are none of us completely outside this cultural and emotional legacy, and although we can choose whether or not to engage with Walker's work, if we do engage, we're likely to be affectively involved—on one level or another—in some frightening excitation. For many viewers this means the shock of recognizing excess in the self connected to the mix of lust and aggression in fantasy and desire—particularly around issues of race. Again, it must be said that this excess associated with lust and aggression in fantasy and desire manifests differently in viewers of different races and differently in different individuals. The safety of moralizing distance though, for all engaged viewers, is a stance disallowed in experiencing Walker's art.[39]

Critic Anne McClintock writes that sadomasochism converts "scenes of disempowerment into a staged excess of pleasure, caricaturing social edicts in a sumptuous display of irreverence."[40] She is describing here commercially performed S and M, but her points about theatricality, caricature, power, sumptuousness, and irreverence are on-target for Walker's art: the exquisite theatricality of Walker's panoramas, their uncomfortable yet fascinating mix of pain and pleasure, their strange mix of glee

and solemnity. In general McClintock is talking about consensual, commercial sadomasochism most often involving a female dominatrix and a male supplicant. McClintock has a redemptive if not idealized attitude toward sadomasochism: "S/M performs social power as both contingent and constitutive, as sanctioned neither by fate nor by God, but by social convention and invention and thus open to historical change."[41] This desire to read sadomasochism redemptively is reminiscent of a line often taken by Walker's supportive critics who tend to focus on instances of her depicting power upsets in her work—and there is some such righteous imagery in Walker's oeuvre. One such scholarly example is Gwendolyn Dubois Shaw's well-argued chapter on Walker's 1996 gouache *John Brown* in which a slave baby is portrayed as rebelliously yanking on Brown's nipple, which she reads as a sign of refusing obedience.[42] On the whole, though, Walker is not evenly or even usually respectful of her black characters; indeed, she seems to court offensively familiar racist scenarios as well as upsets of power in her work.

Creative and theatrical, the personae that Walker generates for herself via her artwork and captions powerfully engage and sometimes puzzle the viewer. She at times ironically presents herself as a nineteenth-century Negress, in fluid and ever-changing roles combining different ages (pickaninny and wench), emotional stages (rage, mischief, humor, ironic debasement, rebellion), and educational states (she sometimes speaks as a slave, sometimes an educated Reconstruction-era black). In this play of artifice, critic Darby English has perceived a freeing of self (and/or its representation). As English articulates, about Walker's self-proclaimed persona as Negress/artist and the impact of her work: "It is from a certain knowledge—and pleasure-seeking indulgence of 'her past' in enslavement—in

the conflictual desires and identities characterizing the moment that Walker derives the self that she frees, if you will, to do the work of mining history's unarticulated passages, art's unmade objects, and the value of counter-memory itself."[43] It's Walker, as manifested in her work and her multiple artistic personae, whom the viewer feels is the one who possesses this power, power that she exercises in ways that go beyond roles of "saint" or "sinner," in other words beyond performances of power easy to subject to judgmentalism. Walker's is the power to appropriate, to wreck, to uplift, to play, to echo, to ironize, to seduce, to stir, to anger, to implicate, and to confuse. Her work is an enacting of this power, a power only heightened by its (in a liberal context) misuse in places as well as its (sometimes earnestly reformist) use in other places. Think female artist, black female artist gaining and using power, but still operating in an (art) commerce setting and so through her success (like any successful artist, black, white, or other race, who is claimed and rejects the claim as subgroup outsider according to race, gender, orientation, etc.) is beyond idealization herself. And to refuse idealization is to claim aliveness and dimensionality for oneself in the public sphere. Walker also publicly performs motility as a subject. By authoring multiple personae so visible *as* personae, Walker remains for the viewer the power behind her irony, caricature, and satire.

This is power, but it is not taking the high road. Walker's (implied) narratives are morally ambiguous and therefore unacceptable for some. In Walker's panoramas, there is no polite separation from the complexities of aggression or Eros. So we can look further at Walker's stance—as an individual artist and as an African American female artist creating erotic and violent subject matter beyond the "morally acceptable"—as a

complex reclamation of the sexual for herself in public through her personae. Psychoanalyst Jessica Benjamin in her provocative essay on pornography, "Sympathy for the Devil," writes about the push and pull of aggression in its function of recognition of the Other and creation of a shared intersubjective space. This she posits against the lonely world of narcissism and fantasies of omnipotence, which miss, among other things, that aggressive bumping up against another and subsequent recognition. That shared space, that recognition, Benjamin finds essential to erotic play and so she argues, "As the inextricable counterpoint to recognition, destruction is not the negation of Eros but its complement." And she issues this challenge: "Because there can be no useful experience of destruction and survival without aggression, the question is how its immortal adversary Eros, can inspire aggression to assume its most creative form, destruction survived."[44] "Destruction survived" can be understood as seeing the other, after emotions or fantasy concerning aggression toward the other occur, as a subject who has survived (and would again be capable of surviving) one's own aggression, and this recognition is a necessity for intimacy. Walker-as-artist, in exerting the power of representing and exhibiting a range of obscene and violent narrative scenes of (sometimes transformed but still recognizable) antebellum Southern racially stereotyped characters, is all about destruction survived. Her role as an artist is to unveil, to create, to depict, to alter, and ultimately to have power over a sadomasochistic subset of the shared racial imaginary. That relationship between the artist and those images is framed within the white-walled contemporary context that is the art exhibition. Thus the artist performs on the art-world stage a powerfully intimate role as creator and destroyer.

Even though Walker often chafes against being asked to "represent" as black and female, or is ironic about it, in this

historical moment and in the high-beam spotlight of her art-world visibility, she is read as a prominent African American female artist. So her particular display of power has meaning for the minority group she is seen to represent and the art world's authority to "crown" members of society with the right to be acknowledged as creative. Part of the creativity of Walker's work—and her refusal to compensate for the inherited stereotype of the aggressive black woman—is in her imaging of violence. In Walker's panoramas, it seems to the viewer that the artist acknowledges and controls what looks to be eroticized and inappropriate violence. In the drawings, moving images, and panoramas Kara Walker exhibited at the Walker, the Whitney, and the Hammer museums in 2007–2008, a viewer could see scenes of, for example, a black woman about to kill a white man, whites about to lynch a black man, a black woman slitting the throat of a white woman, and a white man putting his sword through a black baby. Mixed in with these are also explicitly sexual ones of fellatio, sodomy, missionary-position intercourse, and so on, with participants from a range of ages and races.

Again, it is the "misbehavior" that is quite valuable in Kara Walker's representation of fantasy—specifically, the shifting racial role play and also the slipping back and forth between what's considered in an art-world context appropriate (a seemingly wide range of depictions) and what's considered not (such as an image of a child fellating an adult—a sometimes repeated one in Walker's work).[45] In Kleinian terms, sadism can be considered to always contain some masochism and vice versa. Walker's work mobilizes the topsy-turviness of these already inherently unstable positions—and applies this destabilization to images familiar in the large and shared "archive" of racialized popular culture images and related fantasies. The aggression of

the artist is in creating this destabilization as well as in repre-
senting the "disrespectable." As an artist, Walker rebels against
the politics of respectability that African Americans historically
are often pressed to operate within, and she pushes against art-
world tenets of respectability as well. Then, too, within a given
panorama, the artist's subject position can shift from decrying
traditionally racist imagery to highlighting it with both buf-
foonery and passion, from looking from outside to seeming to
inhabit the inside of a scene (or fantasy of it). A closer look at
the intricacies of one of her panoramas reveals the unsettling
impact of these moves for the viewer.

Raunchy, brilliant, erotic, aggressive, and ambiguous, *The End
of Uncle Tom and the Grand Allegorical Tableau of Eva in Heaven*
(figure 4.1) is one of Walker's best-known works. Reading this
monumental black-on-white silhouette installation panorami-
cally from left to right, the viewer observes that the first image is
of a half-dissolving full figure in profile, one half of a "parenthe-
sis" with the figure in profile at the far right. It appears almost
as if these two are viewing the scene. The dissolving silhouette
on the left is of a white girl. (In general, this dissolution fits
with Walker's structure. Walker's vignettes float in the space of
the white wall and are not montaged closely together: instead
there's a feeling of dislocation, of them not quite fitting to-
gether, which again focuses the puzzled viewer's attention back
to the artist's personae through questioning the artist's narra-
tive intention in image placement. For those seeking to inter-
pret, the perceived link between the vignettes and the missing
pieces of the meaning puzzle is the artist. It is also noteworthy
that Walker arranges some pieces differently in different instal-
lations; for instance, in this work, the left parenthetical figure is
at times placed almost all the way to the right [see the Walker

Art Center catalog illustration of the work, different from the installation view].) The white girl's toe points out and one hand is upheld as if she's dancing or performing a melodramatic gesture. The eaten-away part of her back seems to represent the outlines of vegetation.

Then, still reading from the left, the first cluster of images consists of a group of female African American slaves. They are identifiable as slaves by their bare feet, long, ragged skirts, head rags (on two of them), and stereotypical facial features, and one is carrying a basket on her back. The work's title, also, signals the scenes are set in pre-Emancipation times as it references Harriet Beecher Stowe's 1852 novel *Uncle Tom's Cabin*. (One example of how deeply wedged the antebellum characters and stereotypes are in the shared American cultural consciousness is that I was certain I'd read *Uncle Tom's Cabin*, so familiar were Uncle Tom, Eliza, Eva, and all to me, until I picked up the book while working on this chapter, realized I'd never turned its pages before, and actually read it—for the first time.) The novel's cataloging of violence framed in the ambiguously racist yet deeply well-meaning abolitionist rhetoric of its time is more shocking and more an exploration of sadomasochism than any of Walker's works. As such it—and its many spin-offs and retellings from the mid-nineteenth century to the present—provides a general referent for the artist and viewer; Walker's panorama cannot be read as any kind of literal illustration though. Nor does it speak to the book's incredible power at the time of its publication as effective abolitionist propaganda. Walker's work does however address the secondary and lingering historical effects of Stowe's novel, mainly, its theatrical reinterpretations; these many stagings and retellings forged durable stereotypes, in the main separated from the book's original intentions.[46]

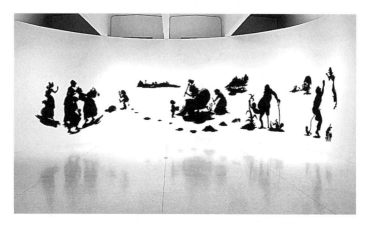

Figure 4.1

Kara Walker, *The End of Uncle Tom and the Grand Allegorical Tableau of Eva in Heaven*, 1995, cut paper wall installation, 13 × 35 feet. Installation view from *Kara Walker: My Complement, My Enemy, My Oppressor, My Love*, Walker Art Center, Minneapolis, 2007.

Photograph by Gene Pittman, Courtesy of Sikkema Jenkins, Co., New York

One of the few similarities between Stowe's book and Walker's panorama might be the utopian beginnings. Stowe, embarrassingly to the present-day reader, places her utopia in Uncle Tom's slave family cabin—the family is happy there. Walker, more provocatively, turns "happy-slave" stereotypes on their heads—mammies here are feeding themselves, not white babies. And they're erotic figures as well. In Walker's panorama, in that first group image, one woman is suckling another's breast and that woman in turn is suckling a third woman's breast (figure 4.2). A baby is about to feed from the first woman's breast. In this closed circuit of suckling, there is a relief from familiar images of black slaves being dominated by whites and specifically the negative stereotype of the plantation mammy who is

Figure 4.2
Kara Walker, detail of *The End of Uncle Tom and the Grand Allegorical Tableau of Eva in Heaven*. Installation view from *Kara Walker: My Complement, My Enemy, My Oppressor, My Love*, Walker Art Center, Minneapolis, 2007.
Photograph by Gene Pittman, Courtesy of Sikkema Jenkins, Co., New York

pictured nurturing white children, not her own, and certainly not other adult women, homoerotically; instead, female slaves here are nurturing and being nurtured, simultaneously sucking and being sucked on by themselves. This kind of comforting/erotic image tells the viewer that she is in the presence of a work that is about overturning historically negative visual stereotypes of African Americans. This is a deceptive impression as Walker's work, in this case and in general, is only partly about that, and such overturning actions are often contradicted or at least rendered ambiguous by other representational functions within the same composition. Walker aggressively courts ambiguity in a cultural arena where racist hierarchy or protest of the same

had reduced too much imagery for too long to, yes, black and white. Our shared and visualized racial imaginary, individually processed and differently fantasized, is so much more fraught and complex than that.

The viewer's sight continues up what appears to be a small hillock on which the cluster of women are standing. In the distance and to the right there floats a delicately rendered cutout of a big plantation house with Southern-seeming vegetation around it and nearby a smaller house, perhaps a slave shanty. In the middle ground is a little black boy with unkempt hair holding a tambourine and wearing only one oversized (connoting a hand-me-down) shoe. He is dancing and defecating, leaving behind a trail of shit-shaped spots, which trot along the bottom of the panorama and slowly transform into plant shapes. Plant shapes or not, in the main, it is not a pretty image, and it associates the slave boy with shit. (Even here, though, as critic Jamie Keesling has pointed out, there's some ambiguity since he's also "shitting on" the scene, which can be read as an act of aggression on his part.) With this connection of the boy to public shitting, the viewer's temporary comfort is dispelled. The artist has represented a black boy as animalistic and producing filth; Walker has reproduced—albeit with an aesthetic flair that in its appeal makes it all the more uncomfortable/implicating for the viewer—a negative racist stereotype.

What is liberating already, though, in the work's sequence of images is the mobility of the (imagined) subject position of the artist from proper to improper and back again, thus eliding what a multiracial liberal audience is used to thinking of as traditional roles for black artists—such as that of rewriting negative stereotypes so they become positive and/or creating new "uplifting" images. And I'd assert that it's exactly this mobility in a

visual theater of subjection and domination that puts Walker in her artist persona in a power position. Art-world white artists have traditionally been "allowed" to express mobility from victim to victimizer and back. For example, the rage expressed often in Barbara Kruger's work is coupled with the mobility expressed in her interpellations—at times, an accusatory "you" is used to imply damage to/victimizing of the subject who seems also to be the point of identification for Kruger's artist persona; at other times, the anger is represented as flowing more freely outward and therefore the artist persona personifies the aggressor. As represented, Kruger's persona is quite complex and not limited to either a sadistic or a masochistic one. It's useful to remember that in Freud's exploration of sadomasochism, he considered a mix of sadism and masochism within an individual to be involved in all sexual dynamics.[47] Fluidity emphasizes the mix, and a controlled and representationally performed fluidity the "ownership" of the mix, and by extension the possession of libidinal energy; again in Walker's work we see the power of the artist's combining aggression with libido. In contrast, black artists in American art history have been expected and pressured to play and represent the role over and over of righteously angry victim, a masochism writ large and clothed in rage.[48] This role has some value, of course, but it's missing the sadistic component of libidinal power.

Critic Hilton Als argues, "Walker's . . . poignant theme [is] our desire to be dominated by someone else whom we will always call the Other."[49] And, I'd add, to have the option of mobility, to dominate as well. There is nothing one-sided about Walker's work. Walker's refusal—in her persona as artist, the unseen but omnipresent character in the panorama—to sit still, so to speak, to play simply the victim or for that matter the victimizer, even

and especially in her fantasized, eroticized version of the historical arena of popular slavery- and antebellum-based imagery, that is her radicality. Walker's power in aggressively performing a mobility of roles concerning the stagings of these images invites viewers to unsettle their own relationships to the same inherited trove of imagery and explore their own complex relationship to it. It also invites those viewers who are so inclined to identify with the libidinal aggression that the artist represents and so strategically deploys in her art.

The central image of *The End of Uncle Tom* is a vignette of a white girl in a hair-bow and petticoats with an axe who seems to be threatening a naked black toddler who in turn holds a bucket in supplication. But a stump sits between her and the toddler, and the axe blade is pointed backward instead of forward. Behind her crouches a "wench," a young slave girl in apron and head rag, purposefully holding a sharpened stick beneath the girl's petticoats as if intending to ram it up her ass—yet another example in Walker's work of her overt tying together of aggression and eroticism.[50] Violence and sadistic fantasy threaten front and back in the group, but the potential outcome is unclear. If the white girl is Eva from *Uncle Tom's Cabin*, though, she's not depicted in this vignette as sickly and she's no heroine.

Moving right, the next image the viewer sees in the foreground is that of an older white man, bald and with one peg leg. (In the background between these two image clusters floats a haunting cutout of trees and their shadows.) He is standing, leaning backward on a sword, which is skewering a black baby. A black child in front of him holds onto a plant and joins him at the groin as if becoming either another limb or a sex toy. His gaze fixes on the man's big belly. There is a strangely harmonious balance to this scene, some kind of stasis built on violence and sex, and the stillness of the figures and their lack of facial

expression remind the viewer that this is a depiction of a fantasy. The silhouetting and the quaint datedness of the clothes lend theatricality to the image. Mimesis is trumped by the surreal here, but it's an uncomfortable surrealism for the viewer, trading as it does on the long history of titillating sadistic racist imagery consumed by a portion of mainstream majority-white audiences from slave times through today. In interviews Walker talks about her use of racist erotica and/or race-driven romance novels as indirect source materials. For instance, she told interviewer and art historian Thelma Golden: "I approach this work the same way a Harlequin Romance novelist might approach it, all the history, the petticoats—it's all artifice, just a ruse to tantalize the viewer."[51]

In the background next is another cut-out, highly detailed scene of a female figure standing on the porch of a shanty under a Southern tree hanging with Spanish moss and a male figure running fast, full out, legs spread wide, arms reached out to a leaning outhouse. There is an echo of minstrelsy in this vignette, as if it's an illustration of some broad racist humor about a black slave in some kind of predicament of bodily functions—with the runs.

Returning to the foreground, a male slave (in raggedy clothes), with his arms upheld and palms clasped together as if in prayer or general supplication, balances on one leg, slightly crouched, pants down, and from his buttocks protrudes an umbilical cord attached to a baby who sits on the ground. In front of him and higher up is a silhouette in profile (the other half of the parentheses), which appears to be dissolving, of a white girl pointing, and at her feet is the head of a black girl (in a pickaninny hairdo of head braids, with a front-leaning one visible) staring out. Is the pants-down man supposed to be Uncle Tom? Is the image degrading of and simultaneously granting birthing

powers to Uncle Tom? Walker's images are frequently shocking but also often ambiguous; like her perceived artist personae the content of her art has the power of oscillation and obfuscation, of refusing to play simplistic parts, or even to always be read clearly in a narrative sense.

In the lower right, the place commonly used for an artist's signature, seems to be a small shadow of a rabbit and a pickaninny's braided head. Both are recurring figures for Walker and represent characters mischievous, powerfully misbehaving, sometimes victims, and sometimes victimizers. With these figures, especially the pickaninny girl, there's continuity in Walker's work, a familiar cast of characters not just from *Uncle Tom's Cabin* but also from historical Southern tales now recast as Walker's.

In conclusion, how does Walker's work resonate in this book's discussion of feminine aggression? First, I see Walker's art in the context of Kleinian ideas that aggression is always with us along with the need, as discussed, to acknowledge, experience, and represent it. Walker's art, the artist's personae it implies, and the scenes she presents for the viewer are seen here as a complex example of reclamation of public expression of aggression and Eros, one that generates a particular meaning in the public spaces of the art world concerning Kara Walker's power as an artist. Second, this book argues for the messiness and largeness of aggression—that it can't be simplistically reduced to sadism, to harming others, that instead it's more fruitful to regard it as a key element of force, and further to explore how it combines with other factors, internal and external to the individual, to fuel actions of power in intersubjective space. The multiple, strategic, intense ways in which Walker uses and explores aggression are, for me, a strongly impactful representation of that complexity.

This chapter contains an examination of contemporary public representations by certain African American female producers of African American women as fully, fluidly, and imaginatively sexual in self-determined ways—with these representations in contrast to the lingering cultural legacies of myths of prescribed hypersexuality or conformist uplift. Questions are raised about the combining of libidinal energy and aggression—in the representations themselves and likely in the strategies of representation, and what it might mean not only for individuals but also for a large and diverse group. In Zane's case, as we've seen, the pairing of libido and aggression as expressed in her erotic novels is ambitiously and it would seem successfully (as measured by the popularity of her best-selling books and in other ways) about freeing—in the sense of articulating and prioritizing—representations of sex, fantasy, and pleasure for a broad range of African American women. Without aggression there is no Eros, without Eros no libido, without libido no full self. This is a radical rebellion in representation in a range of subsets of African American female culture, resulting in a claiming of Eros and aggression in a *public* sphere. This is a public positioning of the self as erotic and aggressive within a series of intersubjective spaces including those in the majority white culture.

In Kara Walker's case, there is an ebullient and unsettling performing of fluid sadomasochistic fantasy intertwined with a contemporary recasting of memory—at times posited as collective, at times individual—of racial and racist imagery. Walker's art first and foremost proclaims her own artist persona's power within the influential art world, and also a power of mobility and misbehavior; a power of dimensionality, wit, and rage, and not one reduced to a repressed and flattened victim performance; a power to act aggressively and to inject her personae of

the then-Negress and/or now-intellectual artist with aggression; a power to claim creativity in the broadest sense, and to use the art world as the very effective platform it is to redefine the boundaries of creativity normally "allowed" black artists. Creativity, as Winnicott has extolled, is life's blood; sadomasochism as standing in for a full range of desires is its sometimes uncomfortable kissing cousin related through libidinal energy. Walker aggressively and publicly claims both—creativity and desire—represented in and through her art, without propriety.

5

MORE SIBLINGS: AGGRESSION WITHIN ART AND ACTIVIST GROUPS

In this chapter, we look at relational aggression at the center of group cultural production. In doing so, our discussion shifts from the representation of images to the *production* of culture. In the context of production, we further explore how necessary it is to express and deploy aggression and its indispensability in interpersonal relations and in creativity. Accordingly, considered here are the experiences of female producers in two influential artists groups and a female director of a cultural activism institution in terms of their use of interpersonal aggression. In these cases my analyses are both specific to the situations and general concerning issues of aggression and group cultural production.

The three case studies are cultural producers in the performance group Toxic Titties, a producer in the artist collaborative Haha, and a director of the cultural institution Hull House. Toxic Titties (2000–the present) actively engages with and creates images and performances dealing with, among other issues, aggressivity in women. Haha, whose founding members include men and women, has not focused on these issues, but it is included here as a model of one type of artist group production that works with complex interpersonal layers within both the group itself and vis-à-vis different collaborating populations. Thus the ways Haha deploys aggression are a kind of structural template for interlocking cultural group production among multiple groups. In turn, this analysis is in keeping with an understanding of a broad culture comprised of a large and multidimensional web of interrelated group and institutional producers. Haha has worked thoughtfully and complexly in different ways and at different times with different populations inside and outside the group. In these first two cases, Toxic Titties and Haha, there's an intricate group/public dance between members of the group who brainstorm and do the majority of

production work and their "viewers," who tend to be partici-
pants and whose participation is part of the art production.

Hull House is an unusual addition to this series of case stud-
ies because it is not an independent, self-defined artists group
like Toxic Titties and Haha, but a workplace that is an arm of a
university (University of Illinois at Chicago). It often draws a
more clearly defined line between producers and audience in
the staging of its events; however, there are participant events
like the food-and-sustainability series "Soup Tuesdays," in
which participants have a particularly active role. Hull House,
founded in 1889 by Jane Addams and Ellen Gates Starr, histori-
cally has had a number of significant and varied permutations;
today under the directorship (2006–present) of Lisa Lee, it func-
tions as a public pedagogical, cultural, and activist institution.
It is included here for one of the same reasons as Haha: the view
of cultural production as accomplished by an interconnected se-
ries of cultural groups and institutions. Indeed Hull House is a
hub for networking, discussions, and productivity of different
Chicago populations. Hull House is also included, though, be-
cause it is a workplace with a hierarchical structure, with regular
paychecks, and that is answerable to a state university. In this
it serves as a model for thinking about women's interpersonal
aggression and productivity within cultural and pedagogical
workplaces, raising issues that resonate for many institutionally
employed women.

Among the producers I interviewed for this chapter, there
was a strong interest in the functions of conflict and aggres-
sion in group situations. Experientially, it seemed that intermit-
tent and recurring friction, while difficult to negotiate, has been
helpful in maintaining productive group working relationships
over a substantial period of time. For some, there has even been

a conscious embrace of aggression. Julia Steinmetz of Toxic Titties says of her co-artists, "They're the only people I've said 'fuck you' to, and we still love each other." Ah, but how to negotiate the love and the aggression? How does friction aid the longevity of working relationships and productivity? How can aggression in groups be both accepted and managed? How might independent and workplace group dynamics differ in these regards?

In addition to Melanie Klein's and D. W. Winnicott's thinking on aggression, the theoretical underpinnings of my explorations in this chapter come from the writings of Juliet Mitchell on siblings, Claire Bishop on "relational aesthetics," and Chantal Mouffe on radical democracy. Not surprisingly, with this look at interpersonal aggression we are back in the theoretical territory of siblings. This chapter, then, is the other bookend to the girls and sports chapter, but in the adult groups under consideration here there are no tidy sports rules (or the representation of these in movies) but instead the pragmatic necessities of intersecting with institutions of production, earnings, and dissemination. Additionally, in the art groups there is the shared goal of production and therefore the necessity of negotiating relationships within the group, without, in most cases, fixed organizational structures. A related goal often is the longevity of the group beyond creating a single project and therefore the creation of sustaining, if fluid, cultural and social mores within it, including the expression and management of aggression.

The questions asked here are also stimulated by the work of art critic Claire Bishop on aggression and relational aesthetics. Two of the three groups can be considered under the umbrella term "relational art": Toxic Titties, an art and activist group whose core members, Julia Steinmetz, Heather Cassils, and Clover Leary, began working together when they were

graduate students at the California Institute of Arts (CalArts); and the art and activist collaborative Haha (1988–2008). Toxic Titties and Haha can be categorized as belonging to the broad historical sweep of collectivist-produced art, from the modernist avant-gardes to the present, and whose recent surge in the 1980s, 1990s, and 2000s has been particularly focused on relations with and among viewer-participants, as well as site specificity. Variously expressed and critically debated, a rich critical discourse about site and community exists that is arguably more visible and perhaps influential than the art itself.[1]

Bishop helpfully focuses on the quality, meaning, and complex emotions of the relations among viewers involved in contemporary art projects, and she questions utopian claims of community made by certain artists and critics. Instead of relational art that celebrates an idealized harmony among like-minded art venue visitors, Bishop privileges art projects that stir conflict and related difficult emotions connected to more truly democratic discourses. She goes into detail about why these agonistic emotions are indispensable to democracy, utilizing the theories of Chantal Mouffe and Ernst Laclau about radical democratic goals and the importance of discord.[2] I've been inspired by Bishop's exploration of the importance of agonism/aggression to arts reception to ask questions about inner-group aggression among producers of works that are participation-oriented. Although there is no simplistic mirroring between the emotional dynamics of how a work is produced and those it encourages in viewer-participants, it seems that an openness toward and an ability to negotiate conflict within a group may well influence its ability to tolerate or use aggression in discourses and relations it helps create through its work. I'm also interested, in terms of individual groups, in how the

self-conscious managing of aggression impacts practice, crea-
tivity, and productivity over time—although in many relational
art projects there is an intentionally blurry line between produc-
ers and viewers, with claims of them together comprising some
sort or another kind of "community." I focus in each case on the
core brainstorming and production group and look at issues of
aggression among the members and how that helps sustain the
group dynamic over time. My interest is in how aggression func-
tions in productive processes.

Like Bishop, I employ Mouffe's radical democratic theories
where the latter convincingly argues for the necessity of what
she terms "agonism" within democracy. In her essay collection,
The Democratic Paradox, Mouffe clearly distinguishes between
"antagonism" and "agonism." "Antagonism is struggle between
enemies, while agonism is struggle between adversaries."[3] (How-
ever, it should be noted that both antagonism and agonism are
forms of aggression.) She sees encouraging agonistic dissent as a
primary task of democratic societies, one that allows a pluralis-
tic range of citizens' opinions but that also allows for temporary
compromises (if not actual agreements) between citizens. These
compromises are possible—and in fact necessary for a function-
ing democracy—specifically if citizens see themselves as ad-
versaries and not enemies. It's important to note that Mouffe,
like Klein, sees aggression as ever-present in interpersonal re-
lationships. Moreover, antagonism is an inextricable thread
in Mouffe's understanding of the political. She writes: "By the
'political,' I refer to the dimension of antagonism that can take
many forms and emerge, in different types of social relations.
'Politics,' on the other side, indicates the ensemble of practices,
discourses, and institutions which seek to establish a certain
order and organize human coexistence in conditions that are

always potentially conflictual because they are affected by the dimension of the 'political.'"[4]

As a functional matter, in that citizens must come together as adversaries instead of enemies when actually seeking to get concrete things done or form temporary consensus, Mouffe argues for the necessity of agonistic conflict and disagreement within democracies. The perfect ideal of a democracy of full equality and liberty is not attainable, but the boiling of agonistic discourses functions as a protection of these goals and a weapon to ward off a no-argument totalitarian state. Usefully for my exploration, Mouffe emphasizes the potential function of institutions to shelter and promote democratic agonistic discord. In doing so, institutions like universities could contribute to democracy or a pragmatic version of it, and are not just the passive recipients of democratic politics and culture.[5] In this sense, I'm regarding Toxic Titties, Haha, and Hull House each as institutions, even though only Hull House, itself part of the University of Illinois at Chicago, defines itself that way. Each has courted democratic discourse with those it interacts with outside the core production group. The groups of individual artists have also striven for democratic decision making among their members, whereas Hull House relies on a more traditionally hierarchical workplace structure incorporating moments of dissent. Each is a model of how aggression can be mixed with relational productivity over time.

With this theoretical context in mind, as well as other questions about aggression being addressed in this book, I've elected to interview each individual producer/director on her relationship to the complex set of interpersonal relations within the group and thus continue the consideration of feminine subjectivities regarding aggression and its affect.

Toxic Titties

Externalized displays of aggression are easily visible in Toxic Titties' performances and demonstrations. Consider, for instance, a spectator's video of part of *Lesbian Gang* (unofficial title), a performance by Toxic Titties at the March 28, 2008, opening of a women, art, and politics exhibition, *The Way That We Rhyme*, at the Yerba Buena Center for the Arts in San Francisco (figure 5.1).[6] Three of the Toxic Titties performing that day, wearing black or pink face masks with holes cut for their features, and costumed for the most part in black, white, and pink pants and tops, and in one case, sporting a pink mohawk, accost a woman wearing a black and white dress with a bow in her hair. One of the Toxic Titties waves a gun. Yelling and screaming they strip the woman down to her bra and panties, force her to her knees, and cuff her. She, also a performer, yells back, resisting and pushing. Another woman in a black and white dress joins the fray, and her dress opens in the front. The performance isn't separated from the crowd on a stage and is instead in the middle of the opening crowd milling around. There's something happy, loud, and sloppy about the performance with its theatrical roughness. And it's unclear what it's supposed to represent. Are these the lesbian gender police going after more traditionally femme women? But both the gang members and the women in dresses are marked more by standard signs of San Francisco lesbian or queer fashion than signs of differing stereotypes. One of the accosters wears a long, black evening glove along with her street look; the handcuffed woman-in-a-dress wears knee-high black leather, round-toed heavy boots. The Toxic Titties often state in interviews and in their own writing their intention to portray the category "woman" as fluid, slippery, and open. What this

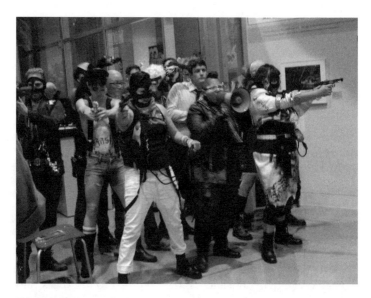

Figure 5.1
Toxic Titties, *Lesbian Gang*, performance, Yerba Buena Center for the Arts, San Francisco, March 28, 2008.

performance mainly feels like, though, is a kind of vague take on roughhousing, and parodic, although of what—some kind of gang action?—the viewer isn't certain. Uncertainty, of course, does not necessarily translate into an experience of gender identity as fluid. The aggression, and the pleasure taken in its performance, though is clear and boisterous. Elsewhere, on Flickr, a photographer posts images she took of an audience member, Kari, standing face to face with the motorcycle-jacket wearing Toxic Titty. Kari is smiling. The caption reads, "Kari gets held up and felt up."[7] It's an opening, a party performance, and it's fun, ironic, and erotic.

Toxic Titties have done a number of such roughhousing per-
formances, most in their guise as Toxic Troopers. In their own
words on their Web site (www.toxictitties.com), they describe
the Troopers as an "elite military," and exhort viewers to "join
us or move aside, but do not stand in our way."[8] In these Trooper
events and other performances, they tap aggression—in them-
selves, in their audience, on a conscious emotional level. But
unlike groups that elicit overtly the trauma/fear/anger nexus of
affect (certain historically effective queer-based groups such as
ACT UP being key examples), Toxic Troopers employs humor for
entries into aggression that are not necessarily trauma-based.[9]
Instead theirs is an aggression mixed with libido—kin to that
evident in some examples discussed earlier such as Zane's and
Lynda LaPlante's lusty characters—and humor. In Toxic Titties'
case, it's an aggression mixed with libido intended to increase
fluidity of gender and sexual identifications in their perfor-
mances. The Toxic Troopers ask rhetorically what they want
and answer with lust and aggression, "Freedom! Power! Money!
Respect! Pleasure! Representation! Sex!" There's a campy, rule-
breaking reckless glee to many of their personifications. While
some are also intensely aggressive, others are light. See, for ex-
ample, the Toxic Titties Web site publicity image for the gallery
symposium/camp on feminism created by Toxic Titties, "Toxic
Titties Put the Camp Back into Camp!" The poster presents five
buff female bodies, one figure with short pink hair, all wearing
pink scarves tied Boy Scout–style. One in a very un-Scout-like
pose grasps the muscular thigh of the camper with pink hair.
The whole group is improbably photoshopped against a wild-
flower field.

As critic Kristen Raizada summarizes Toxic Titties' costumes:
"The Toxic Titties have appeared as queer perversions of camp

counselors, police officers, a feminist militia, blushing brides, B-movie lesbian starlets, and high society art collectors."[10] These roles are put into motion, performed in a variety of urban spaces, and often pastiched on their bodies with signifiers that connote lesbianism and/or queer identities. The montage of signifiers they exhibit in different performances is read differently by different audiences. This happened most notably in a Toxic Troopers event in which Toxic Titties performed these roles in 2002 with a large number of local women artists in Mexico City. It was meant as an antimilitaristic parody and at the same time a demonstration of female power. Together, the visiting and local artists in Trooper costumes marched on July 4 from the U.S. Embassy to the Ex Teresa Arte Actual Museum. During the march, Toxic Titties member Julia Steinmetz recounts, their militaristic uniforms were not necessarily interpreted by viewers as ironic, and as a result the group was followed by police for the entire route: "People were freaking out, thinking we were Nazis. . . . We were taking one position, but it wasn't coming across at all. . . . What had been clearly performative and playful in one context became really more aggressive."[11] They were seen as invasive and frightening, not necessarily read as parody. What the group experienced as a misreading of their work became cause for conflict: "We had a fight after that one . . . whose fault is this that this didn't turn out?" In a telephone interview, I asked whether there'd been a constructive outcome to this fight, and Steinmetz replied in essence, yes, that it had laid the groundwork for more and necessary acceptances of inner-group friction about projects in the future.

"A lot of times because we'd worked collectively together over a number of years it seemed like we were so close we'd know what each other was thinking. In Mexico we'd assumed

that we each knew what the others were thinking but. . . . So we learned about communication, something about being more explicit and not assuming others know what you're thinking especially working in an unfamiliar context." This fight happened in the second year of their working together, and perhaps the creation of the space to argue while still continuing to work together helps explain the longevity of Toxic Titties as a group—as of this writing in 2010, they're still active after ten years.

Toxic Trooper performances—however much one might want to interpret them as celebrating gender fluidity—are difficult to read as anything other than a broadly defined, self-ironic, boisterous, queer art militia. They can be criticized as promoting not so much fluidity as vagueness, if in an at times entertaining way, at least for this viewer of the documentation. In contrast, more pointed and complex are the performances Toxic Titties aim directly at the art world. In spring 2001, Toxic Titties members Heather Cassils and Clover Leary took on Vanessa Beecroft, the artist known mainly for her performances commanding large numbers of female nudes or seminudes often in heels to pose in regimented ways in fashionable art and consumer spaces. Typically, the women she recruits are shaped like high-fashion models, and their display invites viewers to stare at them. Understandably Beecroft is often read as merely duplicating with a grandiose flair the exploitative aspects of the fashion culture she appears to be commenting on. With Beecroft erasing any sign of dissent or individuality in her performers, instead having them embody obedience with long-enduring frozen stances during her many-houred performances, and the Toxic Titties' embrace of performing aggression, Beecroft seems a made-to-order target for Toxic Titties.

Toxic Titties members Cassils and Leary infiltrated a Beecroft performance at the Gagosian Gallery in Beverly Hills, working for Beecroft for four days as models, posing for studio photographs, and standing rigid during the performance itself. They were both compliant in serving as models and rebellious in doing labor organizing (specifically, negotiating for overtime pay for all models in the project) with the other models. Subsequently they created artwork and, along with Toxic Titties Julia Steinmetz, wrote about the experience, openly expressing anger and negative criticism.[12] Cassils's and Leary's participant protest against Vanessa Beecroft in 2001 can be read as an embodied attempt to queer the performance. This attempt was frustrated both by their need for the pay, which prevented open disruption, and later by Beecroft's Photoshopping of their images in the photographs she exhibited and sold that were related to the performance. In Cassils's case, her weight-lifter's self-sculpted boyish physique was altered to appear softer and implicitly heteronormative. (And it's Beecroft's photographs that command high prices, are illustrated and sold, are visible in museum collections, and so forth, whereas her performances garner comparatively smaller numbers of viewers.) Steinmetz later describes the transformation and analyzes a Beecroft photograph of Cassils as having been "neutered through digital manipulation, her body builder's muscles smoothed out to conform to a more feminine ideal." Gone are "the broken straps on the models' shoes, Cassils's muscles, the sweat dripping down her body."[13]

On its Web site, Toxic Titties describes *Beecroft Intervention* with activist vocabulary: "Toxic Titties Infiltrate Vanessa Beecroft: In 2002 Toxic Titties collaborators were hired to perform in a work by Vanessa Beecroft at the Gagosian Gallery in Beverly Hills. In the parasitic performance, *Vanessa Beecroft Intervention*,

the Toxic Titties hijacked Beecroft's work and subverted her vision by engaging other performers in a critical dialogue, and by unionizing them which forced up the cost of labor."[14] And Toxic Titties published an essay in *Signs* that was primarily written by Steinmetz with additional commentary by Cassils and Leary.

When Cassils recounts the experience, she describes feeling impotent, and yet she also describes herself with love and pride, particularly concerning her self-sculpted muscles and her anger. So, the anger and the power in her body-ego (and her body is displayed naked in the Vanessa Beecroft performance) are at the ready but not, to her, usable in this situation. Needing the money, she doesn't say no to Beecroft's sadism, but she does negotiate overtime pay for the twenty-eight models working naked and in physical discomfort for Beecroft during their four-day stint, thereby raising their total pay significantly. She also endures the performance by enjoying explicit queer fantasies about her fellow naked models, later creating writing and drawing about her desires. And meaningfully for this book's exploration of the articulation and representation of aggression, Cassils lets herself feel her anger, pictures herself as embodying it, and expresses it forcefully later in her essay in *Signs*.

In Cassils's words,

As the first viewers entered the white cube my quadriceps started to shake so hard I thought I was going to fall out of the designer heels that cost more than my rent. My fists were clenched and stomach taut. I felt like my skin was a force field against the eyes that were drinking me in. I wanted to make myself menacing and indigestible. In my mind contracted muscles bounced their viewership off my body like fists in the boxing ring. My jaw was clenched and I was dripping from quiet exertion. The more I stood the more energy built up in me until I started to feel like I was going to explode in my stillness. "Wow, she's so angry.

Wherever did she find her? Really great." And it was in this moment that I realized I was powerless in this situation. My silent anger was easily subsumed by the art work.[15]

Later on, though, through the *Signs* essay, widely available to researchers and students in libraries and through copies, which Toxic Titties stealthily inserted in Beecroft catalogs in bookstores, and her drawings, Cassils expressed her anger. For instance, Cassils recounts her overtime strategy: "As 7:00 p.m. (the time when we had been told the shooting day would be over) approached . . . we were informed that if any of us left production would cease and no one would be paid. 'Bullshit,' I said, 'If any of us leave, you don't have an image.' At this point I negotiated the fee of $50 for every thirty minutes we were kept past 7:00 p.m., almost doubling the initial fee we were quoted."[16] So, negotiating the overtime was another way in which the aggression was expressed. In the case of Toxic Titties' responses, articulating anger well, strategically, and publicly really was the best revenge.

I asked Steinmetz about the relationship between the group's ability to express aggression among themselves and Toxic Titties' ability to last. She described how the arguments cleared emotional space for individual flexibility and difference. And she spoke of the necessary admixture of love and aggression for constructive outcomes. She related Toxic Titties' dynamic to her own natal family where she is one of three girls and where "we can fight viciously because we love each other so much." In Toxic Titties' case, Steinmetz cited as an example their fighting when she decided to move to New York to pursue a doctorate in performance studies at New York University. We also discussed how negotiating love and aggression, with love dominant, resonates with Melanie Klein's vision of healthy adulthood.[17]

Thinking in transferential terms, Steinmetz referred to D.W. Winnicott's essay about the importance in the therapeutic process when a patient can conceive of the analyst surviving the patient's attacks. This specific case, in fact, for Winnicott is a model of a subject's (always ongoing project of) learning or relearning to accept the world outside herself as separate and different from herself—of being able to withstand her aggression. This realization, for Winnicott, is key to negotiating subjectivity in relation to other people, and efforts to accept the power of both others and the self.[18]

Essential to group productivity is a consciously shared reality and the ability to use or psychically "bounce off" one another and to create together in that space. As Winnicott writes (again about the analysand/analyst relationship), "The destructiveness, plus the object's survival of the destruction, places the object outside the area of objects set up by the subject's projective mental mechanisms. In this way a world of shared reality is created which the subject can use and which can feed back other-than-me substance into the subject."[19]

Aggression is essential for group productivity. For group productivity there needs, as well, to be a conceptualization of shared reality for—in the broadest sense—playing, which we have seen also represents a degree of psychic aggression. Once a shared playing, creative, and productive space is established and maintained by various fluid admixtures of aggression and love, perhaps there's room, too, for nearby private play that feeds into the shared creativity. It's a complex and wonderful dynamic to conceptualize—and one necessary to action in culture and politics. Wonderful because the balancing and negotiation between the self and a group dynamic is always in flux, and I have a sense of wonder about those moments when mobile love and

aggression together create spaces for individual and group play. (In my own life, I have wonder and gratitude, too, for the emotional power of such moments felt amid a roiling topography of psychic energies that comprises everyday experience.) The map would need to be conceived as a dynamic, shifting one, but the ingredients, even in the most utopian view, and definitely in a pragmatic one, would include aggression. In Toxic Titties' case they have incorporated aggression at times in their group dynamic and in discussions about projects, and they explicitly perform aggression as well in many of their pieces. That fine line between production and representation seems to disappear—if not necessarily for their viewers then at least for the performers themselves. I appreciate the power in Heather Cassils' translation of her feelings of angry criticality to images and words. Some of this aggressive production, the drawings, she did solo, whereas her writing and publishing was part of a group collaboration.

"Purposive behavior," Winnicott states, always includes "aggression that is meant," that is, conscious.[20] The ability to feel, mobilize, and express aggression in conscious adult life, he argues, is tied to the deep, unconscious development of the aggressive instinct in infancy, and either one of these two elements, the emotion and the instinct, "cannot be studied without the other."[21] With early infancy as his example and, as is so often the case with psychoanalytic writers of the object-relations school, his metaphor for adult life as well, he develops a case for the *need* for aggression-inducing opposition: [The infant's] "impulsive gesture reaches out and becomes aggressive when opposition is reached. There is reality in this experience, and it very easily fuses into the erotic experiences. . . . *It is this impulsiveness, and the aggression that develops out of it, that makes the infant*

need an external object and not merely a satisfying object."[22] Extrapolating from this observation about infants, Winnicott continues about adults: "In adult and mature sexual intercourse, it is perhaps true that it is not the purely erotic satisfactions that need a specific object. It is the aggressive or destructive element in the fused impulse that fixes the object and determines the need that is felt for the partner's actual presence, satisfaction, and survival."[23]

In this 1950–1955 essay, Winnicott presents a different discussion than in his later 1969 one about analyst/analysand aggression, and Winnicott's theory in general evolves over time. It is useful, though, to see the space for lateral adult relationships Winnicott opens up at the end of the earlier essay in light of his later consideration of play and creativity. In doing so, it helps me think about a space in group production that includes not only a sense of shared reality but also a general ability of individuals within the group to make use of fused aggression and libido for purposeful activity, interpersonal relations, and creative group play. For each of these related activities aggression is a necessity in the mix.

Haha

In the functioning of self-created productive groups, there are no set rules except those created explicitly and implicitly by the group. With groups that focus on interactions with audiences and communities, there are additional structures worked out as they interface with the institutions that represent their publics and/or facilitate the group's interaction with its audience. It's helpful to turn, then, to Haha and its set of experiences managing and negotiating aggression within a creative group, in this

case one that has interfaced with a variety of external institutions and publics. Formed in 1988 in Chicago, Haha initially consisted of two women and two men—Wendy Jacob, Laurie Palmer, Richard House, and John Ploof. (House returned to England in 2000, but the other three remained with Haha until 2008.)

Haha started working as a group in 1988, a time when discourse on aggression was not prominent in the art world. (That discourse, I believe, started later, and an inspiring critical text that marked its coming to the fore in conjunction with art criticism's embrace of the Melanie Klein theoretical revival is Mignon Nixon's pivotal "Bad Enough Mother" published in *October* in Winter 1995.) There was initially, in fact, a distinct avoidance of conflict in Haha. As artist Laurie Palmer explains:

What characterized our working methods from the beginning was that we aimed for a group-mind kind of place. . . . Our discussions were not about defining difference, but finding commonality. We would throw ideas out into the shared space and they would either fall and disappear, or else be picked up and elaborated upon by the next person, so that they could own them too, and those ideas would have a life, potentially. Our meetings were often filled with long silences, and also with cooking and eating and just being together. . . . They could go on for nine hours.[24]

The group dynamics over time evolved beyond this kind of negotiating through silences to more articulation of differences. Palmer explains, "Projects that were more explicitly political raised more conflict. These conflicts were sometimes really tough." "Conflict also," Palmer recalls, "happened when we tried to articulate, in words, what we were doing in our work, doing written pieces for different publications. We struggled with how to articulate multiple perspectives in one piece." Haha gave four-person public lectures in which each group

member experimented with presenting her or his own perspective. Palmer recounts that these interpretational differences aired in public sometimes "surprised and disoriented us."

This relational aggression expressed as conflict about differences also called for reparation (in the Kleinian sense) and retooling among the members after conflicts. (For Klein aggression and love exist in any dynamic, but following the feelings of aggression and related fantasies, she theorizes complex paths to reparation employing the experience of guilt and the "depressive position" that when successfully processed can in turn lead to love and gratitude. Even in this sketchy description of Kleinian processes, we can see that it opens up myriad possibilities to consider in terms of reparative negotiations.[25]) Simply put, with a group that functions well together for many years—in Haha's case for twenty, from 1988 until its friendly disbanding in 2008—there have been times of friction followed by reparation through discussion, production, and a trying out of new methods for collaborative work.

In Haha's case, differences became incorporated into the process of production. Palmer recalls, "Later, we tried to divide up who did what [according to abilities]. That also became hard. It was hard to acknowledge, well, this person is better at that than I am . . . or hard for some of us anyway, and I am talking maybe mostly about myself. I wanted to think that I was good at everything but that position was not useful in terms of trying to differentiate." Moving toward differentiation and acceptance, then, was aided by a selective use of aggression, as we've seen in Juliet Mitchell's theories about sibling-like groups. Haha was still at times conflict-avoidant, with perhaps good pragmatic reason. Recounts Palmer, "We didn't want to get into those battles which were a waste of time. . . . The need to deal

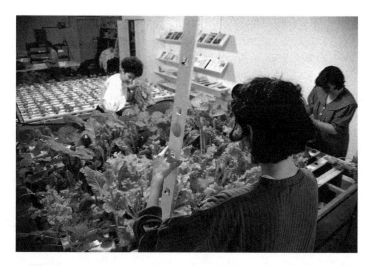

Figure 5.2
Haha, *Flood: A Volunteer Network for Active Participation in Healthcare*, Chicago, 1993.
Photograph courtesy of Haha

with logistics led to an opening up of space and a sharing of responsibilities."[26] In creating *Flood: A Volunteer Network for Active Participation in Healthcare*, 1992–1995 (figure 5.2), Haha expanded by forming lateral, sibling-like relationships outside the group as well as within, by working with other collaborators, in effect expanding the production group while also thoughtfully examining new relations its members were forming.

Funded initially by Chicago's Culture in Action for one year and then self-funded, *Flood* was a service and pedagogical contribution to HIV/AIDS awareness, prevention, and activism.[27] Its functions included (1) creating and maintaining a hydroponics garden to grow vegetables and herbs for hostel dwellers and any

HIV-positive person who requested them; (2) HIV/AIDS educa-
tion through classes, discussions, lectures, and other exchanges;
(3) for the first year of its existence cooperating with the art con-
text provided by Culture in Action (which brought in art view-
ers by bus and in other ways); and (4) encouraging like projects
in other locales. Haha describes *Flood*, located at 1769 Greenleaf
Street in Chicago's Rogers Park neighborhood, as follows:

A group of twenty to thirty people initially organized by Haha—built
and maintained a hydroponics garden in a storefront on the North
Side of Chicago. Participants grew vegetables (kale, collards, mustard
greens, Swiss chard) and therapeutic herbs for people with HIV. For sev-
eral years *Flood* provided biweekly meals, educational activities, meet-
ing space, public events, and information on alternative therapies, HIV/
AIDS services in Chicago, nutrition and horticulture, as well as a place
to garden.[28]

Although the storefront closed in 1995, *Flood* was a future-
directed seed project in several important ways. *Flood* partici-
pants volunteered at social service organizations in Rogers Park
and elsewhere in the Chicago metropolitan area. *Flood* hosted a
series of roundtable discussions between social service and com-
munity-integrated organizations; as a result, a collective effort
emerged to build a comprehensive HIV/AIDS facility in Rogers
Park. Opened in 1997, the facility contains a food pantry, an al-
ternative high school, a community center, and administrative
offices for four organizations. In addition, *Flood* worked in other
communities (DeKalb, Illinois; Cedar Rapids, Iowa) to plant gar-
dens, each of which developed the project relative to the local
context.

Flood became a kind of turning point in the group dynamic,
as Palmer recounts: "We became much bigger, opened out the
group to other artists, students, community people, so that

allowed us a lot of space." Fellow Haha co-founder John Ploof, artist and art educator, talked about the collaborative teaching arm of the project: "We ran several classes with students from De Paul University, Columbia, and SAIC [School of the Art Institute], and other interested people that formed a group different than Haha. The whole project got bigger than us. This expansiveness gave us more room to work independently."[29] The group expanded to include students, neighborhood residents, other artists, people who were HIV positive, and those with intersecting identities among these populations. *Flood* had many layers of participation options, pedagogical functions, and service aims, all concerned with information and discussion about living with HIV and delivery of healthy food to those who were HIV positive. Constructively, this mix of functions and aims produced an ongoing consideration and discourse about the relations being formed in and around *Flood*.[30]

Flood had originally been commissioned by Sculpture Chicago and funded by Culture in Action, a public art program with major support from the Lila Wallace–Reader's Digest Fund and the National Endowment for the Arts, but that curatorial connection and funding only lasted one year. After that, Ploof recalls, "We tried a lot of things to stay afloat financially. *Flood* eventually stopped paying rent on the place with the hydroponic garden and the adjoining space for discussions." The landlord wasn't addressing plumbing problems, "so we gave ourselves some 'rent adjustments,'" Ploof laughs. But he acknowledges that "having that external conflict certainly helped galvanize the group." In general, Ploof finds, too, that opening up to a range of working methods and collaborative experiences, including conflict, "allowed us in our later work like *Flood* to participate in a project in different ways and to value how

we're different—allowing that difference to be a guiding force."
This experience, of course, would be in keeping with Chantal
Mouffe's philosophy: "One of the keys to the thesis of agonis-
tic pluralism is that, far from jeopardizing democracy, agonistic
confrontation is in fact its very condition of existence."[31] The
sibling-like love we've heard about in both Toxic Titties and
Haha would then be instrumental in negotiating with inner-
group aggression to keep conflict (usually) in the realm of what
Mouffe would call agonistic debate between adversaries.

Hull House

Although production related to the art world is inevitably tied,
directly or indirectly, to the art market, collective and collab-
orative work coming out of the art world can tend toward uto-
pian. This is a utopianism for the future built on an unusual
degree of creative and structural control in the present—as well
as broad political and social goals. By control, I mean specif-
ically that the group can work out together its internal rules,
politics, and culture, and have a great deal of self-determina-
tion of these processes, even while also engaged in public
interface. With this degree of self-determination, or "self-in-
stitutionalization" as Greg Sholette calls it, these groups differ
greatly from most workplaces.[32] Yet there are some workplaces,
for example, nonprofit foundations and a range of pedagogical
institutions, that could be considered kin to these artistic col-
laboratives. Although bound more by traditional institutional
rules and cultures, many of these share some educational goals
with contemporary collectives like Toxic Titties, and often in-
ternally seek to apply some of their educational ideals to group
dynamics, even hierarchical ones. I want to close the chapter

by considering the pragmatics of a workplace institution, albeit a fairly idealistic, educational one—Hull House, precisely because in its hierarchical form, it isn't structured as a democracy or even close to one, and yet it upholds, or tries to, democratic teachings predicated on the values of liberty and equality (values Mouffe defines as core for democracy). In discussions at such institutions there may be moments of dissent in which the workplace dynamics reflect the larger democratic values that the institution promotes publicly. The question then, for this case study, is how inner-group aggression is managed and channeled at Hull House and by extension what the issues are for other pedagogical institutions seeking to work with and teach democratic values.

Mouffe writes, with hope, for the potential of functioning institutions to preserve agonistic conflictual discourse. For instance, she advocates "the encouragement of a massive development of many non-profit activities by associations, interacting with both the private and the public economies to provide for the emergence of a truly pluralistic economy, instead of a purely market one."[33] When I read these hopes of hers, it seems to me that implicitly they are sketched against the backdrop of her own sustaining institutions in academia and the relative job security possible within it. This kind of security and the idea (if not the actuality) of complete intellectual freedom in academia makes it conducive to imagining educational institutions as open forums for debate and the agonistic discord that feeds it. In addition Mouffe writes from a European context where the predominance of government-funded cultural institutions—while again not 'pure'—can perhaps more easily inspire a picture of them as scenes for agonistic debate than can their U.S.-equivalent cultural institutions, most private and driven

by fund-raising goals.[34] Whatever Mouffe's background moti-
vations may be, it is a strong part of her argument that radi-
cally democratic ideals like academic freedom and open cultural
debate are unreachable but absolutely necessary as part of the
larger ever-present struggle in democracies to achieve liberty
and equality. Considering the ethical struggles of a pedagogical
workplace, in fact, fits with Mouffe's always-careful distinguish-
ing between the ideal and the attainable:

> As an ethics which strives to create among us a new form of bond, a
> bond that recognizes us as divided subjects, the psychoanalytic 'ethics
> of the Real' (Žižek) is, in my view, particularly suited to a pluralistic de-
> mocracy. It does not dream of an impossible reconciliation because it
> acknowledges not only that the multiplicity of ideas of the good is ir-
> reducible but also that antagonism and violence are ineradicable. What
> to do with this violence, how to deal with this antagonism, those are
> the ethical questions with which a pluralistic democratic politics will for
> ever be confronted and for which there can never be a final solution.[35]

In other words, Mouffe is a champion of the importance of un-
realizable but always-present democratic political goals, par-
ticularly those that contribute to liberty and equality and the
paradoxical incompatibility of equality and justice (because
every consensus including legal ones includes within it the vio-
lence of exclusions). So, with these distinctions between the
ideal and the actual in mind, academia can be seen as one set of
Mouffe's useful institutions that attempts to preserve disagree-
ment as well as agreement with the powers that be.

In this context, my final exploration of inner-group aggres-
sion is Hull House, a nonprofit public institution devoted to
social and cultural activism and a part of the state-funded Uni-
versity of Illinois at Chicago (UIC), specifically its College of Ar-
chitecture and the Arts. Additionally, Hull House does some of
its own fund-raising. I'm particularly interested in long-time

Figure 5.3
Hull House, *Rethinking Soup*, Chicago, May 6, 2008.
Photograph courtesy of the Jane Addams Hull House Museum at the
University of Illinois at Chicago

activist Lisa Lee's directorship, which began at Hull House in
2006 and continues to the present. Previously, Lee worked from
2000 to 2006 at Chicago's private nonprofit, The Public Square,
which fostered public discussions on social issues. In her pres-
ent work at Hull House, Lee promotes intellectual discussion,
political activism, food and cultural workshops, and the honor-
ing of history (Hull House also functions as a history museum).
In these ways, Hull House's current activities resemble the pro-
duction of many contemporary art collectives. For example, in
2008, Hull House offered, among other programs, *Soup Tues-
days* or *Rethinking Soup* (figure 5.3) to promote activism around

food-related issues such as sustainability, local production, fair wages, and health. It also hosted "Conversations on Peace and Justice," speakers and forums on "ending militarism globally and creating conditions for peace to flourish in our communities," and it provided "Arts and Democracy," performances and classes in the tradition of "Jane Addams's belief that the arts and culture are essential to promoting democracy and citizenship."[36] But Hull House, originally founded in 1889 as a groundbreaking settlement house by Jane Addams and Ellen Gates Starr, in its current embodiment, is part of academia; it is a hierarchical structure in a university much like a department. Accordingly, I interviewed its director Lee about the ideals of radical democracy in the context of a nonprofit hierarchical structure and about her own uses of power: aggression plays a role in each of these questions. Further, a familial model for aggressive interplay also applies. Hull House is ruled by UIC's administration, its deans and president, who in turn are subject to funding decisions by the State of Illinois. If the UIC administration can be considered the "parents" of Hull House, then Lee functions as a powerful older sister, and a familial model brings its own set of questions about the functions of aggression and power, inflected by gender.

I talked with Lee about some of the tensions between ideals and structure, and about her own deployment of power. One question she has for herself is "how to acknowledge the actual power dynamic, the existence of a real power structure, especially in this place which is supposed to be about peace and love. It's a nonprofit organization in which an individual has to subsume individual goals to a mission [as if] everyone's own desires should be subordinate to the mission. I've learned not to believe that."[37] The current mission of Hull House is to honor

the history and ambitious legacy of Jane Addams's Hull House, which gives it a broad mandate for activism in issues of global peace, urbanism, justice, immigrant rights and history, culture, education—and fostering open political discussion of these issues. The present-day institution also maintains the remaining two buildings of the original Hull House complex as a museum open to the public. *Soup Tuesdays*, for example, are held in the original dining hall, where historical luminaries like W. E. B. DuBois, Addams, Gates, and others once met to debate politics and culture and plan actions.

With an assertiveness that seems inflected by new feminine roles employing aggression and very much opposed to self-erasure, Lee is unabashed about her leadership role within the hierarchy, "The myth of the collective comes in [regarding] how we adjudicate the competing desires. [In this case] there is a vertical power structure within the organization." And Lee finds her power useful in many ways, including dealing with affect: "Even though I give lip service to radical democracy [ideas] [and part of that is that staff] feel acknowledged as people as opposed to workers, [when there's someone who is bringing] a constant flood of personal issues to work, at a certain [point you have to say] there really is a job and these have nothing to do with the professional world."

Feminine passive-aggressive behavior can commonly be found in men and women in nonprofits according to an institutional culture that still idealizes consensus and fears aggression. Lee continues, "People tend to think in binarisms. If you're not being aggressive is the only thing left being docile? There's all this 'niceness' at staff meetings because no one wants to be seen as aggressive. Passive-aggressive behavior comes out when you can't acknowledge your own desires and ambition and you have

to try to couch everything as, 'Wouldn't it be better for the institution if . . . X,' [when what you mean is that it'd be better for you]. No one is willing to take a stand. We don't get stuff done then." Lee admits that her own role, though, can be an inhibiting one despite her saying she wants lively debate: "I'll throw out an idea and what I want to do is have people fight about it. Through that argumentative process, we can figure out the best way to do it. But because of the power dynamic there is that question are you really allowed to fight with me[, the director]."[38]

Lee wrestles, too, with particularly feminine gendered questions about leadership. In this light there appears to be pressure to be supportive and nurturing of her underlings on the staff. "I want to acknowledge your [a staff member's] stress. But do I need that [kind of emotional work] in my workplace? Who does that acknowledgment for the person at the top? There isn't that reciprocity. How does that lack express itself?—[it creates a] resentment that you have to do it, but you don't get it back. I don't want to do it, but I've made a decision to try to practice it." This ambivalence about embodying the maternal role is also what made me think of the older-sister one, like Anne Marie's fictional role in *Blue Crush*.

However, Lee deconstructs a sports model's applicability as follows: "The problem with using a sports metaphor is that with a business it's obvious what winning means. But for nonprofits you don't reach the utopian goal of, [say,] no more starvation. If the struggle is eternal then there's no more winning. We lapse back into the family thing. . . . There is no winning. . . . There is a boss and everyone is 'filled with love.' You're supposed to love each other, but we didn't choose each other." Here is the workplace institutional ambivalence.

I asked Lee about what she has experienced as fruitful disagreement in her workplace, and she replied:

The times it's been most productive and there hasn't been resentment [afterward] are when someone admits they're wrong. . . . You can't hold the tension as tension. . . . In my experience at nonprofits that tension festers and builds a boiling pot of resentment. Someone has to acknowledge they're wrong, one idea is better. . . . Some things are arbitrary and [then I state my preference.] I don't pretend: I acknowledge the power structure and that I'm making the call. They accept that. Perhaps the dissent influences me more than is obvious: it influences how I make my decision.

Again, this is not a democratic institution although it promotes democratic values.

And as Lee summarizes the negotiation of ideals and pragmatics, she stresses the element of time. "There is a tension between utopian ideals and practice which take place in time. Time is the friend of practice and the enemy of utopia. We're not in a pretend utopia where everyone's opinion counts equally. We don't have endless time to debate forever." Time, then, functions for Lee as the arena in which to exercise her power, an exercise that requires her aggression. Yet, in light of Lee's ethical and practical struggles, it's also possible to see her channeling employee aggression to encourage debate while also retaining hierarchical power as director.

The use of power is dependent on the deployment of aggression. As Winnicott has pointed out, any "purposive behavior" employs aggression.[39] The conscious use of power can be seen then as incorporating "the use of force to create change," as I define aggression. (This change can even include the use of power conservatively to maintain the status quo since to halt flux and evolution also requires force.) The *Oxford English Dictionary* gives multiple definitions of "power," among them: "1. a) Ability to

act or affect something strongly; physical or mental strength; might, vigor, energy; effectiveness; . . . 2. a) Control or authority over others; dominion, rule; government, command, sway. . . . 2. b) Authority, given or committed. Also liberty or permission to act . . . 2. c) Capacity to direct or influence the behaviour of others; personal or social influence . . . 3. a) More generally: ability, capacity. . . ."[40] So, much like the current slipperiness of the common-use definitions of "aggression," these definitions of "power" range from those connoting agency and strength in an individual to those about dominating others. But it's the twin attributes of agency and authority that most interest me in terms of Lee's subjectivity within group dynamics. The personal interview with Lee gives a sense of her employing power interpersonally to achieve a combination of conflict, authority, teamwork, and productivity. To do this, the ingredient of aggression is a necessity, both in the self and in accepting it in others. And we've seen this deployment in the interest of what Mouffe might term agonistic moments in the deliberative processes of the respective group dynamics with which each is or has been affiliated. But, after all, Lee is the director, and aggression is still not an ingredient that women in many U.S. workplaces—women being statistically underrepresented at the top of hierarchies and pay scales—can creatively deploy in explicit ways, without some negative repercussions. What next then?

As historian Joan Scott has bluntly put the important question, "If significations of gender and power construct one another, how do things change?"[41] There is not one answer to this, but the internal (self) and external (public) use of aggression to assert, create, and rethink power by members of a group historically forbidden such deployment must be one of the paths toward full equality within a democracy. The public exercise of

aggression and power need not be a solely individual one and indeed in pragmatic terms, and sometimes idealistic ones as well, is likely to involve groups and institutions for efficacy of production and possibilities of change.

Aggression is a fiery fuel, a key element in the exercise of power, not only to assert power in the traditional understanding of establishing dominion over others but to work productively *with* others—in a hierarchical structure or otherwise—in a way to create change. Not only new representations of aggressive women, but also new and rethought structures of productivity that consciously include aggression within a group dynamic, can aid an internal (self) and external (public) permissiveness in women's actual deployment of aggression. As cultural producers we can work to forge new habits for the articulation of feminine aggression and for its deployment in production.

Within culture, both production and representation can be means of redesigning old habits (in Žižek's sense as the unspoken rules that support and enforce norms[42]) that serve to forbid public displays of aggression for women and of creating or articulating new habits that support new assertions of feminine aggression. A nontotalitarian use of aggression in a culture-producing institution would be one that enables moments of democratic debate as well as the conscious affirmation of power and aggression of its members, whatever subcultural identity they identify and are identified with. These new habits themselves would need to be kept in motion to avoid reifying new norms and to keep opening agonistic expression to disempowered groups and individuals through cultural representation and production. In general the use of democratically oriented aggression in cultural production has the potential to contribute to a discursive and energized space for democratic actions and agonistic expressiveness.

As one of many cultural and behavioral examples that together additively comprise this discourse, this study, it is my hope, makes an aggressive contribution to this space. In writing this book with its championing of aggression, I'm adopting such an aggressive persona myself in engaging in a dynamic with the people I interview, the cultural works I study and analyze, the theories I use and reconstitute, and the ideas I create. I hope to engage with you, the reader, in a way that acknowledges feminine aggression—variously in culture, in you, and in myself.

Aggression is both embodied and represented by us and by such producers as those whose work is discussed in this book from Jessica Bendinger to Zane to Marlene McCarty to Julia Steinmetz to Lisa Lee—not simply through their allegorical display of muscle, but through the complex and conscious deployment of aggression in the self, within productive groups, and in culture. Fire in the belly now leaps onto movie screens and *Soup Tuesdays* and Toxic Trooper performances. It is not completely controllable nor should it be because then it would cease to function in a political dimension and to have democratic potential. But we can channel feminine aggression in agonistic directions. We can further enflame it in processes where one moment follows another in mobile negotiations that combine aggression with ethics, with politics, with love, and with production. By articulating and enacting our aggression, we are powerful.

6

CONCLUSION

In the conclusion, I consider images of and writing about women's amateur boxing, thus pulling together the issues the study started with—the embodiment, representation, celebration of feminine aggression—with complexities gathered along the way, particularly about limits and performances of interpersonal aggression. In boxing, the uncontainability and full range of aggression is embraced in order, paradoxical as it may seem, to manage it, and more, to use it to implement power internally and as an individual or with others externally. I also note the continuation of the counterdiscourse that is repressive toward women's aggression, at least in its representation. And, finally, I wonder about the cultural montage of old myths and new, what its impact might be, and what it says about hope.[1]

There remains an open question: can the large and growing set of images of aggressive women have an impact on individual viewers' bodily egos, habits, and experiences? Firmly sidestepping a simplistic cause-and-effect approach, we have explored connotative and suggestive readings in this book, and the hope they might represent for those who choose to read them as such a sense of the possibilities for feminine aggression. I want to note as well the chicken-and-egg simultaneity today: at the same time that this cultural trend of mainly positive images of aggressive women is expanding, a strong behavioral necessity exists for many women for increased aggression. With more women spending more of their adult lives in the workplace and living without a man, there is an increased awareness by many women of the necessity to be aggressive at times just to survive—for example, arguing, strategizing, and pushing for a raise. The traditional habits associated with having a man around to aggressively defend, or appear to aggressively defend, a woman are outdated. With today's divorce rate, single parent

rate, and the growth in the numbers of women who choose to live without a man present in the household (in some cases, these can be overlapping categories), the ready daily presence of a man performing aggression on behalf of both genders is not a good bet. Simply put, most women cannot afford to be passive. Accordingly, it's possible to say that for broad sociological reasons, as well as the many other reasons discussed in this study, the myth of passive femininity is dead. Or should be.

However, one of the challenges that has persistently excited me while writing this book is how old cultural myths and new and future fantasies all coincide and coexist in the present. At the time of this writing, there's still a boiling confusion for many about how aggressive a woman can be without garnering negative outcomes. There's a moving sense of awkwardness as quite different women teach themselves new survival and behavioral habits concerning their own force. And then, aggression itself is messy. Even for men, how much aggression to exert and when and in what legal form remains a series of questions, although too often unspoken ones.

In this book, along with other participants in the discourse on aggression, I explore cultural issues about feminine aggression for and alongside others who define themselves as women. One of the beliefs structuring this book has been that culturally representations of feminine aggression can be used, by those who chose to do so, to contribute to an acceptance of the potential of a full range of aggression in the self. Ironically, I argue that this kind of acceptance is part of stopping short of violence—knowing one's capacities in other words is part of being able to choose how to use them.

For some women, a corporeal exploration of those capacities compels a physical testing of aggression's limits, control,

strength, and wildness—a pushing of its interpersonal use in offense and defense. In short, fighting. There is a growing literature and set of visual representations about women's physical fighting, corresponding to the growth in popularity of women's involvement in martial arts. Whereas I've talked about awareness of capacity, the emphasis here is on proving capability. In my world as a writer and a professor, the existence of cultural representations of aggressive women is part of the support I feel in a self-aware effort to deploy my own aggression effectively. I'd suspect that for many different women (here, those with access to computers), the social networks on the Internet are daily reminders of the potential for public self-expression and a non-passive relationship to culture. Specifically, for those women who choose to post images of themselves and/or other women as aggressive, the social networks can stand for a potential to enact as well as represent aggression in cultural production. In the intersection with online social networks and women's boxing, the reach for aggression is palpable.

One grim detour, though, before we reach the optimistic world of the Internet. To look broadly at the issues related to women's boxing images is to receive, among more hopeful images, evidence of the continuation of repressive, punitive representations of women's aggression. As is traditional, these tend to be overtly in the service of myths of domineering masculine aggression, narrowly defined so as to be, I would argue, potentially harmful to men, too, or at least the ones who chose to identify, as these comprise in sum a restrictive cultural identity for masculine aggression. A prime example is the 2004 Clint Eastwood–directed, Academy Award–winning *Million Dollar Baby*. The ostensible protagonist of the movie, the female boxer Maggie Fitzgerald (Hilary Swank) is not the hero of the movie.

Clint Eastwood playing her trainer Frankie Dunn is. The movie is narrated by Morgan Freeman whose character Eddie Scrap-Iron Dupris is a former boxer who now cleans the boxing gym Frankie owns. He is the third protagonist and, like Maggie, is subordinate to Eastwood's character. The acting in the movie by all three actors is outstanding. The plot, though, is all too familiar. At the start the movie seems as if it might be part of the new mainly positive visualizations of women's aggression. The plot arcs from Maggie's hard-core determination to succeed as a boxer and to fight her way out of poverty, not only for the money but to be someone and to do what she enjoys doing. Next is her gritty ascension within women's professional boxing up to the world championship level. With that title almost in her grasp, the movie turns into a tragedy. (And it's not that I believe that all images of feminine aggression must be celebratory or exclude tragedy, but the Hollywood plot arc where a female character is in effect punished and humiliated in the arena where she dared to express her aggressive force is something I no longer care to stomach.) Maggie becomes paralyzed from the neck down due to a boxing injury. Viewers then witness her horrifying physical decline including an amputation of one of her legs, an attempt to kill herself by biting her tongue so she might bleed to death, her sedation, her bed sores, and so on. We see Maggie beg Frankie at length to help her die. Finally she gets her wish. It's an all-too-familiar arc because her tragedy and victimization are the impetus for Frankie's inner growth. Uck. I prefer the new myths and find them—imperfect and shimmery as all myths are—to be in aggregate inspiring.

Now, the good news, as exemplified by amateur boxer Amanda Riecke's videos and photographs posted on YouTube and Flickr. I close with this example to underline the existence

in everyday life of the new cultural mythologies. Although public athletic displays of self can be flattering and a source of pride in one's appearance as well as proof of strength, skill, or training, such images are of a sport famously unpretty and potentially face-smashing. Clearly for women something more than advertising one's own appearance is at stake in posting boxing images of the self.

Women's boxing has become—as a symbol for many and an actuality for practitioners—evidence of the will to fight without shame, and to be able to take a hit and come back with a powerful hook, canny strategy, and intricate foot-play. I don't find it a sport I want to try. But I appreciate those who do and the written and visual discourse that has sprung up around boxing. The discourse is a sharp, thoughtful reminder that managing aggression and using it effectively is not only about owning, focusing, articulating, and controlling it—large tasks already. It is also about fighting, that is, responding to others' aggression and/or striking out aggressively, all the while persevering in complex interpersonal ways.

Carol-Ann Farkas in academic writing and Leah Hager Cohen in first-person journalism, among others, have articulated the importance of physical fighting as a way for women to experience, deeply experience, competency by pushing, mind and body, beyond limits.[2] Boxing of course is not the only arena for that, but it is one that incorporates and flaunts aggression. It is also one in which pain and fear so often flip to anger and aggression, a profound and potentially overwhelming emotional progression. There are rules, too, to help control the embodiment of this progression, although excess and serious physical damage, even in amateur boxing where headgear is required, remain always a possibility.

Cohen started hanging out in a boxing gym in Somerville, Massachusetts, to write about the girls who trained there and over time became a serious amateur boxer herself. She first trained with the girls, and then continued on her own. She writes eloquently about the interpersonal love and aggression between sparring partners and perceptively about the inner negotiation with the boxer's own rage. Cohen quotes one of the girls, Jacinta, as saying, "'In the ring . . . I feel safe, very safe—I feel as if I won't hurt people that much because of rules and boundaries of boxing.'" Cohen then observes, seemingly talking about her own emotions as well as Jacinta's, "The safety she [Jacinta] craves most is the safety to let go, to unleash all her body's power without fear of it being too much. The freedom to bring forth every aspect of herself and hold nothing back. In delivering this, boxing offers something invaluable to girls."[3]

For boxers and nonboxers alike, the growing visual discourse on online social networks like YouTube and Flickr invite the viewer/reader to watch the process of becoming a serious amateur boxer. (In contrast, the professional women's boxing sites are about branding a saleable and already-polished "product" and are more difficult, at least for me, to identify with.)

On YouTube, I watched amateur boxer Amanda Riecke's training, sparring, and fighting videos, all taped and posted in 2009 during her training for and fighting in the Chicago Golden Gloves competition. Riecke is 5 feet 3 inches and regularly competes in the 112-pound weight class, although to find a match at Golden Gloves she had to gain weight to move up a category. Her Golden Gloves match was on April 17, 2009. Golden Gloves is the annual U.S. amateur boxing competition held first in major cities. Then winners in different weight categories can go on to compete in the national Golden Gloves tournament.

It is predominantly male with usually just one women's match, if any, in each category. It is multiracial and multiclass. Historically, boxing has been a sport attracting those from impoverished subgroups who are literally trying to fight their way out of poverty. It is a controversial sport because of the perceived and actual risk of sustaining injury, and perhaps because of its connotative position as the sport of the marginalized. Because of the relatively recent popularity of women's boxing, though, there are relatively few opportunities for matches either professionally or on an amateur level. For most women boxers today it seems an activity more about personal growth than potential financial gain, or so goes the discourse. (For men, too, of course, a large part of the discourse is about personal growth, and also masculinity, as has been long, widely, and often even poetically commented on.)[4]

Riecke's posted videos, a total of twelve at this writing, were taken by a friend. They show her training with her coach Montel Griffin, sparring in a South Side gym, and in her Golden Gloves match. Each video is from one point of view, usually long shots with occasional zoom-ins to middle shots. Lighting is decent but image quality is middling. The videos are fascinating. Most range in length between twenty-eight seconds for a sparring shot and 10:08 minutes for the Golden Gloves match.[5] The YouTube user plugs "Chicago women's boxing" into the search box and Riecke's Chicago Golden Gloves match comes up, among other videos; clicking Riecke's match video then leads to a trail of "Manda boxing" videos in the related videos section. If the viewer's interest is about growth and development in a still relatively new boxer, the series of Riecke videos is a magnet. Watching them is to see a novice's improvement in technique, a letting go (humorously, to the viewer) of saying "I'm sorry"

after hitting someone in the ring, and incredible perseverance. I think it's the perseverance that drew me emotionally into the series. Amanda gets hit, she keeps going, she hits back, she gets hit again . . . over and over.

I talked with Riecke about her boxing experience and the videos, and the responses she's received to the videos.[6] At the time of our conversation, Riecke was twenty-six and had been training off and on for about two years. In high school, she hadn't been active in sports, and had only got into fitness in college. Employed full-time as a senior portfolio analyst in the University of Chicago's Office of Investments, she'd trained from the beginning of January up until her mid-April match four to five times a week for the Golden Gloves. During this time, the original motivation for creating the videos was to aid training. "When you're sparring," Riecke explains, "there's so much going on in your mind it's hard to focus on technique. So it's good to go back to the videos so you can see what you're doing." Posting them on YouTube also became a way to share them with friends and family. Riecke had mixed feelings about making them public on YouTube, though. She considers herself a boxing novice and so feels apprehensive about someone more knowledgeable seeing the videos and her developing technique. On the other hand, she didn't seem bothered that her mother in Louisiana, after watching some of the videos, stopped and refused to watch more, even the Golden Gloves one. And Riecke is equally sanguine about the gender-diverse responses she gets from friends; men like the videos whereas her female friends tend to caution her to not get hurt, to protect her face, and to not get her nose broken.[7] For Riecke the focus is on seeing and being seen by other boxers.

Even with that self-consciousness though, Riecke is proud of her Golden Gloves performance and the posted video of it. Riecke lost her senior-novice-division match by decision to her opponent Natalie Malik. Why the pride then? "I put my full effort behind it. In all my sparring and training that was my best bout. I was much more aggressive. . . . They [the Golden Gloves officials] are very quick to call the fight when there are women boxing. . . . Much more apt to do that with women. I'm proud that I went all three rounds into decision. Even though I didn't win. Proud of that." And the impact of her boxing on the rest of her life? "I was very passive in my relationships [before I started boxing]. With boxing, I've developed a new outlet for frustration and anger. It's given me confidence."

Riecke is a sympathetic figure to watch. At 5 feet 3 inches she tends to be shorter than her sparring or fighting opponents so her vulnerability, as well as her pugilistic toughness, is apparent. In the Golden Gloves video, the point of view is mainly long-range, from the seats and slightly above the arena, showing the whole ring. At times the camera zooms in to mid-range. Riecke starts out aggressively charging her taller, lankier opponent, but by the end of the first round has sustained more head blows. She is outboxed in the second round, and the viewer sees her repeatedly being hit in the head. At one point Malik has her pinned against the ropes, Riecke starts to pull away, and the referee has to separate the two boxers. Riecke goes to her corner. The camera zooms in on her, and the viewer can see her face. It's bloody. The third round starts. Riecke comes out swinging again. The crowd is yelling and cheering throughout the match. As a nonboxer, what really grips me in round three is Riecke's perseverance. After it's over and the two fighters have gone back

to their corners, they come out again, and, as is ritualistically traditional, hug each other. Throughout most of the fight, it's been clear who has been scoring the most hits, so it's no surprise when Malik is declared the winner at the end.

Watching the video of Riecke and Malik's Golden Gloves match is intense. I'm both rooting for Riecke (even before interviewing her I felt as if I knew her somewhat because I'd seen her train and spar on YouTube) and wanting the fight to be over. Over because I don't like seeing the head hits that they both sustain. What I like is witnessing the effort and fierce concentration of both fighters. I'm also impressed with their skills as when Riecke ducks a punch. But compared with seeing professional fights on TV, the novices' techniques seem subtly sloppy. In fact that perceived sloppiness, in addition to their perseverance, is what makes it possible for me to identify with them as somehow recognizable people putting a full effort into what they're doing.

Kate Gardiner's professional photographs posted on Flickr of Riecke boxing are sharper, better composed, and mid-range. They are shot intelligently for dramatic effect. They are among the many photographs uploaded by Gardiner in order to make them available for sale to Chicago Golden Gloves boxers. In figure 6.1, Gardiner has caught both boxers in the Malik/Riecke match landing punches simultaneously. The photograph is shot from below the ring, and its angle exaggerates the two fighters' height differences. What's harder for the photographs to convey though is the incredible sense of perseverance beyond reasonable limits seen in the Golden Gloves match video. However, Riecke's mixture of toughness and vulnerability, of strength earned from training and wariness of her opponent, comes through movingly in figure 6.2. In this photograph, Riecke

stands with her boxing-gloved fists up and ready; the rich darkness around a single spotlight takes up ample space above her in the frame; the inclusion of the ropes and the dark space in front of her with the crowd blurrily visible in the background heightens the confrontational tension. Underneath her headgear, Riecke's face is visible, intent, and wary, her gaze focused ahead. The engaged viewer can read in this image fear, determination, and the potential for aggression.

Stepping back now from individual case studies and thinking instead of the large set of cultural representations concerning women and aggression in its many dimensions, I have conflicts and hopes. My hopes have to do with radical democracy in which there's the possibility to share power because there is dissent via agonistic expression open to all subgroups and individuals. As Chantal Mouffe would argue, for survival, liberty, and equality, this vision of democracy is both a necessary and an impossible ideal, as all ideals are. But we can strive to approach the ideal, asymptotic though our efforts might be. I argue that the self-acceptance of individual and group capacity for a full range of aggression is key in this effort.

I find in the new images of aggressive women signs of hope for a cultural permissiveness and openness that can enable new habits for those of us who define ourselves as women. And they are in aggregate signs of hope that go beyond gender in functioning as an example of a historically disempowered (still a consideration no matter how much we women may wish ourselves beyond that situation!) subgroup's transition toward—or desire to transition toward—a fuller, equal, and aggressive deployment of power.

Ernst Bloch, philosopher of hope and utopia, has signaled what I would describe as the impetus for aggression within hope:

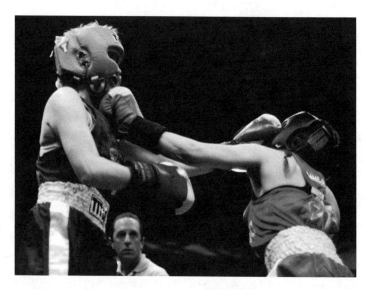

Figure 6.1
Natalie Malik (left) and Amanda Riecke (right) match at Chicago Golden Gloves, April 17, 2009.
Photograph by Kate Gardiner

"Hope is surrounded by dangers, and it [hope] is the consciousness of danger and at the same time the determined negation of that which continually makes the opposite of the hoped-for object possible."[8] Hope, in other words, includes pushing against. In the realm of this study, it could mean pushing against disempowering myths still at times wrapped around and constraining the readings of representations of aggressive women as in *Million Dollar Baby*. And it means so much more. It means the conflicts that come with hope, the realization of the conjoined nature of dreams and fears. There is much danger, much disempowerment, much inequality, gendered and otherwise in

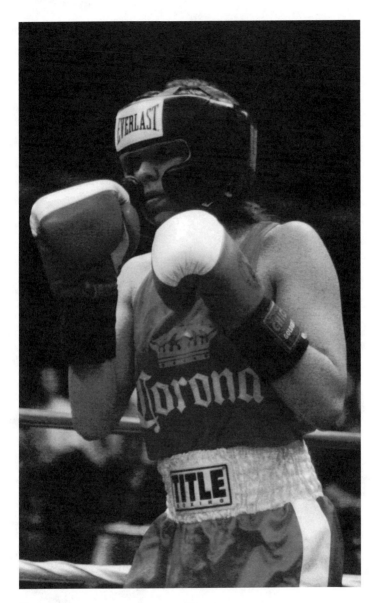

Figure 6.2
Amanda Riecke at Chicago Golden Gloves, April 17, 2009.
Photograph by Kate Gardiner

U.S. society, to shove hard against. And these shoves, in themselves aggressive, can be used constructively in so many ways to open a space for an empowered, representative, and agonistic democracy. In that space, with so much else of life and thriving and excess and fluidity, would be, I believe, for each person the full embrace, conscious pleasure, and strategic deployment of aggression.

Notes

Introduction

1. See, for example, in psychology, Dana Crowley Jack, *Behind the Mask: Destruction and Creativity in Women's Aggression* (Cambridge, MA: Harvard University Press, 1999); in art history, Mignon Nixon, "Bad Enough Mother," *October* 71 (Winter 1995): 72–92; and in creative nonfiction, Leah Hager Cohen, *Without Apology: Girls, Women, and the Desire to Fight* (New York: Random House, 2005); and of course in a number of disciplines—particularly, psychoanalytic theory—the Melanie Klein revival.

1 Sibling Play

1. "The ego is first and foremost a bodily ego; it is not merely a surface entity, but it is the projection of a surface. . . . the conscious ego . . . is first and foremost a body-ego." Sigmund Freud, *The Ego and the Id*, trans. Joan Riviere (New York: W. W. Norton, [1923] 1960), 20–21.

2. Mary Jo Kane et al., *Physical Activity and Sport in the Lives of Girls*, The President's Council on Physical Fitness and Sports, Department of Health and Human Services, 1997, http://www.fitness.gov/girlssports.htm (accessed July 18, 2009).

3. Ibid.

4. Diana Nyad and Candace Lyle Hogan, "Women: Empowered by Sports Technology," in *The Cult of Performance*, ed. Akiko Busch (New York: Cooper-Hewitt and Princeton Architectural Press, 1998), 47.

5. Dana Crowley Jack, *Behind the Mask: Destruction and Creativity in Women's Aggression* (Cambridge, MA: Harvard University Press, 1999).

6. The first-wave feminists were, of course, the suffragettes.

7. Iris Marion Young, "Throwing Like a Girl: A Phenomenology of Feminine Body Comportment, Motility, and Spatiality," in *Throwing Like a Girl and Other Essays in Feminist Philosophy and Social Theory* (Bloomington: Indiana University Press, 1990), 139–165.

8. See, in particular, Leslie Heywood and Shari Dworkin, *Built to Win: The Female Athlete as Cultural Icon* (Minneapolis: University of Minnesota Press, 2003); and Pat Griffin, *Strong Women, Deep Closets: Lesbians and Homophobia in Sport* (Champaign, IL: Human Kinetics, 1998).

9. J. Laplanche and J.-B. Pontalis, "Aggressiveness," in *The Language of Psycho-Analysis* (New York: W. W. Norton, 1973), 17–21.

10. This is a basic idea throughout Klein's work. See, for example, Melanie Klein, "Envy and Gratitude," in *Envy and Gratitude and Other Works, 1946–1963* (New York: Free Press, 1975), 176–235.

11. Some important historical precedents include *Personal Best*, 1982, which also raised gender and sexual orientation issues, and earlier Esther Williams's spectacular athleticism in her swimming musicals and the skill of female dancers from Ginger Rogers to Shirley Temple in other movie musicals. There is a great difference, of course between the cloaked power of Ginger Rogers's ballroom dancing and the relatively unrepressed and highly visible aggression portrayed in the recent sports movies.

12. Juliet Mitchell, *Siblings: Sex and Violence* (Cambridge: Polity, 2003), 215.

13. *Blue Crush* was produced by Imagine Entertainment, Mikona, Shutt/Jones, and Universal Pictures and distributed in North America by Universal Pictures; its U.S. gross from August 18–October 3, 2002, its

primary run, was $40,390,647, http://www.imdb.com (accessed July 18, 2009).

14. Bruce Jenkins, "For the Most Part, 'Blue Crush' Gets It Right," *SF Gate*, August 22, 2002, http://www.sfgate.com/cgi-bin/article.cgi?f=/ g/a/2002/08/22/surfcol.DTL (accessed July 18, 2009).

15. Susan Orlean, telephone interview with the author, September 27, 2006.

16. Jenkins, "For the Most Part, 'Blue Crush' Gets It Right." It should be noted that by 2008 women's surfing competitions had rapidly become more aggressive. For example: "During the final of the Reef Hawaiian Pro last month [Coco] Ho dropped in on a wave Beachley was surfing, cut her off and launched an aerial. Ho was cleared of any wrongdoing by the judges. But the move rankled Beachley, who believed it deprived her of a potential winning wave and demonstrated a lack of respect." Matt Higgins, "Daring Young Women Are on the Curl of a New Era," *New York Times*, December 11, 2008, www.nytimes.com/2008/12/11/ sports/othersports (accessed December 11, 2008).

17. *Wahine Surfing*, October 2, 2006, www.wahinesurfing.com/news (accessed November 10, 2006).

18. Mitchell, *Siblings*, 213.

19. *Stick It*, 2006, Jessica Bendinger director and writer; produced by Kaltenbach, Spyglass, and Touchstone; distributed in the United States by Buena Vista Pictures, U.S. gross April 30–July 23, 2006, $26,870,825, http://www.imdb.com (accessed July 18, 2009).

20. Mary Ann Doane, "Film and the Masquerade: Theorizing the Female Spectator," *Screen* 23 (September–October 1982): 74–87. For Doane, it should be noted, these terms are part of a complex exploration of the relationship between spectatorship and the masquerade. See also Doane's useful attention to whether or not a given text can "insure the availability of a feminist interpretation to the female spectator." Mary Ann Doane, "Masquerade Reconsidered: Further Thoughts on the Female Spectator," in *Femmes Fatales: Feminism, Film Theory, Psychoanalysis* (New York: Routledge, 1991), 42.

21. Melanie Klein, "Notes on Some Schizoid Mechanisms," in *Envy and Gratitude and Other Works, 1946–1963* (New York: Free Press, 1975), 9.

22. Mitchell, *Siblings*.

23. Perry Kim, email message to the author, on opening weekend in-theater survey (April 29, 2006) from WD Studies Motion Pictures, July 31, 2007.

24. See Joan Ryan's excellent reportage in her *Little Girls in Pretty Boxes: The Making and Breaking of Elite Gymnasts and Figure Skaters* (New York: Warner, 1995).

25. "Maddy did all of her own stunts with the exception of part of the handspring-front, which Kate Stopper doubled." Jessica Bendinger, email message to the author, November 28, 2006.

26. Jessica Bendinger, email message to the author, November 18, 2006.

27. Ibid.

28. Ibid.

29. *Bring It On*, 2000, director, Peyton Reed; writer, Jessica Bendinger; produced by Beacon Communications; distributed by Universal Pictures in the U.S.; U.S. gross August 27, 2000–January 1, 2001, $68,353,550, http://www.imdb.com (accessed July 18, 2009).

30. Jessica Bendinger, email message to the author, October 6, 2006.

31. Peter Marks, VP Research & Strategy of Universal Pictures, telephone conversation with the author, July 31, 2007.

32. Mitchell, *Siblings*.

33. Judith Butler, "Athletic Genders: Hyperbolic Instance and/or the Overcoming of Sexual Binarism," *Stanford Humanities Review* 6 (2) (Fall 1998): 84–112.

34. Heywood and Dworkin, *Built to Win*, 111.

35. Jack, *Behind the Mask*, 105–107.

2 Aging and Aggression

1. National Center for Health Statistics, "Estimated Life Expectancy at Birth in Years, by Race and Sex: Death-Registration States, 1900–1928, and United States, 1929–2002," Table 12, *National Vital Statistics Reports* 53 (6) (November 10, 2004), www.cdc.gov/nchs/data/dvs/nvsr53_06t12 .pdf (accessed July 24, 2009).

2. Mignon Nixon, email message to author, June 27, 2007. Thanks to Mignon Nixon for this key masking/marking point.

3. Margaret Morganroth Gullette, *Declining to Decline: Cultural Combat and the Politics of Midlife* (Charlottesville: University of Virginia Press, 1997).

4. Barry Bosworth, Gary Burgless, and Eugene Steuerle, "Lifetime Earnings Patterns, the Distribution of Future Social Security Benefits, and the Impact of Pension Reform," *Social Security Bulletin* 63 (4) (2000), 74–98; this quotation is from p. 78.

5. www.bls.gov/news.release/skyeng.nr0.htm (accessed July 17, 2007).

6. U.S. Department of Labor, Bureau of Labor Statistics, "Employment Status of the Civilian Noninstitutional Population by Age and Sex, 2005 Annual Averages," Table 1, 2005, http://www.bls.gov/cps/ wlf-table1-2006.pdf (accessed July 24, 2009).

7. Kathleen Woodward, "Against Wisdom: The Social Politics of Anger and Aging," *Journal of Aging Studies* 17 (2003): 56.

8. Angela Djurovic, "Sit Up Straight and Smile: Construction of the Postmenopausal Woman in Pharmaceutical Advertisements" (master's thesis, Department of Interdisciplinary Studies, DePaul University, Chicago, 2000).

9. *Prime Suspect* aired in the United States on PBS in seven multipart episodes, in 1992, 1993, 1994, 1995, 1997, 2004, and 2006.

10. Lynda La Plante, telephone interview with the author, August 3, 2007.

11. Television Research Partnership, Tim Colwell, and David Price, *Rights of Passage: British Television in the Global Market*, report commissioned by British Television Distributors' Association and U.K. Trade & Investment, September 2004, http://www.pact.co.uk/uploads/file _bank/1698.pdf (accessed July 24, 2009).

12. Bill Carter, "The Media Business: A British Mini-Series with Many Lives," *New York Times*, May 2, 1994, New York edition, sec. D.

13. "Meeting—Helen Mirren," *People*, February 15, 1993, 14.

14. La Plante, telephone interview.

15. John J. O'Connor, "Review/Television: Feminism Invades London Police in New Three-Part 'Mystery' Tale," *New York Times*, January 23, 1992, New York edition, sec. C.

16. Sigmund Freud, *The Ego and the Id*, trans. Joan Riviere, ed. James Strachey (New York: W. W. Norton, [1923] 1960), 56.

17. This is a key argument throughout Dana Crowley Jack, *Behind the Mask: Destruction and Creativity in Women's Aggression* (Cambridge, MA: Harvard University Press, 1999).

18. The Boston Women's Health Book Collective, *Our Bodies, Ourselves: Menopause* (New York: Touchstone/Simon & Schuster, 2006), 46–48.

19. See, for example, Erika Schwartz, *The Hormone Solution* (New York: Warner Books, 2002), 17.

20. J. Laplanche and J.-B. Pontalis, *The Language of Psycho-Analysis* (New York: W. W. Norton, [1967] 1973), 180–182.

21. As Klein theorizes, "The primary object against which the destructive impulses are directed is the object of the libido, and that is therefore the interaction between aggression and libido—ultimately the fusion as well as the polarity of the two instincts—which causes anxiety and guilt. *Another aspect of this interaction is the mitigation of the destructive impulses by the libido.*" Melanie Klein, "On the Theory of Anxiety and Guilt," in *Envy and Gratitude and Other Works, 1946–1963* (New York: Free Press, 1975), 41–42; my emphasis.

22. D. W. Winnicott, *Playing and Reality* (New York: Routledge, [1971] 2005); see especially the essay "Contemporary Concepts of Adolescent Development and Their Implications for Higher Education," 186–203.

23. Jack, *Behind the Mask.*

24. Kathleen Woodward, *Aging and Its Discontents: Freud and Other Fictions* (Bloomington: Indiana University Press, 1991). See especially chapter 4, "The Look and the Gaze: Narcissism, Aggression, and Aging . . . Virginia Woolf's *The Years*," 72–91.

25. Jacques Lacan, "Aggressivity in Psychoanalysis" (1948), in *Ecrits: A Selection*, trans. Alan Sheridan (New York: W. W. Norton, 1977), 19.

26. Ibid.

27. Ibid., 24.

28. The seminal work in the body of critical writing on cultural myths of aging is Simone de Beauvoir, *The Coming of Age*, trans. Patrick O'Brian (New York: W. W. Norton, [1970] 1996). See also Kathleen Woodward, "Simone de Beauvoir: Aging and Its Discontents," in *The Private Self: Theory and Practice of Women's Autobiographical Writings*, ed. Shari Binstock (Chapel Hill: University of North Carolina Press, 1988), 90–113; and, in general, the oeuvres of Kathleen Woodward and Margaret Morganroth Gullette.

29. La Plante, telephone interview with the author.

30. See Jane Juska, *A Round-Heeled Woman* (New York: Villard, 2004); Jill Nelson, *Sexual Healing* (Chicago: Agate Books, 2003) and *Let's Get It On* (New York: Amistad/HarperCollins, 2009).

31. Jack is referring to J. T. Shipley, *Dictionary of Word Origins* (Totowa, NJ: Littlefield, Adams, 1967). Jack, *Behind the Mask*, 45.

32. Winnicott, *Playing and Reality*, 200.

33. Laplanche and Pontalis, *Language of Psycho-Analysis*, 21.

34. Winnicott, *Playing and Reality*, 210.

35. On Deasy's alcoholism in particular and alcoholism endemic to police work in general, see Alan Riding, "Murder, Booze, and Misery: A Female Cop's Last Hurrah," *New York Times*, November 8, 2006, New York edition, sec. E. And for more on the controversy about the last episode, see Libby Brooks, "Comment and Debate: Struck Down in Her Prime: Jane Tennison's Fall Was a Sad End for a Character Emblematic of Women's Workplace Struggle," *The Guardian* (London), October 24, 2006.

36. John Leonard, "Iron Maiden," *New York Magazine*, November 13, 2006, 93–94.

3 Violence

1. Paul Duncum, "Attractions to Violence and the Limits of Education," *Journal of Aesthetic Education* 40 (4) (Winter 2006): 21–38; these quotations are from p. 32.

2. Dolf Zillman, "The Psychology of the Appeal of Portrayals of Violence," in *Why We Watch: The Attractions of Violence*, ed. Jeffrey Goldstein (New York: Oxford University Press, 1998), 179–211. This quotation is from p. 206; emphasis in original. Zillman's complicating of common critical assumptions about mechanisms of identification in viewing film is provocative and useful, and yet he is a scholar whose work is relatively unknown in cultural studies. Zillman began his education in design at Ulm (graduating in 1959 with a diploma in communication and cybernetics) and continued it in the fields of communication and psychology (PhD, University of Pennsylvania, 1969) in the United States. He worked in the private sector in marketing and became a distinguished and innovative communications scholar in academia. Jennings Bryant, David Roskos-Ewoldsen, and Joanne Cantor, "A Brief Biography and Intellectual History of Dolf Zillman," in *Communication and Emotion*, ed. Jennings Bryant, David Roskos-Ewoldsen, and Joanne Cantor (Mahwah, NJ: Laurence Erlbaum Associates, 2003), 7–27. For me, he is refreshing to read at this point in the evolution of visual cultural studies because of the odd mix of his adherence to empirical studies and his ambitious rethinking of conceptual frameworks involving perception and reception.

Zillman is perhaps best known for his midcareer research on the connections between sexuality and aggression (not so useful for this book—Zillman defines aggression in the traditional way as harm to others), in which he empirically studies responses to pornography and conceptualized ideas of excitation transfer. Dolf Zillman, *Connections between Sexuality and Aggression*, 2nd ed. (Mahwah, NJ: Lawrence Erlbaum Associates, [1984] 1998). But as a cultural critic, it's most enjoyable to read some of his curmudgeonly later work, in which he dismisses easy ideas such as the assumption that watching violence provides viewers with catharsis or even that violence itself is pleasurable to watch. He argues instead that it's viewing violence in certain contexts, such as retributive ones, that gives pleasure and excitation.

3. Zillman, "Psychology of the Appeal of Portrayals of Violence," 179–211.

4. Melanie Klein and Joan Riviere, *Love, Hate, and Reparation* (New York: W. W. Norton, 1964), 5.

5. Juliet Mitchell, *Siblings: Sex and Violence* (Cambridge: Polity, 2003), 11.

6. Ibid., 28.

7. Ibid., 134.

8. Sigmund Freud, *The Interpretation of Dreams*, trans. James Strachey (New York: Avon, [1900] 1965), 284.

9. Ibid., 286.

10. Lisa Coulthard, "Killing Bill: Rethinking Feminism and Film Violence," in *Interrogating Postfeminism: Gender and the Politics of Popular Culture*, ed. Yvonne Tasker and Diane Negra (Durham: Duke University Press, 2007), 153–175.

11. http://www.thenumbers.com/movies/series/KillBill.php (accessed January 2, 2009).

12. Susan Buck-Morss, "The Cinema Screen as Prosthesis of Perception: A Historical Account," in *The Senses Still: Perception and Memory as Material Culture in Modernity*, ed. C. Nadia Seremetakis (Boulder, CO: Westview Press, 1994), 45–62.

13. "The Kleinian universe . . . is dominated by the mother. The omnipotence of this archaic figure is threatening and terrifying. Is the mother so pernicious that we have to abandon her and hasten her death? . . . Does the requisite abandonment of the mother constitute a journey toward the father, as Freud and Lacan believed? Or does it set the stage for subsequent reunions with a good mother who is finally restored, gratifying, and gratified? That is more likely because, in the eyes of our author, there is no birth without a witch and no baby without envy." Julia Kristeva, "The Cult of the Mother or an Ode to Matricide?" in *Melanie Klein* (New York: Columbia University Press, 2001), 12.

14. Maud Lavin, "Marlene McCarty at Metro Pictures," *Art in America* (July 1993): 102–103.

15. This version of the text is the one accompanying the six drawings (*353 Hibiscus Way*) project.

16. Marlene McCarty, visiting artist lecture at the School of the Art Institute of Chicago, Chicago, IL, October 20, 1997.

17. Cathy Lebowitz, "Marlene McCarty: Cathy Lebowitz Interviews Josefina Ayerza," *Lacanian Ink* 20 (2002): 120.

18. Marlene McCarty, interview with the author, February 2003, New York City.

19. All statistics in this section are from the U.S. Department of Justice, Office of Justice Programs, Bureau of Justice Statistics, "Homicide Trends in the U.S.," http://www.ojp.usdoj.gov/bjs/homicide/gender.htm (accessed July 31, 2009).

20. What have previous critical responses to the *Murder Girls* been? Starting in 1998 and early 1999—particularly in February 1999 with a *frieze* review of the 1998 Swiss Institute show that included some *Murder Girls* portraits—and extending through today, the *Murder Girls* have been regularly discussed in the art and mass media press. Primarily in three- to four-paragraph review form, articles on these works have also appeared in *Flash Art* (2000), *Vogue* (2000), *New Yorker* (2002, 2004), *Artext* (2002), *Artforum* (2002), *Los Angeles Times* (2002), *Lacanian Ink* (2002), *New York Times* (2001, 2002, 2004), *Artforum.com* (2004), *Time Out New York*

(2004), *Print* (2004), and other venues, including catalogs. As is usual, these reviews build on each other and the general discussion about McCarty's controversial works so that later reviews are more sophisticated than earlier ones. Quite arguably, Shonagh Adelman states in *frieze* that the *Murder Girls* reflect "the inviolable association between sexual precociousness and criminal female behavior." Shonagh Adelman, "Where Is Your Rupture?" *frieze* (February 1999): 95. Inviolable?—I don't think so. Another early review, this one in *Flash Art* by Michael Cohen, calls the drawings celebratory and asserts that they go beyond the limits set by law—using outlaw-admiring phrases perhaps more appropriate to early nineties bad girl art than to the figures in this series which Hilton Als later and more aptly describes as "tawdry, laconic, sexy, and sad." Michael Cohen, "The Love Mechanics," *Flash Art* (Summer 2000): 90–93; Hilton Als, "Teen Beat," *New Yorker*, January 28, 2002, 17.

Like reviews of other artists whose work addresses issues of sexuality, identity, and representation (most notably the art criticism about Sophie Calle), a number of writers (myself included, no doubt) seem to involve projection or otherwise an incorporation of their own concerns around these issues. Laurence Rickels in *Artext*, for instance, spends space speculating on the *Murder Girls'* relationships with their dads not moms, even though fathers appear in few of the stories McCarty tells. The dialog in *Lacanian Ink* between Cathy Lebowitz and Josefina Ayerza considers the stories as related by McCarty to be psychoanalytic texts. A number of reviewers, including Rickels, wonder what McCarty's return again and again to the *Murder Girls*—specifically, to the story of the same-named Marlene Olive—reveals about McCarty's preoccupations in her own life. As Bruce Hainley thoughtfully articulates in *Artforum*: "Are these careful mediations also self-portraits? Drawings in the psychic turmoil known as the teenage, McCarty's renderings of girls may be the uncanny equivalent or counterpoint to Larry Clark's portraits of boys, in which being and representing, having and wanting are collapsed." Bruce Hainley, "Marlene McCarty at Sandroni.Rey," *Artforum*, February 2002, 135–136.

There is disagreement in the press about whether the uniform and hairless drawings of naked genitalia that often appear in the portraits over or beneath the clothed images of the girls are erotic or de-eroticized. Interestingly, the word "lassitude" pops up in a number of

reviews to describe the girls, and, I think, to distance the writer from questions of eroticism and voyeurism. Leah Ollman in the *Los Angeles Times* brings up the question of whether McCarty is sympathetic to and/or sensationalizing and exploitative of the girls. A catalog allusion in the Swiss Institute publication makes it clear that this controversial issue is also discussed about the works outside the press in the art world—airing crimes committed by juveniles is taboo in our culture, after all. The contexts of the seventies and of McCarty's lesbianism are rarely mentioned. (Exceptions are provided, respectively, in "Goings on About Town," *New Yorker*, February 9, 2004, 12, and in Hainley, "Marlene McCarty at Sandroni.Rey," 135–136.) By 2004, though, even short reviews speak eloquently of the complexity of the works: "McCarty's subject is a psychological endgame, whereby the forces of individuation and burgeoning sexuality are transformed, via extremes of adolescent narcissism and juvenile myopia, into a rebellious rage with an irreversible outcome. McCarty's drawings of Marlene Olive's sad story place viewers in the uncomfortable position of searching for meaning in murder." Catherine Morris, "Marlene McCarty at Brent Sikkema," *Time Out New York*, January 29–February 5, 2004, 66. Well put, and I would add that the works also put the viewer in the disquieting position of searching for meaning in aggression—that of the subjects and perhaps the artist—but most deeply and uncomfortably, the viewer's own. Selected reviews and press mentions include Shonagh Adelman, "Where Is Your Rupture?" *frieze* (February 1999): 95; Michael Cohen, "The Love Mechanics," *Flash Art* (Summer 2000): 90–93; Holland Cotter, "Dear Dead Person," *New York Times*, May 25, 2001, New York edition, sec. E; Leah Ollman, "Galleries," *Los Angeles Times*, January, 11 2002, sec. F; Hilton Als, "Teen Beat," *New Yorker* (January 28, 2002): 17; Bruce Hainley, "Marlene McCarty at Sandroni.Rey," *Artforum* (February 2002): 135–136; Holland Cotter, "Marlene McCarty at American Fine Arts and Bronwyn Keenan Galleries," *New York Times*, February 22, 2002, New York edition, sec. E; Laurence Rickels, "Marlene McCarty at Sandroni. Rey," *Artext* (Summer 2002): 80–81; Cathy Lebowitz and Josefina Ayerza, "Marlene McCarty," *Lacanian Ink* 20 (2002): 114–123; Joy Press, "Girl Crazy," *Vogue* (September 2002): 486–488; John Reed, "Marlene McCarty at Brent Sikkema," *Artforum.com*, February 12, 2004; "Goings on About

Town," *New Yorker* (February 9, 2004): 12; Catherine Morris, "Marlene McCarty at Brent Sikkema," *Time Out New York* (January 29–February 5, 2004): 66; Roberta Smith, "Marlene McCarty at Brent Sikkema," *New York Times*, January 23, 2004, the New York edition, sec. E; Maud Lavin, "Exploding Powder Puffs," *Print Magazine* 58 (2) (March 2004): 68–73.

21. Juliet Mitchell, ed., *The Selected Melanie Klein* (New York: The Free Press, 1986), 22.

22. Ibid., 95–98.

23. Ibid., 131–132.

24. Jean Laplanche and J.-B. Pontalis, *The Language of Psycho-Analysis* (New York: W. W. Norton, 1973), 17.

25. Dana Crowley Jack, *Behind the Mask: Destruction and Creativity in Women's Aggression* (Cambridge, MA: Harvard University Press, 1999), 12.

26. Patricia Pearson, *When She Was Bad* (New York: Penguin, 1998).

4 Unbuttoning Sexuality

1. Mark Anthony Neal, *Soul Babies: Black Popular Culture and the Post-Soul Aesthetic* (New York: Routledge, 2002).

2. Yvonne J. Medle, "Zane, an Intensely Private Writer of Erotica, Sees Her Profile Grow," *The Washington Post*, October 9, 2005, Sunday final edition, Southern Maryland Extra, sec. T.

3. Vanessa E. Jones, "Zane Uncovered," *Boston Globe*, September 7, 2004, third edition, sec. C.

4. Hortense Spillers, "Interstices: A Small Drama of Words," in *Pleasure and Danger: Exploring Female Sexuality*, ed. Carole Vance (Boston: Routledge & Kegan Paul, 1984), 74.

5. Mary Mitchell, "TV Finally Broaches Female Sexuality," *Chicago Sun-Times*, March 8, 2005, p. 14.

6. Hope Ashby, "*Ebony* Sex Survey: Sisters Speak Out about Their Sexuality," *Ebony* (October 2004): 110–119.

7. Gail Elizabeth Wyatt, *Stolen Women: Reclaiming Our Sexuality, Taking Back Our Lives* (New York: John Wiley & Sons, 1997), 239.

8. Ibid., 123–126.

9. Patricia Hill Collins, *Black Sexual Politics* (New York: Routledge, 2004), 58–59. See also Kevin Gaines, *Uplifting the Race: Black Leadership, Politics, and Culture in the Twentieth Century* (Chapel Hill: University of North Carolina Press, 1996).

10. Collins, *Black Sexual Politics*, 71.

11. Jill Nelson, *Straight, No Chaser: How I Became a Grown-Up Black Woman* (New York: Penguin, 1997).

12. Sigmund Freud quoted in Jean Laplanche and J.-B. Pontalis, *New Introductory Lectures on Psycho-Analysis* (New York: W. W. Norton, 1973), 437.

13. D. W. Winnicott, *Playing and Reality* (New York: Routledge, [1971] 2005), 18.

14. Ibid., 19.

15. Ibid., 17–19.

16. Zane, *Shame on It All* (New York: Atria Books, 2005), 17.

17. Ibid., 18.

18. Ibid., 79.

19. Ibid., 20.

20. Zane, ed., *Breaking the Cycle* (New York: Strebor, 2005).

21. Vanessa E. Jones, "Zane Uncovered: With Her First Book Tour, the Mysterious Author of Black Erotica Goes Public, *Boston Globe*, September 7, 2004, third edition, sec. C; Gina Bellafonte, "A Writer of Erotica Allows a Peek at Herself," *New York Times*, August 22, 2004, Sunday late edition, sec. 9.

22. Zane, Eileen M. Johnson, and V. Anthony Rivers, *Love Is Never Painless* (New York: Atria Books, 2006), 277–279.

23. Tricia Rose quoted in Gary Younge, "Little Black Books," *The Guardian* (London), September 18, 2004, sec. Guardian Weekend Pages, p. 22.

24. Zane, *Addicted* (New York: Atria Books, 1998), 3.

25. E. Frances White, *Dark Continent of Our Bodies: Black Feminism and the Politics of Respectability* (Philadelphia: Temple University Press, 2001).

26. Tricia Rose, "'Two Inches or a Yard': Silencing Black Women's Sexual Expression," in *Talking Visions: Multicultural Feminism in a Transnational Age*, ed. Ella Shohat (Cambridge, MA: MIT Press, 1999), 320; emphasis in original.

27. Eisa Ulen, "Zane Speaks Out on Homophobia," *EisaUlen.com*, May, 10, 2008, http://eisaulen.com/blog//index.php/2008/05/10/zane_speaks _out_on_homophobia (accessed August 3, 2009).

28. Zane, *Afterburn* (New York: Atria Books, 2005), 203–204.

29. Ibid., 204.

30. There are other examples—Terry McMillan and Jill Nelson, to name just two—but it's still overall a rarity in U.S. mass culture.

31. Matthea Harvey, "Kara Walker," *Bomb* 100 (Summer 2007), http: www.bombsite.com/issues/100/articles/2904 (accessed May 17, 2009).

32. Ibid.

33. Kara Walker quoted in Hilton Als, "The Shadow Act: Kara Walker's Vision," *New Yorker* (October 8, 2007): 75.

34. Tang Museum, January 18–June 1 2003; Williams College Museum of Art, August 30–December 5 2003; Walker Art Center, February 17– May 13, 2007; Whitney Museum of American Art, October 11, 2007– February 3, 2008; and Hammer Museum, February 17, 2007–May 11, 2008.

35. The most recent summary and discussion of this controversy is in Sander Gilman, "Confessions of an Academic Pornographer," in *Kara*

Walker: My Complement, My Enemy, My Oppressor, My Love (Minneapolis: Walker Art Center, 2007), 26–35.

36. Gilman, "Confessions of an Academic Pornographer," 31.

37. Eric Lott, *Love and Theft: Blackface Minstrelsy and the American Working Class* (New York: Oxford University Press, 1993); John Strausbaugh, *Black Like You: Blackface, Whiteface, Insult and Imitation in American Popular Culture* (New York: Penguin, 2006).

38. Kymberly Pinder, "Exhibition Review: Kara Walker, My Complement, My Enemy, My Oppressor, My Love," *Art Bulletin* 90 (4) (December 2008): 640–648.

39. Within this frame, Saar would be an example of one who chooses moralizing over engagement or moralizing as a refusal of engagement.

40. Anne McClintock, "Maid to Order: Commercial S/M and Gender Power," in *Dirty Looks: Women, Pornography, Power*, ed. Pamela Church Gibson and Roma Gibson (London: BFI Publishing, 1993), 227.

41. Ibid., 210.

42. Gwendolyn Dubois Shaw, *Seeing the Unspeakable: The Art of Kara Walker* (Durham: Duke University Press, 2004), 67–101.

43. Darby English, "This Is Not about the Past: Silhouettes in the Work of Kara Walker," in *Kara Walker: Narrative of a Negress* (Cambridge, MA: MIT Press, 2003), 143.

44. Jessica Benjamin, "Sympathy for the Devil: Notes on Sexuality and Aggression, with Special Reference to Pornography," in *Like Subject, Like Object: Essays on Recognition and Sexual Difference* (New Haven: Yale University Press, 1995), 211.

45. Robert Reid-Pharr, "Black Girl Lost," in *Kara Walker: Pictures from Another Time* (Ann Arbor: D.A.P./Distributed Art Publishers/University of Michigan Museum of Art, 2002), 27–41.

46. In the book, for example, Uncle Tom was meant as a positive icon, a transparent representation of a black Christ; but in American culture

over time, citing the character became an insult, the sign of a black person complicit in his own subjugation or pandering to whites.

47. Sigmund Freud, *Three Essays on the Theory of Sexuality*, trans. James Strachey (New York: Basic Books, [1905] 1962), 25.

48. For a multilayered discussion of the historical roles of black artist in American art history, along with other related issues, see *Race-ing Art History: Critical Readings in Race and Art History*, ed. Kymberly Pinder (New York: Routledge, 2002).

49. Als, "The Shadow Act," 75.

50. Reid-Pharr, "Black Girl Lost."

51. "Thelma Golden/Kara Walker: A Dialogue," in *Kara Walker: Pictures from Another Time*, ed. Annette Dixon (Ann Arbor: D.A.P./Distributed Art Publishers/University of Michigan Museum of Art, 2002), 46.

5 More Siblings

1. See, for example, Nicholas Bourriaud, *Relational Aesthetics* (Paris: Les presses du réel, 2002); Claire Bishop, ed., *Participation* (London: Whitechapel and Cambridge, MA: MIT Press, 2006); Claire Bishop, "Antagonism and Relational Aesthetics," *October* 110 (Fall 2004): 51–79; Grant Kester, *Conversation Pieces* (Berkeley: University of California Press, 2004).

2. See especially Claire Bishop, "Antagonism and Relational Aesthetics," *October* 110 (Fall 2004): 51–79.

3. Ibid., 102.

4. Ibid., 101.

5. In this, it seems that in a way Mouffe is revisiting Althusser's concept of Ideological State Appartuses (ISAs), but whereas he stresses ISA support of ruling-class ideology and only secondarily their capacity to function as platforms for the articulation of clashes and contradictions, Mouffe emphasizes that capacity. Louis Althusser, "Ideology and Ide-

ological State Apparatuses," in *Lenin and Philosophy and Other Essays*, trans. Ben Brewster (New York: Monthly Review Press, 1971), 127–186.

6. http://www.youtube.com/watch?v=oXahaSK9_07 (accessed July 21, 2009). In addition to the performance, *The Way That We Rhyme* also included Toxic Titties' video *Ikea Project*, parodying ads aimed at "lavender" markets.

7. http://www.flickr.com/search/?s=int&w=all&q=%22Toxic+Titties%22&m=text (accessed July, 22 2009).

8. http://www.toxictitties.com/project/toxictroopers.htm (accessed August 25, 2008).

9. See discussion of trauma and affect in significant affect discourse including critic Ann Cvetokich, *An Archive of Feelings* (Durham: Duke University Press, 2003).

10. Kristen Raizada, "An Interview with the Guerilla Girls, Dyke Action Machine (DAM!), and the Toxic Titties," *NWSA Journal* 19 (1) (Summer 2007): 45.

11. All quotes are from Julia Steinmetz, interview with Maud Lavin, July 13, 2008.

12. Julia Steinmetz et al., "Behind Enemy Lines: Toxic Titties Infiltrate Vanessa Beecroft," *Signs* 31 (3) (2006): 753–783.

13. Both quotations are from ibid., 776.

14. http://www.toxictitties.com/projects/beecroft.html (accessed October 24, 2009).

15. Ibid., 774.

16. Ibid., 764.

17. Melanie Klein and Joan Riviere, *Love, Hate, and Reparation* (New York: W. W. Norton, 1964).

18. After talking with Steinmetz, I returned to Winnicott's classic 1969 essay, "The Use of an Object and Relating through Identification," where he discusses how desirable it is for the patient to perceive the

transferential "object [the analyst] survives destruction by the subject [analysand]." The goal is dual: (1) the key breaking of "omnipotent" roles (Winnicott means the subject's but I believe it's the analyst's as well and the fantastical competitiveness that can result if both identify with personae of omnipotence), and (2) the analysand's realization that the analyst has survived the attack and now understands she can make demands on or use the analyst. And Winnicott, influenced by Klein, describes this action in the context of the admixture of love and aggression: "Usually the analyst lives through these phases of movement in the transference, and after each phase there comes reward in terms of love, reinforced by the fact of the backcloth of unconscious [and I'd add conscious] destruction." D. W. Winnicott, *Playing and Reality* (New York: Routledge, [1971] 2005), 120, 124.

19. Ibid., 126–127.

20. In a much earlier essay on aggression, "Aggression in Relation to Emotional Development" (1950–1955), Winnicott writes of the fusion of aggressive and erotic elements in the individual, and the need for opposition at developmental stages ranging from infancy to adulthood. D. W. Winnicott, "Aggression in Relation to Emotional Development," in *Through Paediatrics to Psycho-Analysis* (London: Hogarth Press, 1975), 204–218.

21. Ibid., 205.

22. Ibid., 217; emphasis in original.

23. Ibid., 218.

24. Laurie Palmer, interview with Maud Lavin, June 13, 2008.

25. Melanie Klein, "Envy and Gratitude," in *Envy and Gratitude and Other Works 1946–1963* (New York: Free Press, 1975).

26. Palmer, interview with Maud Lavin.

27. See Miwon Kwon's discussion of *Flood* as a self-created institution in and outside of the art context. "And in outliving 'Culture in Action,' they [Flood and one other project] exceeded their given status as community-based public art projects: their meaning and value defied the

specific art-oriented contextualization of the exhibition." Miwon Kwon, *One Place after Another: Site-Specific Art and Locational Identity* (Cambridge, MA: MIT Press, 2002), 132.

28. Wendy Jacob et al., ed., *With Love from Haha* (Chicago: Whitewalls, 2008), 56–69; this quotation is from p. 57.

29. John Ploof, interview with Maud Lavin, February 19, 2009.

30. Relevant here is Claire Bishop's observation in *October*: "If relational art produces human relations, then the next logical question to ask is what *types* of relations are being produced, for whom, and why." Claire Bishop, "Antagonism and Relational Aesthetics," *October* 110 (Fall 2004): 65.

31. Chantal Mouffe, *The Democratic Paradox* (New York: Verso, 2000), 103.

32. Gregory Sholette, "Counting on Your Collective Silence: Notes on Activist Art as Collaborative Practice," *Afterimage* (November 1999): 18–20.

33. Mouffe, *Democratic Paradox*, 127.

34. From Chantal Moufffe's faculty page on the University of Westminster Web site, http://www.wmin.ac.uk/sshl/page-1527-smhp=1, accessed on March 30, 2009: "A political theorist educated at the universities of Louvain, Paris, and Essex Chantal Mouffe is Professor of Political Theory at the University of Westminster. . . . Between 1989 and 1995 she was Directrice de Programme at the College Internationale in Paris." Mouffe was born in Belgium.

35. Mouffe, *Democratic Paradox*, 139.

36. http://www.uic.edu/jaddams/hull/newdesign/programs.html (accessed August 29, 2008).

37. Lisa Lee, interview with Maud Lavin, June 26, 2008.

38. Lee, interview with Maud Lavin. Lee quotations that follow are from the same source.

39. Winnicott, "Aggression in Relation to Emotional Development," 205.

40. *Oxford English Dictionary*, "Power," http://www.dictionary.oed.com (accessed August 23, 2008).

41. Joan W. Scott, "Gender: A Useful Category of Historical Analysis," *The American Historical Review* 91 (5) (December 1986): 1073.

42. Slavoj Žižek, "Introduction: Robespierre, or the 'Divine Violence' of Terror," in *Virtue and Terror (Revolutions)*, Maximilien Robespierre (New York: Verso, 2007), vii–xxxix.

6 Conclusion

1. Ernst Bloch, "Nonsynchronism and Dialectics" (1932), *New German Critique* 11 (Spring 1977): 22–38.

2. Carol-Ann Farkas, "Bodies at Rest, Bodies in Motion: Physical Competence, Women's Fitness, and Feminism," *Genders Online Journal* 45(2007); Leah Hager Cohen, *Without Apology: Girls, Women, and the Desire to Fight* (New York: Random House, 2005).

3. Cohen, *Without Apology*, 188.

4. See David Scott, *The Art and Aesthetics of Boxing* (Lincoln: University of Nebraska Press, 2008); and Kathleen Woodward, *Boxing, Masculinity and Identity* (New York: Routledge, 2007).

5. www.youtube.com/watch?v=u1QWsECyUCE&feature=related (accessed August 11, 2009).

6. Amanda Riecke, interview with Maud Lavin, July 29, 2009. Subsequent Riecke quotations are from this interview.

7. There are no comments posted on YouTube underneath her videos; these responses were said to Riecke directly.

8. Ernst Bloch, *The Utopian Function of Art and Literature*, trans. Jack Zipes and Frank Mecklenburg (Cambridge, MA: MIT Press, 1988), 17.

Bibliography

Ahmed, Sarah. *The Cultural Politics of Emotion*. New York: Routledge, 2004.

Als, Hilton. "The Shadow Act: Kara Walker's Vision." *New Yorker* (October 8, 2007): 70–79.

Althusser, Louis. *Lenin and Philosophy and Other Essays*. Trans. Ben Brewster. New York: Monthly Review Press, 1971.

Arendt, Hannah. *The Human Condition*. Chicago: University of Chicago Press, [1958] 1998.

Ashby, Hope. "*Ebony* Sex Survey: Sisters Speak Out about Their Sexuality." *Ebony* (October 2004): 110–119.

Benjamin, Jessica. "Sympathy for the Devil: Notes on Sexuality and Aggression, with Special Reference to Pornography." In *Like Subject, Like Objects: Essays on Recognition and Sexual Difference*. New Haven: Yale University Press, 1995, 175–211.

Berlage, Gai Ingham. "Marketing and the Publicity Images of Women's Professional Basketball Players from 1977 to 2001." In *The Kaleidoscope of Gender: Prisms, Patterns, and Possibilities*, ed. Joan Z. Spade and Catherine Valentine. Belmont, CA: Wadsworth Thomason Learning, 2004, 377–386.

Berry, Ian, et al., eds. *Kara Walker: Narratives of a Negress*. Cambridge, MA: MIT Press, 2003.

Bishop, Claire. "Antagonism and Relational Aesthetics." *October* 110 (Fall 2004): 51–79.

Bishop, Claire, ed. *Participation*. London: Whitechapel and Cambridge, MA: MIT Press, 2006.

Bishop, Claire. "The Social Turn: Collaboration and Its Discontents." *Artforum* (February 2006): 178–183.

Björkqvist, Kaj, and Pirkko Niemelä. *Of Mice and Women: Aspects of Female Aggression*. San Diego: Academic Press, 1992.

Blais, Madeleine. *In These Girls, Hope Is a Muscle*. New York: Warner, 1995.

Bloch, Ernst. "Nonsynchronism and Dialectics." 1932. *New German Critique* 11 (Spring 1977): 22–38.

Bloch, Ernst. *The Utopian Function of Art and Literature*. Trans. Jack Zipes and Frank Mecklenburg. Cambridge, MA: MIT Press, 1988.

Bourriaud, Nicolas. *Relational Aesthetics*. Paris: Les presses du réel, 2002.

Brooks, Libby. "Comment and Debate. Struck Down in Her Prime: Jane Tennison's Fall Was a Sad End for a Character Emblematic of Women's Workplace Struggle." *The Guardian* (London) (October 24, 2006): 33.

Brown, Paula, and Ilsa Schuster, eds. "Culture and Aggression." Special issue, *Anthropological Quarterly* 59 (4) (October 1986): 155–204.

Brundson, Charlotte, Julie D'Acci, and Lynn Spigel, eds. *Feminist Television Criticism: A Reader*. Oxford: Clarenden Press, 1997.

Bryant, Jennings, David Roskos-Ewoldsen, and Joanne Cantor. "A Brief Biography and Intellectual History of Dolf Zillmann." In *Communication and Emotion*, ed. Jennings Bryant, David Roskos-Ewoldsen, and Joanne Cantor. Mahwah, NJ: Laurence Erlbaum, 2003, 7–27.

Buck-Morss, Susan. "The Cinema Screen as Prosthesis of Perception: A Historical Account." In *The Senses Still: Perception and Memory as Material Culture in Modernity*, ed. C. Nadia Seremetakis. Boulder, CO: Westview Press, 1994, 45–62.

Butler, Judith. "Athletic Genders: Hyberbolic Instance and/or the Overcoming of Sexual Binarism." *Stanford Humanities Review* 6 (2) (Fall 1998): 84–112.

Bynum, Victoria. *Unruly Women: The Politics of Social and Sexual Control in the Old South*. Chapel Hill: University of North Carolina Press, 1992.

Cahn, Susan K. *Coming on Strong: Gender and Sexuality in Twentieth-Century Women's Sport*. Cambridge, MA: Harvard University Press, 1994.

Chodos, Elizabeth, ed. *Talking with Your Mouth Full: New Language for Socially Engaged Art*. Chicago: Green Lantern, 2008.

Cohen, Leah Hager. *Without Apology: Girls, Women, and the Desire to Fight*. New York: Random House, 2005.

Collins, Patricia Hill. *Black Sexual Politics*. New York: Routledge, 2004.

Coulthard, Lisa. "Killing Bill: Rethinking Feminism and Film Violence." In *Interrogating Postfeminism: Gender and the Politics of Popular Culture*, ed. Yvonne Tasker and Diane Negra. Durham: Duke University Press, 2007, 153–175.

Cvetovich, Ann. *An Archive of Feelings*. Durham: Duke University Press, 2003.

De Beauvoir, Simone. *The Coming of Age*. New York: W. W. Norton, [1970] 1996.

Dixon, Annette, ed. *Kara Walker: Pictures from Another Time*. Ann Arbor: D.A.P./Distributed Art Publishers/University of Michigan Museum of Art, 2002.

Djurovic, Angela. "Sit-Up Straight and Smile." Master's thesis, Department of Interdisciplinary Studies. Chicago: DePaul University, 2000.

Doane, Mary Ann. *Femmes Fatales: Feminism, Film Theory, Psychoanalysis*. New York: Routledge, 1991.

Doane, Mary Ann. "Film and the Masquerade: Theorizing the Female Spectator." *Screen* 3–4 (September–October 1982): 74–87.

Doyle, Jennifer, and Amelia Jones. "Introduction: New Feminist Theories of Visual Culture." *Signs* 31 (3) (Spring 2006): 607–615.

Du Bois, W. E. B. *The Souls of Black Folk*. Stilwell, KS: Digireads, [1903] 2005.

Duncum, Paul. "Attractions to Violence and the Limits of Education." *Journal of Aesthetic Education* 40 (4) (Winter 2006): 21–38.

English, Darby. *How to See a Work of Art in Total Darkness*. Cambridge, MA: MIT Press, 2007.

Farkas, Carol-Ann. "Bodies at Rest, Bodies in Motion: Physical Competence, Women's Fitness, and Feminism." *Genders Online Journal* 45 (2007).

Flanagan, Mary, et al. "Feminist Activist Art, A Roundtable Forum, August 24–31, 2005." *NWSA Journal* 19 (1) (Spring 2007): 1–22.

Freud, Sigmund. *The Ego and the Id*. Trans. Joan Riviere. Ed. James Strachey. New York: W. W. Norton, [1923] 1960.

Freud, Sigmund. *The Interpretation of Dreams*. New York: Avon, [1900] 1965.

Fromm, Erich. *The Anatomy of Human Destructiveness*. London: Jonathan Cape, 1979.

Garb, Tamar, and Mignon Nixon. "A Conversation with Juliet Mitchell." *October* 113 (Summer 2005): 9–26.

Garbarino, James. *See Jane Hit*. New York: Penguin, 2006.

Gilley, Jennifer. "Writings of the Third Wave: Young Feminists in Conversation." *Reference and User Services Quarterly* 44 (3) (Spring 2005): 187–198.

Gray, Jonathan, Cornel Sandvoss, and C. Lee Harrington, eds. *Fandom: Identities and Communities in a Mediated World*. New York: NYU Press, 2007.

Griffin, Pat. *Strong Women, Deep Closets: Lesbians and Homophobia in Sport*. Champaign, IL: Human Kinetics, 1998.

Grosz, Elizabeth. "Bodies-Cities." In *Sexuality and Space*, ed. Beatriz Colomina. New York: Princeton Architectural Press, 1992, 241–253.

Gullette, Margaret Morganroth. *Aged by Culture*. Chicago: University of Chicago Press, 2004.

Gullette, Margaret Morganroth. *Declining to Decline*. Charlottesville: University Press of Virginia, 1997.

Harris, Adrienne. "Aggression, Envy and Ambition: Circulating Tensions in Women's Psychic Life." *Gender and Psychoanalysis* 2 (1997): 291–325.

Hart, Lynda. *Fatal Women: Lesbian Sexuality and the Mark of Aggression*. Princeton: Princeton University Press, 1994.

Harvey, Matthea. "Kara Walker." *Bomb* 100 (Summer 2007). http://www.bombsite.com/issues/100/articles/2904 (accessed May 17, 2009).

Heywood, Leslie, and Shari Dworkin. *Built to Win: The Female Athlete as Cultural Icon*. Minneapolis: University of Minnesota Press, 2003.

Higgins, Matt. "Daring Young Women Are on the Curl of a New Era." *New York Times*, December 11, 2008, New York edition. http://www.nytimes.com/2008/12/11/sports/othersports (accessed December 11, 2008).

Holmlund, Chris. "Visible Difference and Flex Appeal." In *Impossible Bodies: Femininity and Masculinity at the Movies*. London: Routledge, 2002, 16–29.

Holmlund, Chris. "Wham! Bam! Pam!: Pam Grier as Hot Action Babe and Cool Action Mama." In *Screening Genders*, ed. Krin Gabbard and William Luhr. Puscatawny, NJ: Rutgers University Press, 2008, 61–77.

Hurston, Zora Neale. *Their Eyes Were Watching God*. New York: Harper Perennial, [1937] 2006.

Inness, Sherrie. *Action Chicks*. New York: Palgrave Macmillan, 2004.

Inness, Sherrie. *Tough Girls*. Philadelphia: University of Pennsylvania Press, 1999.

Jack, Dana Crowley. *Behind the Mask: Destruction and Creativity in Women's Aggression*. Cambridge, MA: Harvard University Press, 1999.

Jacob, Mary Jane, et al. *Culture in Action*. Seattle: Bay Press, 1995.

Jacob, Wendy, et al., eds. *With Love from Haha*. Chicago: Whitewalls, 2008.

Jansz, Jeroen. "The Emotional Appeal of Violent Video Games for Adolescent Males." *Communication Theory* 15 (3) (August 2005): 219–241.

Jenkins, Bruce. "For the Most Part, 'Blue Crush' Gets It Right." *SF Gate*, August 22, 2002. http://www.sfgate.com/cgi-bin/article.cgi?f=/g/a/2002/08/22/surfcol.DTL (accessed July 18, 2009).

Joyrich, Lynne. *Re-Viewing Reception: Television, Gender, and Postmodern Culture*. Bloomington: Indiana University Press, 1996.

Juska, Jane. *A Round-Heeled Woman*. New York: Villard, 2004.

Kane, Mary Jo, et al. *Physical Activity and Sport in the Lives of Girls*. The President's Council on Physical Fitness and Sports, Department of Health and Human Services, 1997. http://www.fitness.gov/girlssports.htm (accessed July 18, 2009).

Kaplan, E. Ann. "A History of Gender Theory in Cinema Studies." In *Screening Genders*, ed. Krin Gabbard and Williuam Luhr. Piscataway, NJ: Rutgers University Press, 2008, 15–28.

Kester, Grant. *Conversation Pieces*. Berkeley: University of California Press, 2004.

Klein, Melanie. *Envy and Gratitude and Other Works, 1946–1963*. New York: Free Press, 1975.

Klein, Melanie, and Joan Riviere. *Love, Hate, and Reparation*. New York: W. W. Norton, 1964.

Kwon, Miwon. *One Place after Another: Site-Specific Art and Locational Identity*. Cambridge, MA: MIT Press, 2002.

Lacan, Jacques. "Aggressivity in Psychoanalysis" (1948). In *Ecrits: A Selection*. Trans. Alan Sheridan. New York: W. W. Norton, 1977, 8–29.

Laplanche, Jean, and J.-B. Pontalis. *The Language of Psycho-Analysis*. New York: W. W. Norton, 1973.

Lavin, Maud. "Exploding Powder Puffs." *Print Magazine* 58 (2) (March 2004): 68–73.

Lavin, Maud. "Marlene McCarty at Metro Pictures." *Art in America* (July 1993): 102–103.

Lebowitz, Cathy. "Marlene McCarty: Cathy Lebowitz Interviews Josefina Ayerza." *Lacanian Ink* 20 (2002): 114–123.

Lorde, Audre. "Uses of the Erotic: The Erotic as Power." In *Sister Outsider*. Freedom, CA: Crossing Press, 1984, 53–59.

McCarty, Marlene. *Where Is Your Rupture?* New York: Swiss Institute, 1998.

McCaughy, Martha, and Neal King, eds. *Reel Knockouts: Violent Women in the Movies*. Austin: University of Texas Press, 2001.

McHenry, Susan. "Let's Talk About Sex! Novelist Jill Nelson (*Sexual Healing*) and Cultural Critic Tricia Rose (*Longing to Tell*) Compare Notes on How Today's Sisters Think and Feel about Sexuality and Intimacy." *Black Issues Book Review* 5 (4) (July–August 2003): 40–45.

Messner, Michael A. *Taking the Field: Women, Men and Sports*. Minneapolis: University of Minnesota Press, 2002.

Mitchell, Juliet, ed. *The Selected Melanie Klein*. New York: Free Press, 1987.

Mitchell, Juliet. *Siblings: Sex and Violence*. Cambridge: Polity, 2003.

Mitchell, Juliet. "Theory as Object." *October* 113 (2005): 27–38.

Mitchell, Mary. "Do Tell: Black Women Spill Beans on Their Sex Lives." *Chicago Sun-Times,* September 19, 2004, p. 14.

Mitchell, Mary. "TV Finally Broaches Black Female Sexuality." *Chicago Sun-Times*, March 8, 2005, p. 14.

Mouffe, Chantal. "Citizenship and Political Identity." *October* 61 (1992): 28–32.

Mouffe, Chantal. "Deconstruction, Pragmatism and the Politics of Democracy." In *Democracy and Pragmatism*, ed. Chantal Mouffe. London, New York: Routledge, 1996, 1–12.

Mouffe, Chantal. *The Democratic Paradox*. New York: Verso, 2000.

Neal, Mark Anthony. *Soul Babies: Black Popular Culture and the Post-Soul Aesthetic*. New York: Routledge, 2002.

Nelson, Jill. *Let's Get It On*. New York: Amistad/HarperCollins, 2009.

Nelson, Jill. *Sexual Healing: A Novel*. Chicago: Agate, 2003.

Nelson, Jill. *Straight, No Chaser: How I Became a Grown-Up Black Woman*. New York: Penguin, 1997.

Neuman, Katherine. *A Different Shade of Gray: Midlife and Beyond in the Inner City*. New York: New Press, 2003.

Nixon, Mignon. "Bad Enough Mother." *October* 71 (Winter 1995): 72–92.

Nixon, Mignon. *Fantastic Reality: Louise Bourgeois and a Story of Modern Art*. Cambridge, MA: MIT Press, 2005.

Nixon, Mignon. "Introduction." *October* 113 (Summer 2005): 3–8.

Nyad, Diana, and Candace Lyle Hogan. "Women: Empowered by Sports Technology." In *Design for Sports: The Cult of Performance*, ed. Akiko Busch. New York: Cooper-Hewitt and Princeton Architectural Press, 1998, 46–67.

Parens, Henri. *The Development of Aggression in Early Childhood*. London: Jason Aronson, [1979] 1994.

Parker, Lonnae O'Neal. "Breaking the Chain; An African American Woman Reclaims the Sexuality that History Tried to Steal from Her." *The Washington Post*, October 30, 2005, sec. W, p. 14.

Pearson, Patricia. *When She Was Bad: How and Why Women Get Away With Murder*. New York: Penguin, 1998.

Pinder, Kym. "Exhibition Review: Kara Walker, My Complement, My Enemy, My Oppressor, My Love." *Art Bulletin* 90 (4) (December 2008): 640–648.

Raizada, Kristen. "An Interview with the Guerilla Girls, Dyke Action Machine (DAM!), and the Toxic Titties." *NWSA Journal* 19 (1) (Spring 2007): 39–58.

Rogoff, Irit. "Studying Visual Culture." In *The Visual Culture Reader*, ed. Nicholas Mirzoeff. London: Routledge, 1998, 14–26.

Rogoff, Irit, et al., eds. *A.C.A.D.E.M.Y.* Frankfurt am Main: Revolver, 2006.

Rose, Jacqueline. *Why War? Psychoanalysis, Politics, and the Return to Melanie Klein*. Oxford: Blackwell, 1993.

Rose, Tricia. *Black Noise*. Middletown, CT: Wesleyan University Press, 1994.

Rose, Tricia. *The Hip Hop Wars*. New York: Basic Books, 2008.

Rose, Tricia. *Longing to Tell*. New York: Farrar, Strauss and Giroux, 2003.

Rose, Tricia. "'Two Inches or a Yard': Silencing Black Women's Sexual Expression." In *Talking Visions*, ed. Ella Shohat. Cambridge, MA: New Museum and MIT Press, 1998, 318–324.

Ryan, Joan. *Little Girls in Pretty Boxes: The Making and Breaking of Elite Gymnasts and Figure Skaters*. New York: Warner, 1995.

Sapolsky, Robert. "The Trouble with Testosterone." In *The Kaleidoscope of Gender: Prisms, Patterns, and Possibilities*, ed. Joan Z. Spade and Catherine Valentine. Belmont, CA: Wadsworth/ Thomson Learning, 2004, 46–51.

Scott, David. *The Art and Aesthetics of Boxing*. Lincoln: University of Nebraska Press, 2008.

Scott, Joan. "Gender: A Useful Category of Historical Analysis." *American Historical Review* 91 (5) (December 1986): 1053–1075.

Sedgwick, Eve. *Touching Feeling*. Durham: Duke University Press, 2003.

Shaw, Gwendolyn Dubois. *Seeing the Unspeakable: The Art of Kara Walker*. Durham: Duke University Press, 2004.

Sholette, Gregory. "Counting on Your Collective Silence: Notes on Activist Art as Collaborative Practice." *Afterimage* (November 1999): 18–20.

Smith, Shawn Michelle. *Photography on the Color Line: W. E. B. Du Bois, Race, and Visual Culture*. Durham: Duke University Press, 2004.

Snediker, Michael. *Queer Optimism*. Minneapolis: University of Minnesota Press, 2009.

Spillers, Hortense. "Interstices: A Small Drama of Words." In *Pleasure and Danger: Exploring Female Sexuality*, ed. Carole Vance. Boston: Routledge & Kegan Paul, 1984, 73–99.

Steinmetz, Julia, et al. "Behind Enemy Lines: Toxic Titties Infiltrate Vanessa Beecroft." *Signs* 31 (3) (2006): 753–783.

Stowe, Harriet Beecher. *Uncle Tom's Cabin*. Mineola, NY: Dover, [1852] 2005.

Strausbaugh, John. *Black Like You: Blackface, Whiteface, Insult and Imitation in American Popular Culture*. New York: Jeremy R. Tarcher/Penguin.

Van Deburg, William L. "Review of Mark Anthony Neal, *Soul Babies: Black Popular Culture and the Post-Soul Aesthetic*." *African American Review* 36 (4) (2006): 691–692.

Vergne, Philippe, ed. *Kara Walker: My Complement, My Enemy, My Oppressor, My Love*. Minneapolis: Walker Art Center, 2007.

White, E. Frances. *Dark Continent of Our Bodies: Black Feminism and the Politics of Respectability*. Philadelphia: Temple University Press, 2001.

Williams, Linda. "Skin Flicks on the Racial Border: Pornography, Exploitation and Interracial Lust." In *Porn Studies*, ed. Linda Williams. Durham: Duke University Press, 2004, 271–308.

Wilson, Mick. "Autonomy, Agonism, and Activist Art: An Interview with Grant Kester." *Art Journal* 66 (3) (Fall 2007): 107–119.

Winnicott, D. W. "Aggression in Relation to Emotional Development." 1950–1955. In *Through Paediatrics to Psycho-Analysis*. London: Hogarth Press, 1975, 204–218.

Winnicott, D. W. *Playing and Reality*. London: Routledge, [1971] 2005.

Woodward, Kathleen. "Against Wisdom: The Social Politics of Anger and Aging." *Journal of Aging Studies* 17 (2003): 55–67.

Woodward, Kathleen. *Aging and Its Discontents*. Bloomington: Indiana University Press, 1991.

Woodward, Kathleen. *Boxing, Masculinity and Identity*. New York: Routledge, 2007.

Woodward, Kathleen. "Inventing Generational Models: Psychoanalysis, Feminism, Literature." In *Figuring Age*, ed. Kathleen Woodward. Bloomington: Indiana University Press, 1999, 149–168.

Young, Iris Marion. "Throwing Like a Girl: A Phenomenology of Feminine Body Comportment, Mobility, and Spatiality." In *Throwing Like a Girl and Other Essays on Feminist Philosophy and Social Theory*. Bloomington: Indiana University Press, 1990, 139–165.

Zane. *Addicted*. New York: Atria Books, 1998.

Zane. *Afterburn*. New York: Atria Books, 2005.

Zane, ed. *Breaking the Cycle: A Collection of Short Stories Surrounding Domestic Abuse and the Turmoil It Causes*. New York: Strebor, 2005.

Zane. *Dear G. Spot*. New York: Atria Books, 2007.

Zane. *Nervous*. New York: Atria Books, 2004.

Zane, ed. *Purple Panties*. New York: Strebor, 2008.

Zane. *Shame on It All*. New York: Atria Books, 2005.

Zane, with Eileen M. Johnson and V. Anthony Rivers. *Love Is Never Painless*. New York: Atria Books, 2006.

Zillman, Dolf. "The Psychology of the Appeal of Portrayals of Violence." In *Why We Watch: The Attractions of Violence*, ed. Jeffrey Goldstein. New York: Oxford University Press, 1998, 179–211.

Žižek, Slavoj. "Introduction: Robespierre, or the 'Divine Violence' of Terror." In *Virtue and Terror (Revolutions)*, Maximilien Robespierre. New York: Verso, 2007, vii–xxxix.

Žižek, Slavoj, presenter. *The Pervert's Guide to Cinema: Parts 1, 2, 3*, film directed by Sophie Fiennes. A Lone Star/Mischief Films/Amoeba Film production. 2006.

Index

Notes: Characters in films and artwork are listed as they are most often named in the text; for example, "Beatrix" is listed as Beatrix Kiddo, but "Tennison" is listed as Tennison, Jane. Pages with figures are in bold type. Notes are indicated by n (one on page) or nn (two or more on page).